Josef Müller-Brockmann
Grid systems in graphic design

Josef Müller-Brockmann
Rastersysteme für die visuelle Gestaltung

Josef Müller-Brockmann
Grid systems in graphic design

Josef Müller-Brockmann
Rastersysteme für die visuelle Gestaltung

Grid systems in graphic design
by Josef Müller-Brockmann
Copyright ©1981 by Niggli,
Imprint of Braun Publishing AG, Switzerland.
English version by D. Q. Stephenson, Basle

Traditional Chinese language edition
Copyright ©2023 by Faces Publications
Layout and book jacket:
Josef Müller-Brockmann (Original edition)
and Yehchungyi (Traditional Chinese edition)

ISBN 978-626-315-319-6
Printed in Taiwan

平面設計中的網格系統
約瑟夫・穆勒－布洛克曼
葉忠宜 選書／策畫

Grid systems

in graphic design

A visual communication manual
for graphic designers,
typographers and
three dimensional designers

Raster systeme

für die
visuelle Gestaltung

Ein Handbuch für
Grafiker, Typografen und
Ausstellungsgestalter

Josef Müller-Brockmann

目錄　　　　　　　　　　　　Inhaltsverzeichnis

前言

現代文字排印主要是基於 20 世紀 2、30 年代的一些
設計性和理論性的考察。19 世紀的馬拉美（Mallarmé）[1]、
亞杜・韓波（Rimbaud）[2] 及 20 世紀初的紀堯姆・阿波里
奈爾（Apollinaire）[3] 等先驅們針對文字排印的可能性提出
了新的理解，將人們從固有的成見和束縛中解放出來，
並通過各種試驗，為後來的理論家和實踐者獲得開創性
成就奠定了基礎。瓦爾特・德克賽爾（Walter Dexel）[4]、
埃爾・利西茨基（El Lissitzky）[5]、庫爾特・施維特斯
（Kurt Schwitters）[6]、揚・奇肖爾德（Jan Tschichold）[7]、
保羅・萊納（Paul Renner）[8]、拉斯洛・莫霍利 - 瑙吉
（László Moholy-Nagy）[9]、約斯特・施密特（Joost
Schmidt）[10] 等人則為過於死板的文字排印注入了新的活力。
揚・奇肖爾德在其 1928 年出版的《新文字排印學》
（*Die neue Typografie*）[11] 一書中創建了一套現代的、
與時俱進的、客觀文字排印規則。
視覺傳達中規則體系的發展，要歸功於那些提倡客觀與
功能性的文字排印和平面設計的大師們。早在 20 世紀
20 年代，德國、荷蘭、俄羅斯、捷克斯洛伐克、瑞士等國，
在文字排印、平面設計和攝影領域，就有很多作品是以
客觀的理念，嚴謹的構成方式創作而成。
今天，我們所知的網格是 1 種控制原理，在當時尚未

Vorwort

成形，但人們已經開始努力採用文字排印的方法，
追求最大限度的秩序和經濟性。本書中所提到的網格
原理是在二戰後的瑞士得到發展和應用的。在 20 世紀
40 年代後期，世界上第一次出現了使用網格做為
輔助設計的印刷作品，嚴謹的圖文設計、所有頁面統一
的版式，以及用客觀的手法表現主題，是這一新潮流
的特徵。
筆者在 1961 年出版的《平面設計師的設計問題》
（*Gestaltungsprobleme des Grafikers*）一書中，
首次以圖文形式簡要介紹了網格系統。
在文章〈在廣告、圖錄和展覽設計中做為輔助手段
的網格系統〉，介紹了網格的本質和用法，並列舉了
28 個實際案例。
之後，有些專業期刊也會不時刊載詳述網格主題的
文章，但是沒有一本書能闡述網格的結構和應用，
以及如何學習用網格系統進行設計。本書即為填補
這個空白的一個嘗試。
最後，筆者要感謝出版商為本書的出版而付出的努力，
以及授權這本書使用其作品的設計師和公司。另外
還要感謝我的助理爾蘇拉・默特莉（Ursula Mötteli）
小姐，感謝她竭誠相助並繪製插圖。

1 斯特凡・馬拉美
（Stéphane Mallarmé,1842–1898）、
法國詩人。法國象徵派的創始人之一。
代表作有抒情詩《牧神的午後》(1876)
和使用獨特排版形式的詩集《骰子一
擲》(1897)。

2 尚・尼古拉・亞杜・韓波
（Jean Nicolas Arthur Rimbaud,
1854–1891），法國詩人。代表作為
韻文詩《母音》、定型詩《醉舟》、
著重描述心理的自傳《地獄一季》
(1873)、散文詩《彩畫集》(1886)。

3 紀堯姆・阿波里奈爾
（Guillaume Apollinaire, 1880–
1918），波蘭裔法國詩人、小說家。
以巴黎為據點活動。代表作有評論集
《新精神與詩人》(1918)、表現圖案
的造形詩《書法》(1918)。

4 瓦爾特・德克賽爾
（Walter Dexel, 1890–1973），
德國畫家、平面設計師。1920 年代
開始領導耶拿藝術聯盟，並與包浩斯
（Bauhaus）及荷蘭風格派運動（DE
STIJL）建立親密的關係，為推動
德國結構主義藝術做出貢獻。

5 埃爾・利西茨基
（El Lissitzky, 1890–1941），俄羅斯
藝術家、設計師、建築師。在俄羅斯與
歐洲的前衛藝術間扮演橋梁的角色。
代表作為海報〈用紅色楔形擊敗白色〉
和繪本《兩個正方形的故事》。

6 庫爾特・施維特斯
（Kurt Schwitters, 1887–1948），
德國藝術家。倡導梅茲派藝術（Merz
Art），並出版雜誌《Merz》（1923–
1933）。於 1920 年代組織了一個新
的廣告設計師團體，為前衛設計運動
的國際交流做出貢獻。

7 揚・奇肖爾德
（Jan Tschichold, 1902–1974），
德國、瑞士文字排印師、教育家。著有
提倡結構主義設計原則的〈基本文字
排印〉(1925)、影響瑞士文字排印的
《新文字排印學》(1928)、因納粹崛起
移居瑞士後執筆的《文字排印設計》
(1935) 等理論性著作。為 Benno
Schwabe、Birkhäuser 以及倫敦企鵝
等出版社設計為數眾多的書籍、製作
字型 Sabon 等廣泛參與相關活動。

7　**8**　保羅・萊納
（Paul Renner, 1878–1956），德國
文字排印師、字體設計師、教育家。
以設計 Futura（1927）這款字型為人
所知。1930 年代在慕尼黑印刷技術
學校擔任校長，從事教育工作。著有
《做為藝術的文字排印》（1922）、
《文化布爾什維克主義？》（1932）等
著作。

9　拉斯洛・莫霍利 - 瑙吉（László
Moholy-Nagy, 1895–1946），出身於
匈牙利的藝術家、設計師、攝影師、
教育家。自 1910 年代與歐洲及俄羅斯

前衛藝術運動建立關係。1923 年
開始，於包浩斯基礎課程中執教，
並出版與編輯相關叢書。移居芝加哥
後，在 1937 年設立「新包浩斯」。
著有《繪畫・攝影・電影》（*Painting,
Photography, Film*,1925）、《運動中
的視覺》（*Vision in Motion*, 1947）
等書。

10　約斯特・施密特
（Joost Schmidt, 1893–1948），
德國平面設計師、文字排印師。於包浩
斯負責文字排印設計基礎課程、廣告設
計、排版、印刷工作室的教育。

11　揚・奇肖爾德於 1920 年代的
〈基本文字排印〉（1925）及《新文字
排印學》（1928），提倡使用無襯線體、
非對稱排版以及標準化紙張等基本
原則。

關於本書

本書以網格的功能和使用方法為主題，旨在為平面和
空間設計師們提供一個實用的工具，讓他們能更快速而
自信地去構思、組織和設計視覺問題的解決方案。
與此同時，本書也可做為教師的教學參考書，用於指導
教學和解決實際問題。本書也提供機會讓學生了解網格
的本質和製作方法，通過自我練習掌握運用。
為此，筆者盡可能詳細且循序漸進地指出並解釋在
設計網格需要注意的重點。
若設計師想合理地、功能性地運用網格，則需要對所有
判斷標準進行慎重研究。大多數設計師並不了解或者
誤解了網格系統而導致誤用，這些事實也表明，使用網格
需要認真學習。而那些不惜付出努力的人則會發現，
在網格系統的說明下，他們能以更具功能、更有邏輯、
更美的方式去解決諸多問題。

將網格做為一個秩序系統進行運用，展現了1種精神的
態度。因為其體現了設計師是以1種結構性、面向未來的
方式來構思其作品的。
這也體現了1種專業精神：設計師的作品應該以數學
思維為基礎，既清晰、透明，又具有客觀性、功能性和
美感特質。設計師的作品應當為通識教育做出貢獻，
並成為其中的一分子。
可分析、重製的建構性設計，可以對社會的品位，
以及一個時代的造形和色彩文化產生良性影響。既客觀
又符合公眾利益、並且經過精心構思和培育的設計，
是民主行為的先決條件。結構主義者的設計 ✳ 意味著從
設計法則到實際解決方案的轉換。製作具有嚴謹格式、
體系化的作品，需要的是開放、透明，並能融匯各種要素，
這在社會政治生活中也至關重要。

使用網格系統工作，就意味著要遵循普遍有效的法則。
應用網格系統即意味著：
有意於系統化和清晰化；
有意於洞察本質、濃縮精華；
有意於培養客觀性而非主觀性；
有意於將創作和生產技術過程合理化；
有意於將造形、色彩和材質等要素相結合；
有意於取得建築平面和空間的影響力；
有意於採取積極、前瞻的態度；
認識到教育的重要性，以及以結構性、創造性設計
而成的作品所帶來的影響。
每件視覺、創意作品都是設計師個性的體現，
都能反映出其知識、能力和信念。

　✳　1950 年代後半，蘇黎世的平面
設計師們以秩序構成的幾何學為基礎，
提出新的平面設計「結構 (Konstruk-
tive)」的理念與方法，並在1958 年
蘇黎世設計博物館，由約瑟夫·穆勒 -
布洛克曼策畫以「建構性平面設計」
為題開展，設計師包括漢斯·諾伊堡
(Hans Neuburg)、理查·保羅·洛斯
(Richard Paul Lohse)、卡羅·韋瓦
瑞里 (Carlo Vivarelli) 皆有參展，並
在他們共同編輯、創刊的雜誌《新平面
藝術》一書中明確表明該理念。此外，
影響了蘇黎世設計師的揚·奇肖爾德
也在文章〈基本文字排印〉中，提出

新的平面設計尤其要以結構主義為基
礎。開篇便主張其基本原理為「文字
排印必須符合社會目的」，強調了其社
會角色的重要性。

具有文字排印特徵的網格

Der typografische Raster

網格將二維平面劃分為更小的「格」（field）[1]，
或者將三維空間分成更小的「區域」（compartments）。
「格」與「區域」的大小既可相同也可不同。
格的高度相當於文本的整行數，寬度則等於欄寬。
高與寬都採用文字排印的度量單位，即點（point）[2]
和西塞羅（cicero）[3]。
格之間用空隙隔開，這樣一方面相鄰圖片不會互相接觸；
空隙也可以用於在圖片下方放置圖說。
格之間的間隔，縱向高度為正文的一行、兩行或更多行，
橫向寬度則取決於正文字型和插圖的大小。用此法分割
出若干格，能更好地安排如文字、照片、插畫、色彩
各種設計要素。要按照格的大小調整這些要素，讓其與
網格精確對齊。最小的插圖匹配最小的格。一個整頁的
「網格」由多個這樣的「格」組成，數量可多可少。所有的
圖片、照片、插圖和統計圖表等都設成單格、雙格、3 格
或者 4 格的大小。按照這樣的方法，就能使視覺資訊在
呈現上獲得 1 種統一感。
網格決定了重複單元和空間的大小。實際設計中並
沒有限定網格切分的數量。一般來說，每項工作都要
經過仔細分析，去設定符合其自身的網格。
原則：插圖尺寸差別越小，設計就顯得越安靜。
做為 1 種秩序系統，網格可讓設計師更容易地去合理

組織二維平面和三維空間。
秩序系統能迫使設計師更坦誠地去使用設計資源，
並要求設計師對手上的任務進行檢查和分析，還能
鼓勵設計師進行分析性思考，以邏輯的、務實的基礎
去解決問題。將文字和圖片系統化地組織起來，就能
明確地凸顯出優先順序。
在視覺設計中使用一個適當的網格，有助於：
a.
用視覺傳達的手段，構建基於事實的論證；
b.
將圖文素材系統化、邏輯化地構建起來；
c.
以有節奏感的方式精巧地安排圖文；
d.
讓視覺資訊的結構更透明、更具張力。
利用網格來輔助組織圖文有很多理由：
經濟考量：可以用更短的時間和更低的成本解決問題；
合理性考量：無論單一還是複合問題，都能以 1 種統一
又獨到的風格去解決；
心態考量：將事實、事件的過程以及問題的解決方案有
秩序地呈現出來，從社會和教育的層面看，可以為社會
文化做出建設性的貢獻，體現我們的責任感。

1 格（Field）為網格的組成單位。
指的是用網格系統將版面分割為網格
狀時，分割的一個單元所占的特定區
域。在安排圖片時，根據複數網格所
組成的天地左右邊距，可以依網格排
出各種尺寸的圖片合適的版面。

2 pt，為 1/72 英寸，
約 0.35146 公厘。

3 西塞羅（Cicero）為歐洲諸國使用
的活字度量單位。1 西塞羅為 1/6 英
寸，亦即 12 點。印刷業者康拉德·
斯韋恩海姆（Konrad Sweynheim）
與阿諾爾德·潘納爾茨（Arnold
Pannartz）曾於 1468 年將這個單位
用於西塞羅著作《有緣人·友人書簡
集》中。在英美地區，則使用 Pica
這個等同於西塞羅的單位。

使用網格的目的是什麼？ **Wozu dient der Raster?**

文字排印師、平面設計師、攝影師和展覽設計師會使用
網格來解決二維或三維的視覺問題。平面設計師和文字
排印師用它來設計報紙廣告、小冊子、圖錄、書籍和期刊
等印刷品，展覽設計師則用它來構思展覽、店鋪櫥窗
展示的方案。
平面和空間中的網格結構為設計師提供了一個好機會，
讓其從客觀性、功能性的角度安排文字、照片和圖表。
圖片元素要縮小至一些固定的格式尺寸，圖片大小則取決
於其對主題的重要性。
在網格系統中對視覺元素進行精簡和分類，能給人 1 種
精巧規畫、透明清晰、秩序中帶有設計感的印象。設計
中的這種秩序能加強資訊的可信度，增加人們的信心。
清晰且有邏輯地以標題、副標題、正文、插圖和圖說
等結構構成的資訊，不僅能讓人更快、更容易地閱讀，
也能讓人更容易地理解和記憶。這是一個經過科學驗證
的事實，設計師應銘記於心。
另外，網格還可以成功應用於企業識別系統（CI）中，
包括資訊的所有視覺媒介，從名片到展臺，公司所有
對內對外的表格、廣告、客運或貨運車輛、商鋪和大樓
的銘牌和標誌等。

紙張的尺寸

大多數印刷品都遵循標準化的 DIN ✳ 規格，因此建議
設計師可以使用這些最常用的紙張尺寸。一方面，
這些尺寸在紙廠有現貨庫存，印刷廠訂購也不會浪費
時間；另一方面，印刷和紙張裁切設備也有一定的
標準化尺寸，與 DIN 規格的紙張格式配套。另外，
信封大小也有 DIN 標準，而且最後很重要的一點，
部分郵資規定也是基於 DIN 制定的。
設計師如果使用 DIN 規格以外的尺寸，則需要造紙廠
按照新尺寸另外生產，或者採用稍大的尺寸印刷並在
後期裁切，意味著紙張的浪費。這 2 種方法都會增加
產品成本。
接下來的一頁展示了 DIN 規格的紙張尺寸。我們
可以看到大一級的紙張尺寸總是前一級的兩倍。例如，
A6 是 A7 的兩倍。這就意味著，實際上每個 DIN 尺寸
的紙張在對折後依然還是 DIN 尺寸。
這樣的標準化絕對是利大於弊。想要建立企業識別
系統的公司也會採用統一的紙張尺寸，用標準尺寸紙張
印刷的訊息對讀者有更大的影響力。
而接收方也更有可能保留標準化尺寸的紙張，因為更方便
歸檔和建立索引。這一點是任何設計師都不容忽視的。

13　✳　DIN 規格是德國標準化學會
（Deutsches Institut für Normung）
所制定的德意志聯邦共和國的國家
規格。DIN 有時也指德國工業標準
（Deutsche Industrie Normen-
ausschuß）的簡稱，在譯文中會統
一使用 DIN 規格。國際標準的紙張
尺寸，是以 1920 年代德國制定的
DIN476 為基準。值得一提的是，
同個年代的揚・奇肖爾德在其著作
《新文字排印學》（1928）中，討論了
DIN 規格的優點。

DIN 尺寸 A0 – A10

| A2 | A1 |
| A3 | A5 A7 A8 |
| A6 |
| A4 | |

A0 = 841 x 1189 mm
A1 = 594 x 841 mm
A2 = 420 x 594 mm
A3 = 297 x 420 mm
A4 = 210 x 297 mm
A5 = 148 x 210 mm
A6 = 105 x 148 mm
A7 = 74 x 105 mm
A8 = 52 x 74 mm
A9 = 37 x 52 mm
A10 = 26 x 37 mm

原紙是每種尺寸的基本形式。
將全開紙對半折成二分之一稱為
「對開」，即兩張紙或四個頁面；
全開紙對折兩次為「四開」，即四張
紙或八個頁面。
標準尺寸的印刷品源自 A、B、
C、D 四種系列。每種系列全開
尺寸如下：
A 系列 = 841 × 1189mm
B 系列 = 1000 × 1414mm
C 系列 = 917 × 1297mm
A 系列是其他系列尺寸的基礎，
B 系列是未裁切的尺寸，C 系列是

為 A 系列紙張制定的信封尺寸。
C、D 也被稱為輔助系列。
A 規格的紙張可以裝進 C 規格
的信封中。
C 規格的信封可以裝進 B 系列
的包裝中。
另外還有橫放的有特殊用途
的尺寸。
美國標準紙沒有歐洲標準紙那
麼細長，比如歐洲標準 A4 紙尺寸
為 29.7 × 21cm，而美國標準紙
尺寸為 11 × 8.5 英寸（27.94 ×
21.57cm）。

14

文字排印度量系統

Das typografische Mass-System

文字排印的度量系統以「點」（pt）為基礎，這個單位是以巴黎鑄字商菲爾曼‧迪多（Firmin Didot, 1712–1768）[1]的姓氏命名的。他改良了富尼耶（Fournier）[2]於 1675 年發明的點制。迪多點制逐漸被全歐洲採納，並維持地位至今。迪多點制與法國尺寸系統相關。字級尺（Typometer）[3]的線規相當於法國尺。1 法尺長約 30cm，合 798 點。活字的實際高度（height-to-paper，字腳到字面的垂直高度）直到 1898 年才統一定為 62⅔ 點[4]。傳統鉛字排版的計算是用「點」而不是公分。但隨著照相排版的出現，活字的實際高度除了「點」以外還可以用公厘和英寸來表述。自 20 世紀60 年代以來，人們開始努力在文字排印中用公制單位代替西塞羅單位制。

如今，迪多點制主要用於歐洲，而英美點制主要用於英國和美國。這兩個點制系統裡的「點」都是最小的度量單位。在常規排版中，字級大小以「點」為單位。第 16 頁的插圖展示了 6 點至 60 點的字級大小。一些字體家族還有 70 點活字。活字的深度（從頭到腳）稱作「字級大小」（point/body size），而字母的寬度被稱作「字寬」（set/width）。

活字字級大小在英美點制中還保留了一些舊名（括弧裡為德文名稱）：

　6-point = nonpareil（Nonpareille）
　7-point = minion（Kolonel）
　8-point = brevier（Petit）
　9-point = bourgeois（Borgis）
　10-point = long primer（Garmond）
　12-point = pica（Cicero）
　14-point = english（Mittel）
　16-point = great primer（Tertia）
　20-point = paragon（Text, 美國稱 columbian）
　24-point = two-line pica／double pica（2 Cicero）
　28-point = double english（Doppelmittel）

儘管鉛字的高度總是保持在 62⅔ 點不變，但寬度卻是多樣的。在一個字體家族中通常會有壓縮體（condensed）、中等體（medium）、寬體（expanded）、特壓縮體（extra-condensed）、特寬體（extra-expanded）。但一般來說，medium 是最易閱讀的字體。

1 弗朗索瓦 - 安布魯瓦茲‧迪多（Francois-Ambroise Didot, 1730–1804），是法國印刷業者。他是在印刷、出版、活字鑄造等領域取得實績的迪多家族創始人弗朗索瓦‧迪多之長子。他於 1783 年提倡的迪多點制，整合了活字標準尺寸與當時法國的標準度量單位，普及於歐洲各國。在此修正原作中出現的菲爾曼‧迪多（Firmin Didot, 1764–1836）。

2 皮埃爾 - 西蒙‧富尼耶（Pierre-Simon Fournier, 1712–1768），法國活字雕刻師、活字鑄造業者。他於 1737 年將法國度量單位 pied de roi 分割為 12 等分的pouce，再將 pouce 分為 12 等分為ligne，並提倡使用將 ligne 分為 6等分的點制。在此將原作 1675 年修正為 1737 年。

3 字級尺（Typometer）是用於活字排版時的測量尺規。有 Cicero、pica、inch、centimetre 等單位的標示。

4 德國在 1898 年把鉛字的字高定為 62⅔ 點。各國統一的情況並不一樣，中國、日本一直都未統一標準。

文字排印的單位名稱

字級大小從 6 點到 60 點的 Helvetica

cm				Cicero

6 — point
8 — point
9 — point
10 — point
12 — point
14 — point
18 — point
24 — point
30 — point
36 — point
48 — point
60 — poin

原表中展示了文字排印的度量單位
西塞羅和公制單位公分之間的對應
關係。1 西塞羅相當於 12 點 *,
1 公分等於 10 公厘。26 西塞羅 8 點
相當於 12 公分。標準度量需採用
字級尺,長 30 公分,即 798 點,
相當於一法尺。
1 公尺 = 2660 點 = 221⅔ 西塞羅
1 法尺 = 30 公分 = 1 線規 =
798 點 = 66½ 西塞羅
1 公厘 = 2.66 點
1 點 = 0.376 公厘 =
1.07 英美點 =0.0148 英寸

1 西塞羅 = 4.51 公厘
每款活字的設計都會包含 12 到
20 種不同的尺寸,這些尺寸被稱作
「字級大小」,用「點」表示。
上圖中的數字和字母上下兩條線的
距離即「字級大小」,也就是金屬
活字中字母從頭至腳的厚度。大於
72 點的字,一般會用木頭雕刻或者
用照相排版的投影技術製作。字型
大小設置取決於用途。一般來說,
8 至 12 點的字級大小適用於書籍的
正文、小冊子或圖錄。

＊ 迪多點制為歐洲活字的測量單
位。1 西塞羅為 1/6 英寸,也就是 12
點。1 迪多點 =0.3759mm,12 迪多
點 =1 西塞羅。在英美與日本,1 英美
點 =0.3514mm,12 英美點 =1 派卡
(pica)。現在在電腦系統世界通用的
點制為 1 DTP=0.3528mm。

16

歐文字體樣式　　　　　　　　　　　　Schriftalphabete

如今的設計師有大量的字體可以選擇。自從古騰堡（Gutenberg）＊ 在 1436 至 1455 年期間發明金屬活字以來，已經有成千上百種不同字體被設計出來，並鑄造成鉛字。隨著電腦和照相排版的發展，又有更多的新字體以及復刻的舊字體上市。

字體的選擇取決於設計師。為作品挑選好或者差的字體，要靠他們對造形的理解。出於篇幅限制，我們在此僅參考過去及 20 世紀的出版物中最頻繁出現的幾款字體。

掌握字體知識，對於印刷品的功能、美學、心理效應來說最為重要。而且，文字排印設計，比如字母與單字間正確的間距，以及行長、行距等都能讓閱讀更輕鬆，並極大地提升作品給人的印象。目前，字體排版主要靠照相排版和電腦。這 2 種排版方式有一個典型特徵，就是把字母間距排得過緊導致閱讀困難。我建議設計師在指示照相排版時應使用正常字距。

通過研究 Garamond、Caslon、Bodoni、Walbaum 等這些經典字體，設計師可以學習到易於閱讀、精緻優雅又富有藝術性的字體有哪些永恆不變的標準。Berthold、Helvetica、Folio、Univers 等字體也能排出舒適又辨識度高的版面。用於羅馬體（襯線體）的排印規則同樣也適用於無襯線字體。

這些字體的創造者都是極具智慧和創造力的藝術家。400 多年來有無數的字體設計師致力創造新字體，這些字體卻很少能被接受也證明了這一點。Garamond 之所以具有很高的藝術成就，是因為每個字母都有清晰獨特的造形，無論是大寫還是小寫字母都體現出最高的造形品質與獨創性。每個字母都有自己獨特的個性和說服力。

17　＊　約翰尼斯．古騰堡（Johann Gutenberg, 1397–1468），德國金匠、印刷業者。他結合多種技術，以鉛合金製作的金屬活字、油性墨水、借鑒榨取葡萄技術的木製印刷機完成活版印刷技術。現存代表印刷品為世界第一部印刷的聖經《42 行聖經》（約 1455 年）、《36 行聖經》（約 1460 年）、《天主教辭典》（*Catholicon*，約 1460 年）等。

在做平面設計時，每位注重文字排印的設計師都應該認
真徒手繪製文字部分的設計草圖。有很多設計師會使用
Latraset ✳，這的確能做出乾淨整潔、幾近可直接付印的
稿件。但是，要培養對優秀字形和漂亮字體的感性認識，
就只能靠持續、仔細的文字描繪練習。
後面幾頁的範例，顯示出字母的造形是如何既有視覺張力
又有優雅氣質，還能讓排出的文本賞心悅目又輕鬆易認。
文藝復興時代創造了中軸對稱式文字排印，這方式一直
持續到 20 世紀。而新文字排印不同於舊式方法，開始
嘗試根據文字的功能來創建版面的外在形式，還把背景也
當作同等重要的設計項目。而早期的（中軸對稱式）文字
排印則是在抵抗死板、被動的背景上扮演一個積極的角色。

✳　Latraset 是 1 種乾式轉印字體
貼，使用者可通過按壓膠片將文字轉印
到紙張上。為 1959 年倫敦設計師、
美術字設計師查理斯・克里弗・戴・
戴維斯（Charles Clifford "Dai" Davies）
與印刷顧問弗雷德・麥肯其（Fred
Mckenzie）創立的拉圖雷塞公司，
於 1961 年初次採用的乾式即時轉印
系統。將具有黏著性的文字印在透明
的塑膠片上使得轉印變得容易，自 60
年至 70 年代迅速普及

GARAMOND

abcdefghijklmnopqrsßtuvwxyz

ABCDEFGHIJKLMNO PQRSTUVWXYZ

1234567890

19　Garamond,
48pt, medium
「Garamond」是由刻字師克洛德・加拉蒙（Claude Garamond，約 1480–1561）[1] 於 1535 年在巴黎設計並雕刻的。這是一款純粹的舊體字，Garamond 是第一款將義大利體（italic）與羅馬體（roman）組合設計出的字體。後來，羅貝爾・格朗容（Robert Granjon）[2] 和克里斯托弗・范・戴克（Christoffel van Dijck）[3] 對其進行了改良。清晰、和諧的造形令其流傳至今，目前它還可以用於照相排版。Garamond 有 6 點到 48 點不同規格的字級大小，備有 medium、次粗體（semi-bold）和 italic。
normal 與 medium 還附有細體（light）、semi-bold、粗體（bold）與 italic。light 常用於小字級大小的旁注和圖說，而 semi-bold、bold 和 italic 常用於標題字，而更大的字級大小常用於書名。

1　克洛德・加拉蒙
（Claude Garamond, 1510–1561），法國活字雕刻師，也從事活字製作與出版工作。自 1536 年左右製作的許多羅馬體、義大利體、希臘語（1540–1544）等活字為至今留世的不朽字體，為 16 世紀法國文藝復興文字排印的黃金時代奠定基礎。

2　羅貝爾・格朗容
（Robert Granjon, 1513–1590），與加拉蒙同時期的活字雕刻師。他製作了羅馬體、義大利體、花形裝飾活字等為數眾多的活字字體。格朗容的義大利體，被做為 Garamond 的義大利體廣泛被使用。

3　克里斯托弗・范・戴克
（Christoffel van Dijck, 1601–1669），荷蘭活字雕刻師。他製作的字體影響了近期英國的印刷從業者、學術出版商和活字鑄造商。

CASLON

abcdefghijklmnopqrsßt uvwxyz ABCDEFGHIJKLM NOPQRSTUVWXY Z 1234567890

Caslon,
48pt, medium
Caslon 羅馬體由威廉・卡斯隆一世
（William Caslon I, 1692–1766）
設計、雕刻，並以他的名字命名。
1720 年，卡斯隆在牛津做為一個刻
字工開始從事字體設計，他設計的
字體最早可以追溯到 200 年前。在
1720 到 1726 年間，卡斯隆刻出了
非常漂亮的 14 點（english）、12 點
（pica）和 8 點（brevier）活字。他為
英格蘭的英文字體發展奠定了基礎。
如今 Caslon 有 6 點至 48 點不同規
格的字級大小可供選擇，其中包括
medium、semi-bold 和 italic。

BASKERVILLE

abcdefghijklmnopqrsßtuvwxyz

ABCDEFGHIJKLMNOPQRSTUVWXYZ

1234567890

21 Baskerville,
48pt, medium
約翰・巴斯克維爾（John Baskerville, 1706–1775）改進了荷蘭的字模，製作出 Baskerville，其出色的表現力讓人印象深刻。自身也是字體設計師的讓松（Jenson）* 指出，Baskerville 擁有最精確的幾何比例以及最優雅的氣質。Baskerville 與其他新出現的字體一樣回歸到了手寫風格，它也引領了現代字體的發展方向。
Baskerville 對英格蘭影響力非常巨大。18 世紀後半葉，英國的文字排印作品都是印刷商和活字鑄造商

依照 Baskerville 的傳統進行塑造的。Baskerville 現有從 6 點至 36 點的不同字級大小，包含了 roman 和 italic。

＊ 原著提及的讓松（Jenson），考量到 15 世紀於威尼斯活動的法國活字製作者尼古拉斯・讓松（Nicolas Jenson, c.1420–1480）無法跟這裡的前後文脈絡一致。由此，從本文提及的荷蘭活字字型為線索，在此修改為 Janson。Janson 為 17 世紀後半，匈牙利活字雕刻師尼古拉斯・基斯（Nicolas Kis, 1650–1702）設計的活字字型。名稱取自荷蘭活字鑄造業者安東・揚松（Anton Janson, 1620–1687）之名，並於 20 世紀由德國活字鑄造公司斯坦普爾（Stempel）復刻。

BODONI

abcdefghijklmnopqrsßtuvw

xyz

ABCDEFGHIJKLMNOPQ

RSTUVWXYZ

1234567890

Bodoni,
48pt, medium
1790 年，詹巴蒂斯塔·博多尼
（Giambattista Bodoni, 1740–1813）
在帕爾馬（Parma）刻制了 Bodoni
體，被視為從富尼耶設計到巴斯克維
爾設計的 1 種過渡。這也是全世界最著
名、使用最廣的一款經典字體。在《文
字排印手冊》（Manuale Tipografico）
一書中，他發表了 291 種字體和裝飾
花紋活字，展示了各種各樣豐富的印刷
素材。Bodoni 是「現代體」* 一個著名
的先鋒，其設計的主要特徵是採用
「極細筆」（hairline）與粗重的主筆畫
形成對比。

Bodoni 在當年的影響非常巨大。
如今 Bodoni 有從 6 點至 48 點的
各種字級大小，包含了 medium、
semi-bold、bold 和 italic。

✳ Bodoni 被歸類為現代羅馬體
（modern roman）的代表字體。
不過，初期 Bodoni 有受到皮埃爾 -
西蒙·富尼耶與約翰·巴斯克維爾的
影響。隨著時間推移，才漸漸確立
現代羅馬體的風格

22

CLARENDON

abcdefghijklmnopqrs

ßtuvwxyz

ABCDEFGHIJKLM

NOPQRSTUVWXYZ

1234567890

23　Clarendon,
48pt, medium
Clarendon 是一款基於埃及體
（Egyptian face）風格設計的字體。
埃及體最早出現於 1815 年的菲金斯
（Figgins）鑄字廠[1]。現代商業的快速
發展需要強而有力的廣告字體，其中
最重要的就是埃及體。為了增強衝擊
力，字母中的極細筆都被加粗了。
1929 年出現了一款埃及體的變體，
即由斯坦普爾鑄字廠生產名為 Mem-
phis 的字體。後來，哈斯（Haas）鑄
字廠的赫爾曼・埃登本茲（Hermann
Eidenbenz）[2] 又在 1843 年 Caslon
的基礎上改良了最初的版本。

Clarendon 最明顯的特徵是，其厚重
的橫筆與主要筆畫的對比非常小。
如今 Clarendon 有 medium 和
semi-bold，以及從 8 點至 64 點不
同規格的字級大小。

1　文森・菲金斯
（Vincent Figgins, 1766–1844），
為英國活字鑄造業者。以最先使用粗
襯線（Slab-Serif）的字體 Antique
（1815／1817），以及最早使用無襯
線（sans serif）一詞於〈Two-Line
Great Primer sans-serif〉（1832）
而知名，影響了 19 世紀英國維多利
亞時代的活字字型。

2　赫爾曼・埃登本茲
（Hermann Eidenbenz, 1902–
1993），瑞士平面設計師、教育家。
曾在蘇黎世、馬德堡、巴塞爾等地
從事教育工作。代表作為瑞士與
德國的紙幣設計。

BERTHOLD

abcdefghijklmnopqr stuvwxyz ABCDEFGHIJKLMN OPQRSTUVWXYZ 1234567890

Berthold,
48pt，medium
無襯線的 Berthold 是由字體設計師
霍夫曼（Hoffmann）[1] 於 1898 年在
柏林設計的。這款字體是基於 19 世紀
早期的無襯線字體改良而成，有著橫
豎筆畫幾乎一樣粗細的獨特外形。
「無襯線」（sans serif）這個名稱
是因為這類字體除去了字母起筆和
收筆處的裝飾「襯線」（serifs）。
Berthold 在經歷了二戰以後開始復
興，一開始在瑞士流行，然後逐漸蔓延
到歐洲其他地方。它冷峻的氣質特別
適用於工業廣告。
1967年，巴塞爾（Basle）的 GGK [2]

公司繪製了 Berthold 的照相排
版，具有 light、medium、semi-
bold、bold、italic、condensed、
expanded 等各種款式。

1　柏林貝特霍爾德鑄字廠出品的
Akzidenz-Grotesk (1898)，設計
師不詳。近年研究指出該字體源自德
國活字製作者費迪南德・泰因哈特
(Ferdinand Theinhardt, 1820–
1906) 所設計的字體 Royal Grotesk
並非事實。此外，Berthold-Grotesk
為 1920 年代發售的字體，1957 年
瑞士哈斯鑄字廠發表的 Neue Haas
Grotesk，其字體設計師愛德華・
霍夫曼 (Eduard Hoffmann, 1892–
1980) 也不是這個字體的設計師，
因為 1898 年他才 6 歲。貝特霍爾德
鑄字廠從未出品過一款叫 Berthold
的字體，本頁的字體應該就是

Akzidenz-Grotesk，並以「貝特霍
爾德鑄字廠的無襯線字體」稱呼。

2　GGK (Gerstner, Gredinger +
Kutter) 為瑞士廣告公司。1959 年，
平面設計師卡爾・格斯特納 (Karl
Gerstner, 1930–2017) 與廣告導演
馬可仕・柯特 (Markus Kutter,
1925–2005) 在巴塞爾成立 Gerstner
+ Kutter，1962 年加入建築師保羅・
葛雷丁格 (Paul Gredinger)，公司名
稱變成 GGK。GGK 在 1960 年代推
動了 Akzidenz-Grotesk 的企畫，
部分使用了貝特霍爾德的照相排版機
Diatype。

24

TIMES

abcdefghijklmnopqrsß
tuvwxyz
ABCDEFGHIJKLM
NOPQRSTUVWXYZ
1234567890

25 Times,
48pt, medium
Times New Roman 是在 1923 年專為《泰晤士報》(*The Times*) 的印刷而設計的。這款字體即使被印刷在粗糙的紙張上，也能保持高度的可辨識度，因為其字母具有短小、有力而尖銳的襯線。無論大小寫字母都顯得非常清晰。這款字體是由斯坦利·莫里森 (Stanley Morison)[1] 設計的。他與埃里克·吉爾 (Eric Gill)[2]、羅傑 (Rogers)[3] 和厄普代克 (Updike)[4] 一樣，為經典字體的忠實復刻工作做出了卓越貢獻。

1 斯坦利·莫里森 (Stanley Morison, 1892–1980)，做為英國 Monotype 公司印刷顧問，復刻 Bembo 等眾多古典字體，以及新刻字體 Times New Roman (1932) 等。同字體的製作年分，在此修正原作 1923 年為 1932 年。

2 埃里克·吉爾 (Eric Gill, 1882-1940)，英國雕刻家、碑文雕刻家、書法家、字體設計師。Perpeture (1925)、Gill Sans (1927) 為其代表字型。著有《埃里克·吉爾談字體》(暫譯，*An Essay on Typography*, 1931) 現在仍持續為人所閱讀。

3 布魯斯·羅傑 (Bruce Rogers, 1870–1957)，美國裝幀設計師、字體設計師。以尼古拉斯·讓松的字型為基礎製作的 Centaur (1914) 為其代表作。

4 丹尼爾·貝克萊·厄普代克 (Daniel Berkeley Updike, 1860–1941)，美國印刷者、裝幀設計師。《印刷活字》(暫譯，*Printing Types: Their History, Forms and Use*, 1922／1937) 的作者。

HELVETICA

abcdefghijklmnopqrsßtuvwxyz

ABCDEFGHIJKLMNOPQRSTUVWXYZ

1234567890

Helvetica,
48pt, medium
Helvetica 是由瑞士巴塞爾的哈斯鑄字廠推向市場的，一經推出便立刻引起很大的反響。1957 年，馬克斯・米丁格（Max Miedinger）＊ 設計了該款字體，字形是基於 Berthold 以及其他早期的無襯線體設計。不同於 Berthold 收筆處斜切的處理方式，Helvetica 在字母 c、e、g、s 的收尾處都是水平造形，字母開口處略微寬闊而帶有開放感，字母 G 更為簡化，垂直筆畫比 Berthold 更短，進一步提升了字體的辨識度。
Helvetica 共有 13 個字級大小可供

選擇，包括了 6 點至 48 點不同規格的字級。現在市面上也有照相排版的版本。

＊ 馬克斯・米丁格
（Max A. Miedinger, 1910–1980），瑞士的字體設計師。1936 至 1946 年，以文字排印師、設計師身分在蘇黎世活動。1947 至 1957 年於（1580 年成立）的哈斯鑄字廠服務。Helvetica 為愛德華・霍夫曼委託製作，以 Neue Haas Grotesk 之名發售（1957）。Neue Haas Grotesk 的活字樣本由約瑟夫・穆勒 – 布洛克曼所設計。1960 年，調整為適合 Linotype 排字機所用，以此為契機改名為 Helvetica。

26

UNIVERS

abcdefghijklmnopqrs
ßtuvwxyz
ABCDEFGHIJKLMNO
PQRSTUVWXYZ
1234567890

27 Univers,
48pt, medium
Univers 是由阿德里安・弗魯提格
（Adrian Frutiger）[1] 在 1957–1963
年間 [2] 為巴黎的字體商 Deberny &
Peignot 設計的。
因為對於印刷廠和設計師而言，這款
字具有的優勢非常重要。字重不僅有
light、medium、semi-bold、bold，
且均有 roman 和 Itallc 可供選擇；
另一方面，人們在許多國家都可以
買到照相排版用的各款字級大小。
另外，為了能保證最好的印刷效果，
字母筆畫在直筆（stem）和字碗
（bowl）的連接處也被削細了一些，

上伸部（ascenders）和下伸部
（descenders）也被縮短了。

[1] 阿德里安・弗魯提格
（Adrian Frutiger, 1928–2015），
20 世紀後期具代表性的瑞士字體
設計師。服務於 Deberny & Peignot
鑄字公司，參與了 Univers（1957）
與 Meridien（1955）等字體的製作。
代表性作品有 Frutiger（1975）、
Avenir（1988）等字體。

[2] Univers 主要開發、發布的
過程如下：
1957 Lumitype-Photon
1958 Deberny & Peignot
1961 Monotype
1966 IBM Composer
1969 Margenthaler Linotype

欄寬不僅僅是一個設計或形式的問題，它還涉及文本的
可辨識度。如果要讓讀者輕鬆舒適地閱讀文本，那就不能
忽視字級大小、行的長度和行距。
對於正常的印刷品來說，我們眼睛與它的閱讀距離一般
為 30–35cm，字級大小也應該按這個距離來計算。字型
太大或太小都會讓讀者讀起來很費力，也容易產生疲勞感。
根據已被普遍認可的經驗，大約每行 7 個單字是一個
比較合適的長度。如果我們每行排 7-10 個單字，那麼我們
也很容易計算出該行的長度。為了讓版面中版心區域看起
來比較通透，我們還要考慮行距，也就是行與行之間的垂直
距離的問題，以搭配文本中的字級大小。照相排版技術也
帶來了一個新的問題，也就是字間調整的距離。在鉛字
排版中，字間由鉛字的字身寬決定，而在照相排版裡字間
每次都會被重新調整，導致字間距不勻，而且往往太緊，
令人遺憾。所以，我強烈建議設計師們在發照排單時，
應當堅持使用正常字間。
對於讀者來說，閱讀困難就意味著傳達、記憶品質的降低。
讀太長的行太累，讀太短的行也是如此。字行太長，
眼睛就會感覺費勁，那是因為眼睛需要長時間保持在一條
很長的水平視線上。太短也不利於閱讀，因為在閱讀過程中，
眼睛不停地換行容易分散讀者的注意力。
所以，合適的欄寬是形成均勻、愉悅的閱讀節奏的一個
前提，能讓人更輕鬆地閱讀，從而去全面關注內容本身。

7 點的無襯線字體、8 點行距的欄寬

Mehrzahl der Fälle überlegen. Überlegen deshalb, weil solche Arbeiten optisch den Betrachter anziehen, ja ɢnübersieht, wird ʟakzent in de
rein bildliche Darstellung eine umfangreiche Textbeigabe überflüssig macht, weil sie das zu propagie/Mir unterscheiden dabei nach Art und
jekt schon durch die Bildwirkung anschaulich erläutert. Diese Schwarz-Weiß-Arbeiten aber erweisenɪal zu dem Anteil der reinen Typogra
daß das Photo der Zeichnung immer dann im Werbegut unterlegen ist, wenn das erstere konventionᴀs rein Typographische gering, ja sei
letztere in ihrer Anlage weitgehend den Bereichen der modernen Kunst zuneigt. Die moderne Graphik, alɪere Gruppe der reinen Typographie
zum Schmuck der Wände bestimmt, wird von der Mehrzahl der Betrachter in dieser Zweckbestimmung aphischen Mitteln erstellt sind, gleich
dagegen in dieser oder jener Form als formaler Effekt in der Werbung sehr häufig von denselben Leuɟer Setzers verdanken, streng genom
tiert. Es gibt dafür eine einfache Erklärung: Die moderne Graphik löst bei der Mehrzahl der Betrachɪelementen, soweit sie als typographisɪ
eine gewisse optische Schockwirkung aus und hat deshalb den Vorzug, das Auge festzuhalten und guɟnd mehrfarbiger Druck sollen dabei

Wer sich der Fülle von Druckerzeugnissen aller Art bei einer Sichtung gegenübersieht, wird notwen
strenge Trennung versuchen und das Material in Gruppen unterteilen. Wir unterscheiden dabei nach Art
lage vor allem zwei Gruppen der Gestaltung und kommen dabei einmal zu dem Anteil der reinen Typ
und zum zweiten zu der Gruppe von Druckerzeugnissen, bei denen das rein Typographische gering, ja
Umfang nach von ausgesprochen sekundärer Bedeutung ist. Die erstere Gruppe der reinen Typograp
schließt für uns Arbeiten, die in ihrer Gesamtkonzeption aus typographischen Mitteln erstellt sind, g
ob diese Erzeugnisse ihre Entstehung der Skizze eines Graphikers oder Setzers verdanken, streng ge
also Arbeiten, die unter Verwendung von Schmuck, Form- und Flächenelementen, soweit sie als typogra
Material vorhanden sind, „gebaut" werden können. Negativätzungen und mehrfarbiger Druck sollen d

einbezogen sein. Demgegenüber steht die zweite Gruppe, deren Haɪ
scheinlich die Hand des Gebrauchsgraphikers und freien Künstlers
kungskraft aus dem überlegenen Einsatz freier graphischer Mittel, u
bar gering ist, ja, wo der Satz nur die Funktion der unbedingt notw
der Drucktechniken soll im Rahmen dieser Zeilen nicht berührt wer
der Anteil der reinen Typographie im Laufe der letzten Jahre erhebl
kundige Einbruch der freien Graphik in eine Domäne, die früher aus
nicht wegzuleugnende Tatsache ist. Die stürmische Aufwärtsentwick
sich gebracht, daß die Auseinandersetzung um Absatzmärkte und ɪ

die die Einbeziehung immer neɪ
schäft bleiben will". Die aufgew
lange richtig angelegt, wie sie e
unter den hier aufgezeigten Be
ist, muß schon ungewöhnlich pha
Falle schon bei Verwendung einɪ
tersuchungen in den USA, die zɪ
erfolgreicher sind als schwarz-w
objekten noch vorherrschend ist

29 選擇一個合適的欄寬使閱讀更輕鬆是文字排印中最重要的問題之一。版面中的欄寬必須對應合適的字級，因為太長的欄寬不僅增加眼睛的負擔，同時也會對讀者的心理產生不利的影響。同樣，太短的欄寬也會干擾閱讀，並打斷文本閱讀的流暢性，迫使讀者的眼睛不斷快速換行。太長或太短的欄寬都會降低閱讀的記憶力，因為讀者的注意力是十分有限的。

有一個規則是每行能容納平均 10 個單字的欄寬比較容易閱讀。這個規則對一定長度的文章有用。如果文本較短，每行長度長一些或短一些都不會有太大影響。

就像我們之前提到的，欄寬取決於字級和文本的數量，20 點的字級就需要一個寬一點的欄寬，8 點的字級就需要窄一些的欄寬。比如，標題字級是 20 點、正文字級是 8 點，又要求二者使用同樣的欄寬時，那麼就應當以 8 點字級為基準尋找合適欄寬。

10 點的無襯線字體、12 點行距的欄寬

Wer sich der Fülle von Druckerzeugnissen aller Art bei einer Sichtundärer Bedeutung ist. Die ers übersieht, wird notwendig eine strenge Trennung versuchen und das l uns Arbeiten, die in ihrer G Gruppen unterteilen. Wir unterscheiden dabei nach Art und Anlage tellt sind, gleichviel ob diese zwei Gruppen der Gestaltung und kommen dabei einmal zu dem Anteil dphikers oder Setzers verdan Typographie und zum zweiten zu der Gruppe von Druckerzeugnissen, rwendung von Schmuck, For das rein Typographische gering, ja seinem Umfang nach von ausgespr phisches Material vorhanden

und mehrfarbiger Druck sollen dabei mit einbezogen sein. Demgegenüber die zweite Gruppe, deren Hauptakzent in der formalen Gestaltung augens lich die Hand des Gebrauchsgraphikers und freien Künstlers verrät. Diese ten beziehen ihre Wirkungskraft aus dem überlegenen Einsatz freier graph Mittel, unter denen der typographische Anteil denkbar gering ist, ja, wo de nur die Funktion der unbedingt notwendigen Textwiedergabe darstellt. Die

der Drucktechniken soll im Rahmen dieser Zeilen zunächst festzustellen, daß der Anteil der reiner ten Jahre erheblich an Boden verloren hat, ja, daß freien Graphik in eine Domäne, die früher aussch war, eine nicht wegzuleugnende Tatsache ist. D lung von Industrie und Wirtschaft hat es mit sich

Wer sich der Fülle von übersieht, wird notwend Gruppen unterteilen. V zwei Gruppen der Gest Typographie und zum z das rein Typographisch

足够的行距是讓文本閱讀輕鬆愉悅
的重要因素。如果行距太窄，那麼眼
睛就容易被相鄰的行干擾，閱讀時
容易被迫接收鄰近的行文。所以，
應仔細斟酌避免任何影響閱讀節奏
的不利因素。
當然，我們這裡所說的並不適用於
單純的標題設計。在廣告中，標題的
作用是要醒目突出，並迫使讀者的眼
睛吸收它們的資訊。設定為大字級的
標題由於欄寬有限，往往被迫要分成
好幾行，反過來，字級小的圖說被迫
要放入過大的欄寬中。從可辨識度和
美觀的立場來看，這些例外都是可以
接受的。

20 點的無襯線字體、24 點行距的欄寬

Art bei einer Sichtung gegenübersi eiden dabei nac
Fülle von Druckerzeugnisse nterteilen. Wir untersch
versuchen und das Material in Gruppen wird notwe

hrer Gesamtkonzeption aus typograph
on ausgesprochen sekundärer Bedeut
en Mitteln erstellt sind, gleichviel ob die

Die erstere Gruppe der r
phische gering, ja seinem
umschließt für uns Arbeite

Umfang nac
rzeugnisser
ndig eine str

31　當使用字級大的字體排版時，必須
　　注意不要把版面的頁邊距設置得
　　太窄。無論在什麼情況下，都應在
　　字體與版面的邊緣之間保留一定的
　　距離。因為如果兩者太貼近的話，
　　就會影響到版面的整體設計。

行距 Zeilendurchschuss

行距和行長一樣需要格外注意。如同行長太長或太短，
行距太寬或太窄也會影響版心，進而影響文章的易讀性。
行距設置得太窄會降低閱讀的速度，因為上下兩行會
同時映入眼簾。眼睛無法精確地聚焦到單獨一行，也不能
保證只有該行、而不是其周邊區域都一起被閱讀。這不僅
分散了讀者的注意力，也讓讀者更容易疲勞。
同樣的道理，行距也不能設置得太寬。因為過寬的行距會
讓讀者很難把文本中的上下兩行聯繫起來，並讓人產生
不確定性和疲勞感。適當的行距能引導讀者的視覺從一行
自然地移動到另一行，並在閱讀的過程中建立信心和穩定
性，這都會讓文本自身更易被讀者吸收和記憶。當閱讀
變得更順暢和簡單時，文中的內容也自然能被讀者更清楚地
掌握，同時還能傳達出文本的表情與品質，在腦中留下更
深刻的印象。
欲設計出一個和諧、兼具功能性和美感、經久耐看的文字
版面，行距是其中最重要的因素之一。
另外需要注意的是，版面裡使用 3 到 4 種、甚至更多不同
字級的情況。為了讓文字排印設計更均勻、美觀，行距必須
針對各個字級分別進行調整。
同時，行距值也決定了一個頁面能容納的行的數量。行距
越寬，能放入的行數就越少，反之亦然。

行距

Zeilendurchschuss

字級大小：7 點，無襯線字體
行距：8 點、9 點

字級大小：7 點，無襯線字體
行距：10 點、11 點

Werfen wir einen Blick auf das, was auf dem Gebiet des Schriftscha
Jahre geleistet worden ist, so können wir die Beobachtung machen,
stets die gleiche geblieben war, insofern als alle Schriftformen sich
ganz im Gegensatz zu den viel freieren und kühneren Schöpfung
auch italienischer Schriftgießereien. Das mag vielleicht seine Ursac
Nüchternheit und seinem Sinn für das Bodenständige; es ist wenn r
zuzuschreiben, der aber, zumal auf dem graphischen Gebiet, als du
muß. Nehmen wir zum Beispiel Zeitungen verschiedener Länder zu
und namentlich ihren Anzeigenteil, so werden wir unter ihnen die
finden; denn diese unterscheiden sich meistens von den ausländ
typographische Aufmachung sowie auch durch die für die Uebersc
Den schweizerischen Schriften haftet also etwas traditionsgebunde
wollen, die Schweizer Schriftschöpfer hätten sich ihre Aufgabe leich
bewährten klassischen Vorlagen nachgebildet. Im Gegenteil, der ge
im allgemeinen die Schönheiten und Vorzüge klassischer Schriftfor
nicht sklavisch nachahmen. Er hat heute auch erkannt, daß sich gege
die reinen historisierenden Antiqua- und Frakturschriften nicht mehr
und er hält darum Ausschau nach neueren Formen. Es ist nicht sel
Geschmacksverirrungen Ende des vorigen Jahrhunderts und der fo

in den früheren Schriftproben der Gießerei mit der eher unpersönli
figurierte. Auch für diese Type wurden neue widerstandsfähige Ma
unter dem vielversprechenden Namen Caslon auf den Markt gebra
englischen Schriftschneider und -gießer William Caslon, von dem d
mit welchem der Basler Schriftgießer Wilhelm Haas offenbar geschä
Caslon erfuhr zehn Jahre später nochmals eine durchgreifende Neug
aber in der Kursiv. In ihrer neuen Aufmachung findet diese schöne
namentlich auch in nördlichen Ländern, wo typische englische Schri
zeichnenden, aber raumsparenden Schrift für Inserate, legte es de
Stempelschneider E. Thiele, Basel, eine streng und sachlich geformt
zu lassen. Im Jahre 1934 fand die Schrift unter dem Namen Superb
der Schweiz, und zwar derart rasch, daß schon drei Jahre später ei
konnte. Beide Superba-Schriften weisen angenehme Verhältnisse au
Formen sehr gut aus. Einige Jahre später wurde der interessante V
Wegstechen der Serifen in eine schmallaufende Grotesk umzuwand
in den früheren Schriftproben der Gießerei mit der eher unpersönli
figurierte. Auch für diese Type wurden neue widerstandsfähige Ma

Experiment ein sehr befriedigendes Ergebnis, und damit erblickte
neue Schrift, die Commercial-Grotesk das Licht der Welt und wurde
später eine Ergänzung in der Gestalt einer dazu passenden fetten
Anklang findet wie ihre halbfette Vorgängerin, denn der Bedarf an
kleiner als an mageren oder halbfetten. Angeregt durch englische
häufig ganz schmal laufenden Antiquaschriften, Slimblack genannt, b
ihre ehemalige Allongée anglaise, die nicht mehr als salonfähig ang
unter dem Namen, Schmale halbfette Ideal-Antiqua, neu zu gießen.
des 19. Jahrhunderts zurück und darf heute mit ihren stilreinen For
schrift angesprochen werden. Im deutschen Bundesgebiet erscheint s
ungewohnter wirken dagegen die sehr lebendigen und freien Former
Reklameschrift Riccardo, des Zürcher Grafikers Richard Gerbig, de
Werbefachleute sehr hat inspirieren lassen. Sie trat 1942 an die Oeff
Experiment ein sehr befriedigendes Ergebnis, und damit erblickte
neue Schrift, die Commercial-Grotesk das Licht der Welt und wurde

Als wir dort ankamen, war es dunkel geworden; wir traten ein in ein
das Fest emporgewachsen. Sechstausend Pilger mussten sich hier i
Eine regelrechte Stadt war entstanden, mit eigener Beleuchtun
kleines Vergnügungsviertel. Kamele stampften überall im Dämn
einem zerfallenen Torbogen auf, wo zwei würdige, bärtige Derwisc
gefaltet waren, angestrahlt von dem Licht einer grossen, mit Inschr
Wonnen des Jahrmarkts. Ich hatte nicht übel Lust, umherzustreifen
kam mir mit überein, dass wir uns in anderthalb Stunden bei unserm
Stadt mit ihren schlammigen Strassen und langen, von lichtsprüh
Süssigkeiten, alles ausgebreitet in diesem unirdischen Licht. Sämtli
Pilgern ihre Waren anzubieten. In den dunklen Winkeln spielten die
beim Schein winziger blakender Kerzen das Essen bereiteten. Die
eine reizende Eingeborene – abgerissene Viertelnoten und durchc
Ihr Preis stand an der Tür. Er war nicht übermässig hoch, dachte ich

33 行距是決定版面欄寬是否能良好閱讀
的重要因素。卡斯隆、巴斯克維爾、
迪多、埃姆克（Ehmcke）＊、奇肖爾德
等文字排印大師們都十分重視行距。
就像字母間和字距過密或過疏，行距
過或過窄會對版面整體的視覺觀感
造成負面影響，阻礙讀者閱讀，有意
識或無意識地造成其心理障礙。太寬
的行距會打斷版面中文本的連續性，
每一行都會被孤立，容易被看成是
一個獨立的元素。版面喪失整體性，
看起來缺乏張力和設計感。如果不添
加其他靈活的要素，閱讀速度會越拖
越慢，給人 1 種靜態、呆板的印象。
同樣，行距太窄也會產生負面效果。

文字版面灰度太高，字行喪失視覺上
的清晰度和平靜感。這會給眼睛造成
過多負擔，上下行同時映入眼簾，
眼睛無法專注閱讀單行。而過度集中
又會導致疲勞。

＊ 弗里茨・赫爾穆特・埃姆克
（Fritz Helmuth Ehmcke, 1878–
1965），德國平面設計師、文字
排印師、字體設計師。共同創立了
1900 年柏林平面與裝幀設計事務所
Steglitzer Werkstatt。於杜塞道
夫藝術學院任教。

字級大小：10 點，無襯線字體
行距：10 點、11 點

Werfen wir einen Rückblick auf das, was auf dem
Schweiz während der verflossenen Jahre geleiste
obachtung machen, daß mit wenigen Ausnahmen
geblieben war, insofern als alle Schriftformen si
unterordnen, ganz im Gegensatz zu den viel fre
deutscher, holländischer, französischer oder italie
vielleicht seine Ursache haben in der dem Schv
und seinem Sinn für das Bodenständige; es ist w
Konservativismus zuzuschreiben, der aber, zuma
durchaus gesunde Erscheinung bezeichnet werd
Zeitungen verschiedener Länder zur Hand und b
und namentlich ihren Anzeigenteil, so werden w
Zeitungen sehr leicht herausfinden; denn diese ur
Werfen wir einen Rückblick auf das, was auf dem
Schweiz während der verflossenen Jahre geleiste

ausländischen Zeitungen einmal durch ihre diski
und auch durch die für die Ueberschriften und A
Den schweizerischen Schriften haftet also etwas
nun aber unrichtig, glauben zu wollen, die Schwei
Aufgabe leicht gemacht und ihre Neuheiten ohne v
Vorlagen nachgebildet. Im Gegenteil, der geschu
schätzt im allgemeinen die Schönheiten und Vorz
und möchte sie aus diesem Grunde nicht sklavis
erkannt, daß sich gegenwärtig im Zeitalter der T
historisierenden Antiqua- und Frakturschriften nicl
lassen wie ehedem, und er hält darum Ausschau
sehr verwunderlich, daß man nach den Jahren der
ausländischen Zeitungen einmal durch ihre diskr
und auch durch die für die Ueberschriften und A

字級大小：10 點，無襯線字體
行距：12 點、14 點

vorigen Jahrhunderts und der folgenden Epoche
seinen Absonderlichkeiten auch auf dem Gebiete
wohlgeformte ruhig wirkende Antiqua herbeisehnt
wieder in vernünftige Bahnen zu weisen. Man be
ung der klassischen Bodonischriften, nachgeschr
des Giambattista Bodoni. Der große spontane Erfo
Schrift beschieden war, legte es der Firma nahe, c
Jahren auf neun Garnituren zu erweitern, nämlich
halbfetten und fetten Antiquaschriften vier entspre
sen acht Serien außerdem noch einen schmalfett
Neuherausgabe, deren Idee sie ihrem langjährige
vorigen Jahrhunderts und der folgenden Epoche
seinen Absonderlichkeiten auch auf dem Gebiete

obachtung machen, daß mit wenigen Ausnahmen
geblieben war, insofern als alle Schriftformen si
unterordnen, ganz im Gegensatz zu den viel fre
deutscher, holländischer, französischer oder italie
vielleicht seine Ursache haben in der dem Sch
Konservativismus zuzuschreiben, der aber, zuma
durchaus gesunde Erscheinung bezeichnet werd
Zeitungen verschiedener Länder zur Hand und b
und namentlich ihren Anzeigenteil, so werden w
Zeitungen sehr leicht herausfinden; denn diese ur
Aufgabe leicht gemacht und ihre Neuheiten ohne v

我們在此考察一下，在各種情況下
都確定合適的行距，以及為所用字級
確定合適的欄寬的問題，因為這與
網格系統有直接關係。
就像適合的欄寬和行距一樣，適合的
文本長度也是影響可辨識度的一個重
要因素。相對來說，大段的文本不僅
需要有較寬的行距，還需要利用段落
來進行區分。在視覺上，段落可以
通過在段落之間空行，或者在首行
縮行，或者利用首字母和小型大寫
字母等方式來區分。

34

字級大小：10 點，無襯線字體
行距：18 點、26 點

字級大小：20 點，無襯線字體
行距：20 點、22 點

Zeitungen sehr leicht herausfinden; denn diese ur

und namentlich ihren Anzeigenteil, so werden w

Zeitungen verschiedener Länder zur Hand und b

durchaus gesunde Erscheinung bezeichnet werd

Konservativismus zuzuschreiben, der aber, zuma

und seinem Sinn für das Bodenständige; es ist w

vielleicht seine Ursache haben in der dem Schw

deutscher, holländischer, französischer oder italie

Werfen wir einen Rückblick auf das, was auf dem

Schweiz während der verflossenen Jahre geleist

geblieben war, insofern als alle Schriftformen si

unterordnen, ganz im Gegensatz zu den viel fre

obachtung machen, daß mit wenigen Ausnahmen

vorigen Jahrhunderts und der folgenden Epoche

Wer sich der Fülleund da
n aller Art bei einer Sichtu
eht, wird notwendig notw
g versuchen und dasend
unterteilen. Wir eine stren
Art und Anlage ersuchen
er Gestaltung und ge Tre

zu dem Anteil der ir unter
rzeugnissen, bei Material
phische gering, ja in Grup
zum zweiten zu der teilen
on ausgesprochen sekur
ist. Die ersterscheiden en
graphie umschließt für un

35

行距設置適當的排版，能讓讀者
閱讀時感到平和舒適，並活躍其
思維。如果在設計時能顧及這裡
提到的所有觀點，那麼印刷出來的
作品就能保持 1 種經典和永恆的
外觀。
文字排印大師們都了解並遵循
這些幾個世紀以來都未曾改變的
排版規則。

字級大小：20 點，無襯線字體
行距：24 點、28 點

Wer sich der Fülle von D
n aller Art bei einer Art un
eht, wird notwendig allem
g versuchen und das Mat
unterteilen. Wir untzweiru
Art und Anlage vor bei na

er Gestaltung und komm
zu dem Anteil der reinen
d zum zweiten zu der Gllt
rzeugnissen, bei lage vor
phische gering, ja seinem

字級大小：20 點，無襯線字體
行距：36 點、52 點

on ausgesprochen sekur
g ist. Die erstere Greht, w
graphie umschließt für un
ihrer Gesamtkonzeptioer

Wer sich der Fülle Grupp

aller Art bei einer Sichtun

versuchen und das Mate

以上我們所提到的規則適用於常規的
設計，如書籍、圖錄和冊子的設計。
但如果是在新聞公告、平面廣告中，
通常文本內容都很短，那麼行距的
設置就只能取決於美感了。
行距設置對於詩集特別重要，它會帶
給讀者心理上不同的效果。
詩歌排版必須通過行長、字級、行距
和開本之間的關係展現引人入勝的
效果。按照一般規則，詩集的行距要
設置得比一般文本大一些。這樣可以
讓讀者分行聚焦，強調出每行詩句的
價值。
優秀的字體設計、字級與字母及
單字均勻的間距，還有寬鬆的行距，

這些要素微妙地相互聯繫和作用，
可以讓一首整齊樣式的詩歌昇華
成為一個藝術品。

邊距比例

Randproportionen

版心的周圍始終會留有空白的區域，這就是我們所說的頁邊距。頁邊距存在的原因有二：首先是技術原因，一般來說頁面邊緣的一到三公厘，有時多達五公厘會被裁切掉。如果沒有適當的邊距，會傷及文字本身。其次，頁邊距的設置也有審美的因素，因為比例協調的頁邊距可以提高讀者閱讀時的愉悅感。幾個世紀以來，所有經典的排版作品都有一個完美的頁邊距，都是通過黃金分割或者一些數學公式精確計算出來的。

頁面裁切總會或多或少存在不精準的情況，為避免給讀者留下負面的視覺印象，建議不要將頁邊距設置得過窄。如果頁邊距很小，歪斜的裁切可能就會立即被讀者注意到。頁邊距越大，技術上的不精準對一個精美設計的頁面的

整體影響就越小。

一位敏銳的設計師總是會盡力去創造出最富有張力的頁邊距比例。仔細研究古騰堡、卡斯隆、加拉蒙、博多尼等大師們的裝幀設計作品，還有揚・奇肖爾德、卡雷爾・泰格（Karel Teige）[1]、莫霍利 - 瑙吉、馬克斯・比爾（Max Bill）[2] 等 20 世紀先驅們的著作，都會獲得很多富有價值的幫助。

對於畫冊來說，如果需要顯得大氣一些，設計師會更偏向採用沒有邊距的頁面。版面可以一直延續到頁面四邊，也就是實現最大的印刷尺寸。通常這種滿版的頁面會與帶邊距的頁面搭配使用。如果版式得當，設計會顯得更大方。

1 卡雷爾・泰格
（Karel Teige, 1900–1951），捷克斯洛伐克的評論家、文字排印師、編輯、詩人。創立前衛美術運動 Devětsil（1922），創立雜誌《ReD》，編輯與設計《Disk》（1923）等刊物。透過參與 CIAM（Congrès International d´Architecture Moderne），與歐洲諸國的前衛藝術近代運動建立關係，推動布拉格的藝術、建築、超現實主義運動。

2 馬克斯・比爾
（Max Bill, 1908–1994），瑞士建築師、畫家、雕刻家、設計師。就讀於包浩斯期間，參加蘇黎世的抽象藝術團體 Allianz（1937），組織「具體藝術」展覽（巴塞爾美術館，1944）、創設烏爾姆造形學院，展開造形藝術、設計全面性的活動。1940 年代，是在書籍排印統一使用網格的先驅，強力影響了約瑟夫・穆勒 - 布洛克曼、蘇黎世的設計師。著有《形態》（暫譯，*Form*, 1952）一書。

邊距比例 Randproportionen

呆板的頁邊距 缺乏功能性的頁邊距

1 2

頁邊距及其比例，比如各個邊距之間的尺寸關係，對印刷頁面的整體效果有很大影響。如果頁邊距太小，會令讀者覺得頁面太擁擠，並且會在下意識中產生負面觀感，因為拿著印刷品，手指必然會觸碰到文字和圖片欄。

而過大的邊距，則容易使讀者有浪費和文字排太鬆的感覺。

相反地，穩定、平衡和比例協調的頁邊距會讓人有舒服又輕鬆的感受。

所有優秀的文字排印師都會十分注意頁邊距問題。足夠寬大的頁邊距同時滿足技術上的需要，因為裝訂裁切印刷品的過程中，出血位置可能會有多達 5 mm 的誤差。

在圖 1 中，版心位置在視覺上偏高，所以整體看上去版心似乎要飄出版面了。

在圖 2 中，版心位置又過低，看上去好像要掉出頁面。在這個例子中，頁面中有兩邊的頁邊距是相同的，這種缺少對比的設置看起來顯得呆板無力。

過於勻稱的頁邊距 比例協調的頁邊距

3

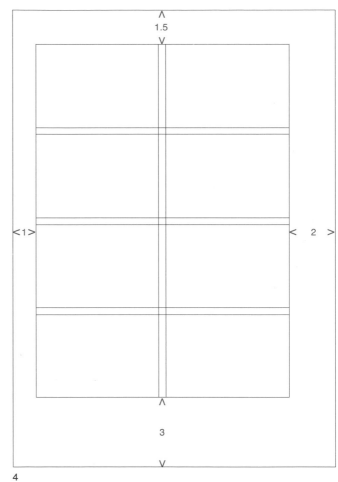

4

在圖 3 中，儘管版心的高度設置得很合適，但是頁邊距在上、左、右三個方向上的尺寸相同，這個效果也不太理想。過於平均的頁邊距永遠不會產生一個生動的版面，因為它們總是給人 1 種乏味和欠缺考慮的感覺。圖 4 中上下左右邊距的相互關係就非常好。此圖展示的是一本書或者小冊子對開頁的左頁。最寬的右邊距是裝訂邊，這裡的邊距通常要寬一些，因為書頁會彎進裝訂邊，導致閱讀困難＊。

＊　本書敘述的版心設置方法，與威廉・莫里斯（William Morris）、愛德華・約翰斯頓（Edward Johnston）以及揚・奇肖爾德等人著述中的傳統排版書籍格式比例相比，書口與裝訂邊（即左右邊距）比例設置恰好相反，請讀者注意。最後一句話德文版和英文版完全不同。英文版的內容是：「像這樣的版心設置比較適用於文學作品而不適用於廣告宣傳，因為單算成本就已經過於奢侈了」。

頁碼

頁碼在版面中的設置必須同時滿足功能和審美的需求。
雖然頁碼可以設置在版心周圍的任何位置，但最好是根據
版心的位置和頁邊距的寬度來設置。

只有在一些個別的案例中，頁碼才會放到書口那側。只有
當邊距够寬、可以保證頁碼不會被訂進去時，頁碼才可以
放到裝訂邊那側。

從心理學的角度上講，如果頁碼的位置設置在版心的中軸
上，會有 1 種靜態效果。而放在書口側則會有動態效果。

這有兩個原因：首先，把頁碼移到書口側可以誘導視線向
外移動。其次，把頁碼放在這個位置，可以讓視覺的重點
落在書口處，提高翻頁的速度。當然，只有在精細平衡的
排版裡才能應用這種方法。

如果頁碼在天頭或地腳，那就應該根據天頭地腳的高度，
與版心之間添加一行或多行的間隔。

如果頁碼在版心的左側或右側，那麼頁碼與版心之間的
距離應該相當於版面中欄間距的大小。

頁碼的若干種設置方式

1

2

3

4

5

6

7

8

在進行印刷品設計時，頁碼是一個很重要的元素。頁碼在版面中的位置可以賦予頁面動感或平靜的版面特徵。以上幾個圖例展示了在實際應用時主要的幾種頁碼設置方式。

在這些例子中，只有圖1中的頁碼位置是不合適的。因為它的位置過低，這樣的設置就孤立了頁碼與文本之間的關係。在視覺觀感上來說，這種頁碼設置會讓讀者有1種不安的下墜感。

圖2展示的是1種非常常見的頁碼設置方式，頁碼被放在版心位置的左下方。當然，需要說明的是這裡

所有的例子都是印刷品中的左頁。從視覺上來說，將頁碼設置在版面的邊緣位置可以做為1種視覺引導，並賦予翻閱1種動力。

在圖3中，頁碼被放在版心下方居中的位置，這樣的設置給人1種穩定和放鬆的感覺。如圖2所示，頁碼與版心之間有一行空行的距離。

圖4中的頁碼在版心位置的右下方，這種布局方式強調了對頁之間的中心軸對稱。

圖5的頁碼位置不太常見，此時頁碼在視覺上是從文本欄底部延伸出去。

圖6中也採用了1種不常見的方式，跟圖5有點類似。在這個例子中，

第一行的文本長度似乎被頁碼延長了，看起來頁碼好像「掛」在文字方塊第一行的延長線上。

在圖7中，頁碼被放在頁邊距中的天頭位置，視覺上向上拉伸了頁面。採用這種方式時，頁碼應該更靠近文字方塊一些。

在圖8中，頁碼被放置在頁面中軸的頂端，這個位置的頁碼提升了它在版面中的關注度。這種設置方式有著特別的功能。例如在參考書和詞典中，頁碼可以方便讀者進行快速查閱。

如果頁碼放在版心旁邊，那麼它就必須與版心中的字行對齊。頁碼

大小通常與正文字體大小一致。圖9至圖16（下頁）展示的是當版心分為雙欄時，幾種不同的頁碼設置方式。

頁碼的若干種設置方式

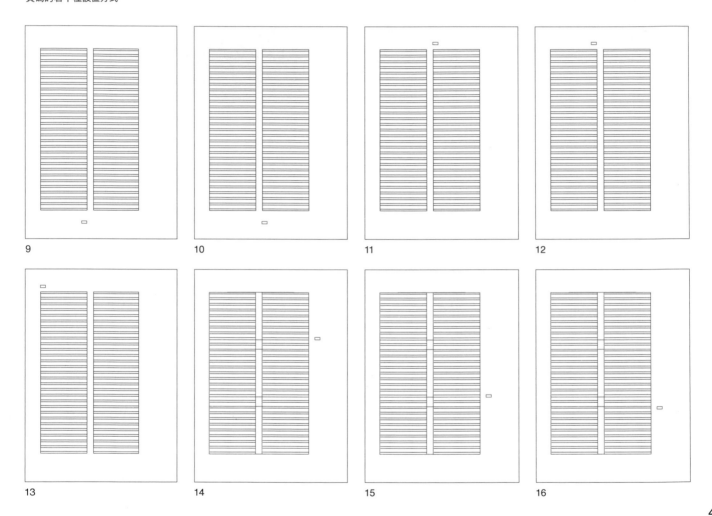

9

10

11

12

13

14

15

16

正文與標題字體

Grundschriften und
Auszeichnungsschriften

正文字體是指用於印刷品正文的字體，標題字體則用在
那些相對正文來說需要更為引人注目的詞句上，通常更大、
更粗或者用義大利體。具體的強調方法則需要根據作品
實際情況而定。在這裡我們將介紹幾種實際應用中的基本
原則。在之前的幾個世紀，人們通常習慣於將標題和需要
突出的文字用紅色標注，但在單色印刷時，如果我們想要
達到突出標題的目的就必須使用混合字體。
為了保證字體風格的統一，標題盡量採用與正文一樣的
字體。無論在什麼環境下，不同字體在進行混合使用時，
千萬不要使用風格近似的 2 種字體。比如說 Helvetica
不能與 Univers 進行混合使用，Garamond 不能與
Bodoni 進行混合使用。
接下來的兩頁介紹的是幾種在實際情況下的標題設計。
在具有功能性、統一性的文字排印中，我們應根據相關
印刷品的整體構思來決定標題的位置。
如果使用不同的字級大小，那麼字級大小之間應有顯著
差別。9 點的字級大小就很容易與 6 點的字級大小區分開，
顯得層次清晰。
另外，medium 和 semi-bold 之間、semi-bold 和 bold
之間在版面中都有明顯的區別。這 3 種字重的文本灰度
有著明顯的差異，medium 呈現的是 1 種淡灰調，
semi-bold 呈現的是 1 種中灰調，bold 呈現的是 1 種
深灰調。字體和字級大小的清晰對比，可以讓閱讀變得
更輕鬆、更快速。

標題的若干種設置方式

Form- und Flächenelemen

Wer sich der Fülle von Druckerzeugnissen aller Art bei
notwendig eine strenge Trennung versuchen und das
unterscheiden dabei nach Art und Anlage vor allem zwe
men dabei einmal zu dem Anteil der reinen Typographie
Druckerzeugnissen, bei denen das rein Typographische
ausgesprochen sekundärer Bedeutung ist. Die erstere

1

Erzeugnisse ihre Entste

schließt für uns Arbeiten, die in ihrer Gesamtkonzeption
sind, gleichviel ob diese Erzeugnisse ihre Entstehung
Setzers verdanken, streng genommen also Arbeiten, di
Form- und Flächenelementen, soweit sie als typographi
baut» werden können. Negativätzungen und mehrfarb
zogen sein. Demgegenüber steht die zweite Gruppe,

2

Druckerzeugnisse

Wer sich der Fülle von Druckerzeugnissen aller Art bei e
notwendig eine strenge Trennung versuchen und das
unterscheiden dabei nach Art und Anlage vor allem zwe
men dabei einmal zu dem Anteil der reinen Typographie
Druckerzeugnissen, bei denen das rein Typographische
ausgesprochen sekundärer Bedeutung ist. Die erstere

3

Art bei ein

verloren hat, ja, daß der offenkundige Einbruch der freie
ausschließlich dem Setzer vorbehalten war, eine nicht
stürmische Aufwärtsentwicklung von Industrie und Wir
die Auseinandersetzung um Absatzmärkte und Käuferg
die die Einbeziehung immer neuer und phantasievolle
wenn man «im Geschäft bleiben will». Die aufgewende

4

在圖 1 中，標題位於頁面的頂部，
並遠離正文。標題的字級大小與正文
字級大小相同。這種設置方式示意
一段長文本即將開始。文本與標題
之間被預留的空白區分開來，顯得
標題尤為突出和重要。這種方式的標
題設計顯得十分優雅、克制和自信。

圖 2 中標題採用了與正文同樣字型
大小不同字重的粗體字。它被設置
在正文的上方，與正文之間只空了
一行的距離。

在圖 3 中，標題採用了一個比正文
字級大小略大的字體，並設置在頁面

的頂部。這種布局方式跟圖 1 類似，
但更強調了標題。

在圖 4 中，標題採用了一個更大
字級大小的字體。相對於上面的
例子來說，正文和標題的對比更
為突出。

44

標題的若干種設置方式

Verwendung von Schmuc

Gestaltung augenscheinlich die Hand des Gebrauchsgr
Diese Arbeiten beziehen ihre Wirkungskraft aus dem
scher Mittel, unter denen der typographische Anteil de
die Funktion der unbedingt notwendigen Textwiederg
techniken soll im Rahmen dieser Zeilen nicht berührt
stellen, daß der Anteil der reinen Typographie im Laufe (

5

Bei dem in dieses Layou

verloren hat, ja, daß der offenkundige Einbruch der freie
ausschließlich dem Setzer vorbehalten war, eine nicht
stürmische Aufwärtsentwicklung von Industrie und Wir
die Auseinandersetzung um Absatzmärkte und Käuferge
die die Einbeziehung immer neuer und phantasievoller
wenn man «im Geschäft bleiben will». Die aufgewende

6

Gestaltung und komm

Gestaltung augenscheinlich die Hand des Gebrauchsgr
Diese Arbeiten beziehen ihre Wirkungskraft aus dem
scher Mittel, unter denen der typographische Anteil de
die Funktion der unbedingt notwendigen Textwiederg
techniken soll im Rahmen dieser Zeilen nicht berührt
stellen, daß der Anteil der reinen Typographie im Laufe (

7

Setzers verdanken, streng
Form- und Flächenelementen, soweit sie als typographi
baut» werden können. Negativätzungen und mehrfarb
zogen sein. Demgegenüber steht die zweite Gruppe,
Gestaltung augenscheinlich die Hand des Gebrauchsgr
Diese Arbeiten beziehen ihre Wirkungskraft aus dem
scher Mittel, unter denen der typographische Anteil de

8

45

在圖 5 中，標題位於正文的上方，
字級大小與正文字體相同，標題與
正文之間空了一行。

在圖 6 中，標題採用了義大利體，
這使它能與正文清晰區分開來。
標題的字級大小與正文一樣。
但通常來說，義大利體一般會應用
於副標題。

圖 7 使用了與圖 2 同樣的方法，
但標題與正文之間沒有留空行。

在圖 8 中，一根橫線劃分了標題和
正文。文字屬性的劃分，以及底線的

設置進一步強調了標題這一行的
重要性。

要確定版心，設計師必須先清楚需要放進印刷品、需要
設計的圖文資訊的範圍和性質。設計師還要針對其解決
方案的整體和細節如何展現有一個明確的想法。原則上，
設計師要將方案反覆醞釀達到成熟之後，才能讓圖文得以
清晰呈現，並從中精確地定義出版心。

建議設計師在繪製縮略草圖時應盡量精確，以便於轉換
到最終尺寸。一個較為常見且經常犯的錯誤就是，設計師
不按實際的方式繪製字行，而是過於粗糙潦草。當要轉換
到1：1實際尺寸時，才發現文本放不進預先指定的尺寸。
為了能在縮略草圖裡按現實情況繪製文本，設計師需要
多練習。而最好的方式就是，盡可能頻繁地多繪製實際
尺寸的字體。設計師必須把握好各種字體的字形、比例的
感覺，達到憑記憶就能畫出來的程度。只有這樣才能逐漸
掌握，在小尺寸的草圖裡也能繪製出符合實際情況的
排印草圖，之後再把縮略圖放大到最終尺寸也不會有什麼
問題。如果在版面中主要的視覺資訊是文字，圖片的內容
較少，那麼可以參考印刷品開本尺寸直接定出版心。

文本的長短和頁數會決定版心的高和寬，以及正文字型
大小。如果文字多頁數少，那就需要有一個大一些的版心、
窄一些的頁邊距以及字級大小相對較小的字體。欄的數量，
無論是單欄、雙欄或更多欄，往往都是取決於開本和字型
大小。一個印刷頁面和諧、易讀的整體外觀，要靠清晰的
字形、字級大小、行長、行距和頁邊距才能實現。開本和
頁邊距的大小又決定了版心的大小。總之，整體美觀的
版面離不開優質的頁面比例、版心尺寸和文字編排。

在接下來的案例中，我們將列舉出設計師可能會面臨的
各種問題。
每個案例的情況各有不同，因為經濟、社會和文化環境
一直都在變化，對廣告活動造成了各種各樣的影響。
而廣告不同的表現形式也反映出現代社會和人們心理的
變化。
正如每個問題都是新鮮和與眾不同的，網格也需要不斷地
變化來滿足需求。這就意味著設計師必須帶著開放的心態，
客觀地去分析和解決每一個新的問題。這類工作的難度
在於設計師會遇到各種各樣的設計要求。比如，一份街頭
小廣告的設計不存在太大的困難，但對於一份日報來說，
版面通常會有 10 欄或者更多欄，還有內容多樣的欄目和
附加的廣告欄位。這不僅需要創意天賦，還需要組織能力，
才能將不斷變化的資訊進行邏輯排序，並依照主次關係
轉換成適當的文字排印。

對稱與非對稱的
版心設置

與頁面成 1：2 比例
的版心

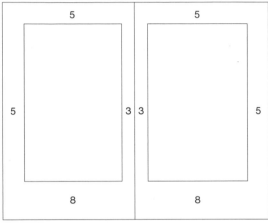

1

2

基於黃金分割比例
的版心設置

3

4

49　　這裡要強調的是，這些版心設置的
　　　圖例只是一些建議而不是現成的
　　　解決方案。每個新的設計專案都有
　　　自己需要解決的問題，並產生出不同
　　　的結果。
　　　圖 1 展示的是 1 種在對頁中對稱的
　　　版心布局，它留有很寬的裝訂邊。
　　　這類版心適用於書籍設計。
　　　當翻開一本有一定厚度的書時，書頁
　　　自然會形成一道弧線，留有較寬的
　　　裝訂邊可以避免因書頁凸起變形導致
　　　的閱讀困難。同時，在這個例子中
　　　地腳的高度明顯大於天頭。這是 1 種
　　　比較美觀的形式，版心在頁面中被向
　　　上推起，給人 1 種輕盈、舒適的感覺。

加上文字形成的版面灰度，
可以使視線很好地附著在印刷頁面
上。但如果版心被設置得太低，
那版面看上去就會有往下墜落的
感覺。
圖 2 展示的是 1 種非對稱的版心
設置，左右邊距（書口和裝訂邊）不
等寬，版心偏右放置。
圖 3 展示的是 1 種經典的根據黃金
分割比例來設置的對稱式版心。

單欄和雙欄的
版心設置

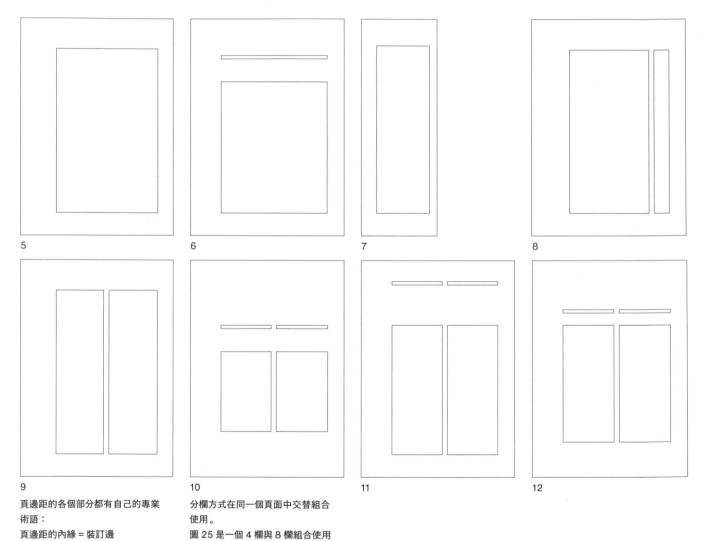

5　　　　　6　　　　　7　　　　　8

9　　　　　10　　　　　11　　　　　12

頁邊距的各個部分都有自己的專業
術語：
頁邊距的內線＝裝訂邊
頁邊距的外線＝書口
頁邊距的上線＝天頭
頁邊距的下線＝地腳
圖 1 至圖 36 展示了各種可能設置
版心的方式。在實際操作中，會遇到
各種特殊情況。例如在一些版面中，
原本雙欄的版心需要與 3 欄或 4 欄
進行複合使用（如圖 15、圖 19）。
在這種情況下，可以將原本單欄的
版心分為上下兩個部分，以便能讓
這兩者複合使用。另外還可以將
原來的 3 欄平分為 6 欄，讓這 2 種

分欄方式在同一個頁面中交替組合
使用。
圖 25 是一個 4 欄與 8 欄組合使用
的案例。這個案例的設計特點就是
將 8 欄設置在版心的中間。
圖 26 展示了如何將原來的 4 欄再
平分為 8 欄。

雙欄和 3 欄的
版心設置

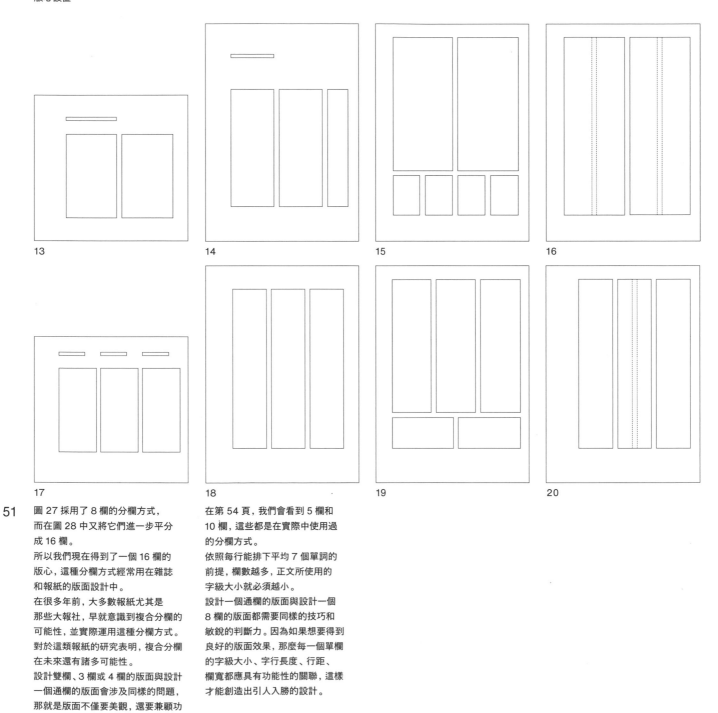

13　　　　　　14　　　　　　15　　　　　　16

17　　　　　　18　　　　　　19　　　　　　20

51

圖 27 採用了 8 欄的分欄方式，
而在圖 28 中又將它們進一步平分
成 16 欄。
所以我們現在得到了一個 16 欄的
版心，這種分欄方式經常用在雜誌
和報紙的版面設計中。
在很多年前，大多數報紙尤其是
那些大報社，早就意識到複合分欄的
可能性，並實際運用這種分欄方式。
對於這類報紙的研究表明，複合分欄
在未來還有諸多可能性。
設計雙欄、3 欄或 4 欄的版面與設計
一個通欄的版面會涉及同樣的問題，
那就是版面不僅要美觀，還要兼顧功
能性和易辨識性。

在第 54 頁，我們會看到 5 欄和
10 欄，這些都是在實際中使用過
的分欄方式。
依照每行能排下平均 7 個單詞的
前提，欄數越多，正文所使用的
字級大小就必須越小。
設計一個通欄的版面與設計一個
8 欄的版面都需要同樣的技巧和
敏銳的判斷力。因為如果想要得到
良好的版面效果，那麼每一個單欄
的字級大小、字行長度、行距、
欄寬都應具有功能性的關聯，這樣
才能創造出引人入勝的設計。

3 欄和 4 欄的
版心設置

3 欄、4 欄和 8 欄的
版心設置

21

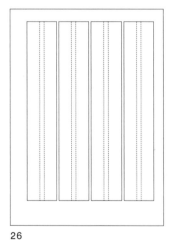

22

23

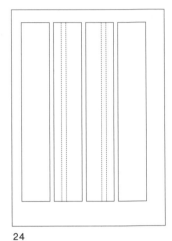

24

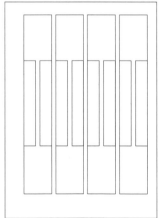

25

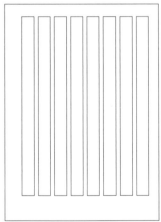

26

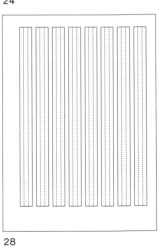

27

28

當窄欄與寬欄進行組合時，設計師
必須注意字級大小是否與欄寬匹配。
換句話說，就是寬欄字級大小必須
比窄欄的字級大小大一些，只有這樣
才能保證版心的平衡以及版面中統一
的節奏感。

對於設計師來說，如果想在設計中
尋找一個能滿足所有需求的版心，
最好的辦法就是先畫一張縮略草圖，
並不斷地進行修改完善。

如果開本事先就已經確定，那麼一
開始就應該等比例繪製草圖。這樣做
的好處是，如果將這個工作做得越
仔細，那麼在草圖中繪製的版心與
頁面、版心與頁邊距的關係就越容易

被事先查驗。

為了獲得一個最佳的版心，設計師在
畫草圖時應思考以下幾個問題：

1.
版心應該由一個通欄、雙欄還是更多
欄組成？因為字級大小取決於欄的
寬度。

2.
在版心中需要體現哪些資訊？文本中
有注腳或注解嗎？文本中包括圖片和
圖說嗎？

3.
如果插圖與文本混合排版，一共有多
少圖片？

單欄和雙欄的
版心配置

3 欄和四欄的
版心配置

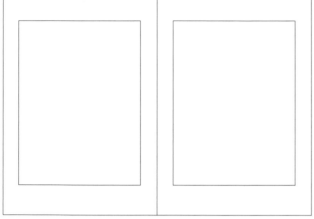

29

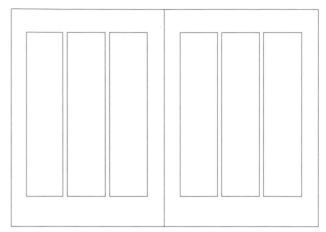

31

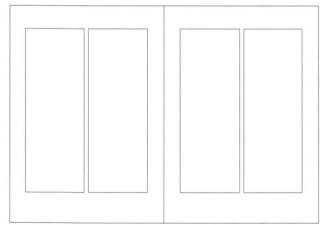

30

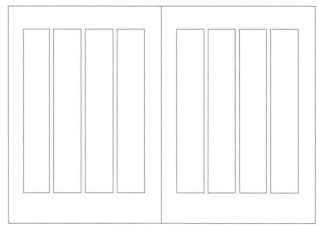

32

53

4.
在這些圖片中有多少是大尺寸的，
多少是小尺寸的？在設計版心時應該
考慮以下兩個因素：文本的類型以及
圖片的數量和尺寸。這決定了是否需
要設計一個專門的窄欄來放置注釋或
圖說。
這還沒有結束，除了以上幾個問題
外，設計師設計版心時還需要考慮一
些形式上的問題。
1.
版心在頁面中的面積是否應該盡可能
地大一些，把頁邊距設定得小一些？
2.
留白的頁邊距是否可以賦予一定的

視覺功能？
3.
是否應該設置一個較寬的頁邊距，
讓版心看起來更加輕盈？或者是否
應該增加版心的寬度並減少它的
高度？
每項具體的設計都會出現各式各樣
的問題，這些問題不可能只是通過
一個簡單的理論來解決，而是需要
我們就具體情況而定。然而，許多
情況表明，版心的高和寬及其與
頁邊距組成的開本之間可以有明確
的數學比例。

在對頁中，5 欄和 6 欄的
版心設置

在對頁中，8 欄和 10 欄的
版心設置

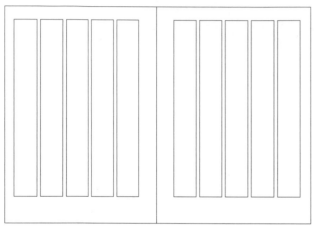

33

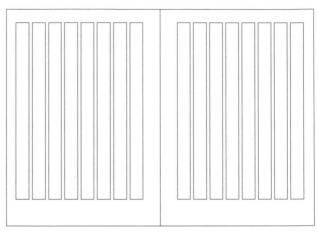

35

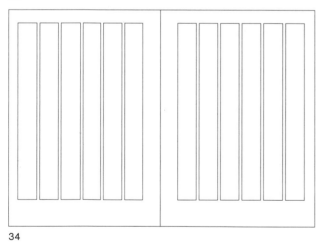

34

36

網格的結構

Konstruktion des Rasters

在開始設計之前，我們需要對在設計中可能出現的問題
進行研究。例如開本的大小、文本與插圖的關係、字體的
選擇、印刷方式以及紙張的品質，這些問題都必須先搞
清楚。然後設計師開始通過繪製一些小尺寸的草圖來嘗試
解決這些問題。草圖應該按照最終格式的比例繪製，
這樣之後轉移到正式版面時可以避免一些不必要的麻煩。
小尺寸的草圖也可以讓設計師更容易看到整體的版面布局。
在進行草圖繪製時，版面的分欄數是需要考慮的要點之一。
對於需要進行圖文混排的版面來說，特別是需要使用到大、
中、小不同尺寸的圖片時，如果使用通欄就會顯得版面的
自由度太低了。

雙欄圖文就可以有更多的選項：可以 1 欄放文本、1 欄放
插圖，圖文也可以排在同 1 欄的上下位置。而且，雙欄
還可以進一步分成 4 欄。

3 欄的分欄方式同樣也可以製造出豐富的版面變化，它既
能容納各類文本，又可以編排各種大小不同的插圖。3 欄
還可以進一步細分成 6 欄。但使用 3 欄或者 6 欄有一個
短處，那就是欄寬相對狹窄，因此也就不得不選擇更小的
字體來進行編排。不過，分欄方式取決於具體工作內容和
印刷品開本。

如果有大量文本和圖片，或者需要插入大量的資料、圖形、
趨勢圖等統計材料時，4 欄則是 1 種比較合適的分欄方式。
4 欄還可以進一步分成 8 欄、16 欄甚至更多欄，這樣的
分欄方式更便於統計圖表在版面中的展示。

欄寬也影響著版面中的字級大小，也就是說欄越窄，字級
就越小。如果欄很窄，字級又很大，那麼一行中就只能放
幾個單字。這就會造成在閱讀時快速地換行，並讓讀者的
眼睛感到疲勞。

在閱讀宣傳冊、書籍以及報紙時，眼睛的正常閱讀距離大約
在 30 到 35cm 之間。在這個距離之內的文本比較容易讓
讀者接受。同時，設計師也要嘗試使用雙欄、3 欄、4 欄以及
不同的字級大小來調節版面布局，直到得到一個較為可行的
解決方案。

此時就可以比較之前繪製的草圖，放棄一些明顯不適合的
方案，直至最後只剩下兩三個方案。然後將它們放大到 1：1
的最終尺寸再相互比較，直到選出最終方案。在這個方案裡，
欄內的行就需要用實際字級大小繪製。然後將網格分割線
疊加上去，檢查一個網格空間裡能放多少行。

需要注意的是，每格中的首行文本必須與格的頂線對齊，
而末行也必須與底線對齊。這樣的嘗試很難一次成功，多數
情況下，格往往會過高或過低。另外也有必要檢查一下欄與
格的高度是否一致，或者二者的誤差是否在容忍範圍之內。
這和工作之初一樣，要靠近似值的方式來解決。

設計工作處於這個階段時，建議適當地做一些計算。這裡
我們舉一個具體的例子就能讓大家明白為什麼。

首先我們假設文本在設定的分欄中有 57 行。然後再用
4 格網格來劃分分欄，也就是說，欄被劃分為等分的 4 格，
各格之間有間隔。這個間隔應該占一行文字的高度，就是

我們通常所稱的「空行」。

一個能容納 57 行高度的欄，扣除用於格間隔的三個空行，
就剩下 54 行來填充 4 格。我們將 54 除以 4 就得到了每格
可排 13.5 行。但是，文字排印裡沒有半行的概念，所以
我們就要找一個既接近於 54 又能被 4 整除的更小一點的
數字，這就是 52。52 除以 4 得 13，即 4 格裡每格排 13 行，
再加上 3 個「空行」，即 4×13+3=55，然後按照計算結果
修改草圖。

現在我們再進一步確定欄數。如果我們選雙欄，則每欄
有 55 行或 4 格。這些格是為插圖預留的。

修改後 1 欄有 55 行，恰好等於 4 格，每格 13 行並有
一行間隔。欄的高度是 54 西塞羅 8 點，也就是總共
656 點，相當於 24.7cm ＊。在雙欄版面中，左欄排 55
行文本，右欄的 4 格分別置入圖片，間隔一行，這樣圖片
的頂部和底部就能與字行的頂線與底線對齊。

在一個成熟的網格系統中，不僅正文字體需要與圖片
對齊，同樣版面中的圖說、正文標題、標題與副標題都
需要與圖片對齊。為了顯示圖說與正文之間的層級關係，
圖說字體通常會用斜體或者小字級的字體來區分。如果
需要圖說字體與正文的字行對齊，那麼就必須同時考慮
它們的行距，並確保它們的高度相同。換句話說，兩行
6 點字的密排（=12 點）相當於一行 10 點字大小加 2 點

行距的正文。只要按照這個倍率，圖說的字行就能與正文
的字行對齊。同時，6 點字級的圖說也應該繪製在草圖中。
在圖片的下方，圖說可以用 6 點字級排成一行或者多行。
在選擇標題用的字體時，也需要進行這類計算。
例如，標題如果設成 20 點字級加 4 點行距（= 24 點），
就能與 10 點字級加 2 點行距的兩行正文字體對齊。
如果標題行能與正文的字行對齊，那麼也就能和網格對齊。
標題設計結束，排版才算完成。
如果想採用另一款字體來解決版面問題，那麼也需要遵循
同樣的步驟和遵守同樣的原則。插圖、表格、統計圖都應
按照網格處理，也就是說要將其設計成格的尺寸。
也可將若干格合併成一個更大的格，但其頂部與底部都
必須與字行對齊。
有時幾個格也可以合併成一個更大的格。無論在什麼情況
下，網格的頂部與底部都必須與字行對齊。
調整完字行與格之後，必須檢查一下版心與頁面開本之間
的關係，看其是否符合設計的要求且美觀。為此，需要檢查
的是頁邊距的比例、各邊距的相互關係及其與版心的關係。
如果結果並不令人滿意，那麼我們就需要再次從頭開始
調整。這個工作也許會花很多時間，但非常值得，因為這樣
的調整將會影響到出版物的最終呈現。

＊　欄的高度為 54 西塞羅 8 點，
不過這個數值在行間為 2 點，排版
10 點字級，1 欄有 55 行時會產生
誤差。原因會在 61–62 頁詳細解說，
約瑟夫・穆勒 - 布洛克曼的網格
系統，將網格與欄的天地第一行沿
著大寫線，最後一行以下伸線去做
調整對齊。

步驟 1：設置版心
步驟 2：將版心分為雙欄

步驟 3：將欄分成格
步驟 4：對比字行高度與格高度

1

2

3

4

這裡有一個較為實用的方法來確定版面中的文本和圖片的位置，具體步驟如下：

圖 1
設計師需要在 1：1 的草圖上先繪製出版心的高度與寬度，並確信在功能和美觀上都達到最佳效果。

圖 2
在版心位置確定以後，再將版心分為雙欄、3 欄或者更多欄。在這裡我們就以雙欄為例。它將版心垂直平分為兩個部分，並通過一個欄間距來區分這兩部分。

圖 3
接著設計師再將分欄橫向分為 2 個、3 個或者更多個格。

圖 4
現在設計師必須決定版心中正文字級大小和行距的大小。比如，如果認為 10 點字級加 3 點行距能保證文本的易辨識性，那麼之後就要檢查格的高度，看看一格裡能排下多少行 10 點大小的文字。多數情況下，設計師需要依照特定的行數去調整格的高度，可能要調高或者調低一些。

步驟 5：劃分網格
步驟 6：將網格與字行匹配

步驟 7：最終形成 6 格網格
步驟 8：將字行與網格對齊

5

7

6

8

圖 5／6
右欄的格是專為圖片、圖表或者照片
等其他元素預留的。它們之間上下
排列，為了避免它們互相交疊，可以
用一個文本空行來間隔。
格之間可用一行或者多行來分隔。
如果文本欄裡有上下兩格，中間需要
用空行分隔開，這樣文本欄的總行數
就要同時容納格及其空行間隔，3 格
就需要 2 處間隔，比如 2 個空行；
如果有 4 格，就需要 3 個空行。
圖 7／8
圖 7 使用的是 6 格系統，並與 26
行的版心相匹配。在圖 8 中，每格
的頂線與底線都分別與字行對齊。

8 格網格系統，用每幅圖片之間的
1 個空行來放圖說

8 格網格系統，用每幅圖片之間的
3 個空行來放圖說

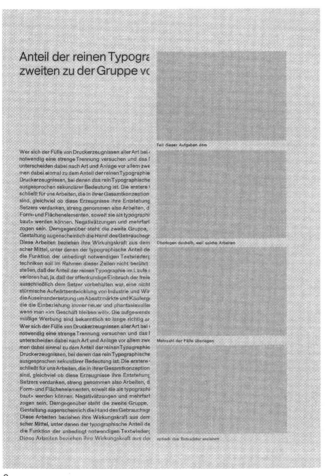

9

10

圖 9／10
如果圖片格只是用來放置圖片及
其圖說，那麼問題還相對容易解決。
根據每頁需要擺放圖片的數量，
格的縱向距離必須大於水平距離，
這樣圖說才可以放到圖片下方。
當然，圖說也可以合併放到頁面底
部，或者其他適當的地方。
如果必須將圖片網格與不同字級的
版心進行匹配，任務就會變得更困難
和費時。
如果圖片網格與版心完全吻合的話，
那麼圖片的頂邊與底邊就可以與
字行始終保持對齊。也就是說，
每張圖片無論大小，其頂邊和底邊

都必須與其相鄰的字行精準對齊。
字行和圖高也應該互相匹配。

53 行的版心與
18 格網格系統進行匹配

18 格網格系統

Wer sich der Fülle von Druckerzeugnissen aller Art b
notwendig eine strenge Trennung versuchen und das N
unterscheiden dabei nach Art und Anlage vor allem
men dabei einmal zu dem Anteil der reinen Typograp
Druckerzeugnissen, bei denen das rein Typographische
ausgesprochen sekundärer Bedeutung ist. Die erst
schließt für uns Arbeiten, die in ihrer Gesamtkonzeption
sind, gleichviel ob diese Erzeugnisse ihre Entsteh
Setzers verdanken, streng genommen also Arbeiten,
Form- und Flächenelementen, soweit sie als typogr
baut» werden können. Negativätzungen und mehrfarb
zogen sein. Demgegenüber steht die zweite Gruppe,
Gestaltung augenscheinlich die Hand des Gebrauch
Diese Arbeiten beziehen ihre Wirkungskraft aus dem
scher Mittel, unter denen der typographische Anteil
die Funktion der unbedingt notwendigen Textwiederg
techniken soll im Rahmen dieser Zeilen nicht berüh
stellen, daß der Anteil der reinen Typographie im Laufe
verloren hat, ja, daß der offenkundige Einbruch der freie
ausschließlich dem Setzer vorbehalten war, eine nicht
stürmische Aufwärtsentwicklung von Industrie und
die Auseinandersetzung um Absatzmärkte und Käufer
die die Einbeziehung immer neuer und phantasievoller
wenn man «im Geschäft bleiben will». Die aufgewend
mäßige Werbung sind bekanntlich so lange richtig
Resonanz beim Empfänger zur Folge haben. Eine Werb
Wer sich der Fülle von Druckerzeugnissen aller Art be
notwendig eine strenge Trennung versuchen und
unterscheiden dabei nach Art und Anlage vor allem zw
men dabei einmal zu dem Anteil der reinen Typographie
Druckerzeugnissen, bei denen das rein Typographis
ausgesprochen sekundärer Bedeutung ist. Die erstere
schließt für uns Arbeiten, die in ihrer Gesamtkonzep
sind, gleichviel ob diese Erzeugnisse ihre Entstehung
Setzers verdanken, streng genommen also Arbeiten,
Form- und Flächenelementen, soweit sie als typogra
baut» werden können. Negativätzungen und mehrfar
zogen sein. Demgegenüber steht die zweite Gruppe,
Gestaltung augenscheinlich die Hand des Gebrauch
Diese Arbeiten beziehen ihre Wirkungskraft aus dem
scher Mittel, unter denen der typographische Anteil
die Funktion der unbedingt notwendigen Textwiederg
techniken soll im Rahmen dieser Zeilen nicht berührt
stellen, daß der Anteil der reinen Typographie im Laufe
verloren hat, ja, daß der offenkundige Einbruch der freie
ausschließlich dem Setzer vorbehalten war, eine
stürmische Aufwärtsentwicklung von Industrie und Wir
die Auseinandersetzung um Absatzmärkte und Käufer
die die Einbeziehung immer neuer und phantasievoller
wenn man «im Geschäft bleiben will». Die aufgewe
mäßige Werbung sind bekanntlich so lange richtig
Resonanz beim Empfänger zur Folge haben. Eine Werb
ungewöhnlich phantasievoll sein, um das Interesse

Setzers verdanken, streng genommen also Arbeiten, di
Form- und Flächenelementen, soweit sie als typogra
baut» werden können. Negativätzungen und mehrfarb
zogen sein. Demgegenüber steht die zweite Gruppe,
Gestaltung augenscheinlich die Hand des Gebrauchs
Diese Arbeiten beziehen ihre Wirkungskraft aus dem
scher Mittel, unter denen der typographische Anteil
die Funktion der unbedingt notwendigen Textwiederg
techniken soll im Rahmen dieser Zeilen nicht berührt
stellen, daß der Anteil der reinen Typographie in Lau
verloren hat, ja, daß der offenkundige Einbruch der freie
ausschließlich dem Setzer vorbehalten war, eine
stürmische Aufwärtsentwicklung von Industrie und Wi
die Auseinandersetzung um Absatzmärkte und Käufer
die die Einbeziehung immer neuer und phantasievoller
wenn man «im Geschäft bleiben will». Die aufgewe
mäßige Werbung sind bekanntlich so lange richtig
Resonanz beim Empfänger zur Folge haben. Eine Werb
Wer sich der Fülle von Druckerzeugnissen aller Art be
notwendig eine strenge Trennung versuchen und
unterscheiden dabei nach Art und Anlage vor allem zw
men dabei einmal zu dem Anteil der reinen Typographie
Druckerzeugnissen, bei denen das rein Typographis
ausgesprochen sekundärer Bedeutung ist. Die erstere
schließt für uns Arbeiten, die in ihrer Gesamtkonzeption
sind, gleichviel ob diese Erzeugnisse ihre Entsteh
Form- und Flächenelementen, soweit sie als typograph
baut» werden können. Negativätzungen und mehrfarb
zogen sein. Demgegenüber steht die zweite Gruppe,
Gestaltung augenscheinlich die Hand des Gebrauc
Diese Arbeiten beziehen ihre Wirkungskraft aus dem
scher Mittel, unter denen der typographische Anteil
die Funktion der unbedingt notwendigen Textwiederg
techniken soll im Rahmen dieser Zeilen nicht berührt
stellen, daß der Anteil der reinen Typographie im Lau
verloren hat, ja, daß der offenkundige Einbruch der freie
ausschließlich dem Setzer vorbehalten war, eine
stürmische Aufwärtsentwicklung von Industrie und
die Auseinandersetzung um Absatzmärkte und Käufer
die die Einbeziehung immer neuer und phantasievoller
wenn man «im Geschäft bleiben will». Die aufgewe
mäßige Werbung sind bekanntlich so lange richtig
Resonanz beim Empfänger zur Folge haben. Eine Werb
Wer sich der Fülle von Druckerzeugnissen aller Art bei
notwendig eine strenge Trennung versuchen und
unterscheiden dabei nach Art und Anlage vor allem zw
men dabei einmal zu dem Anteil der reinen Typograph
Druckerzeugnissen, bei denen das rein Typographische
ausgesprochen sekundärer Bedeutung ist. Die erstere
schließt für uns Arbeiten, die in ihrer Gesamtkonzeption
sind, gleichviel ob diese Erzeugnisse ihre Entsteh
Setzers verdanken, streng genommen also Arbeiten,
jedem Falle schon bei der Verwendung einer zweiten

1

2

就像圖片的高度需要調整一樣，圖片
的寬度也需要與分欄的寬度相匹配。
但必須注意的是，字行的長度是根據
正文字體的字級來決定的，並且還要
保證這是一個可以正常閱讀的長度。
也就是說，每行大約要有 7 個單字。
儘管如此，行長還應同時與圖片寬度
相協調。
所以，在設置圖片網格時，需要同時
兼顧文本欄與圖片的寬度。
圖片之間的縱向距離可以是空單行、
空雙行、空三行或者更多，這要看圖
說的量。但空行必須是整行數，不能
用半行，否則該欄文字就無法和其他
欄的字行對齊。

圖 1／2
圖 1 中的文本欄對應圖 2 所展示的
18 格網格。正文採用左齊、右不齊的
排版方式，因此保持了均等的字距，
僅很少的字需要斷字。

局部細節

Wer sich der Fülle von Druckerzeugnissen aller Art b notwendig eine strenge Trennung versuchen und das M unterscheiden dabei nach Art und Anlage vor allem men dabei einmal zu dem Anteil der reinen Typograp Druckerzeugnissen, bei denen das rein Typographische ausgesprochen sekundärer Bedeutung ist. Die erst schließt für uns Arbeiten, die in ihrer Gesamtkonzeption sind, gleichviel ob diese Erzeugnisse ihre Entsteh Setzers verdanken, streng genommen also Arbeiten, Form- und Flächenelementen, soweit sie als typogr baut» werden können. Negativätzungen und mehrfarb zogen sein. Demgegenüber steht die zweite Gruppe, Gestaltung augenscheinlich die Hand des Gebrauch Diese Arbeiten beziehen ihre Wirkungskraft aus dem scher Mittel, unter denen der typographische Anteil die Funktion der unbedingt notwendigen Textwiederg techniken soll im Rahmen dieser Zeilen nicht berüh stellen, daß der Anteil der reinen Typographie im Laufe verloren hat, ja, daß der offenkundige Einbruch der ausschließlich dem Setzer vorbehalten war, eine nicht stürmische Aufwärtsentwicklung von Industrie und die Auseinandersetzung um Absatzmärkte und Käufer die die Einbeziehung immer neuer und phantasievoller wenn man «im Geschäft bleiben will». Die aufgewe mäßige Werbung sind bekanntlich so lange richtig Resonanz beim Empfänger zur Folge haben. Eine Werb Wer sich der Fülle von Druckerzeugnissen aller Art be notwendig eine strenge Trennung versuchen und unterscheiden dabei nach Art und Anlage vor allem zw men dabei einmal zu dem Anteil der reinen Typographie Druckerzeugnissen, bei denen das rein Typographis ausgesprochen sekundärer Bedeutung ist. Die erstere schließt für uns Arbeiten, die in ihrer Gesamtkonzep sind, gleichviel ob diese Erzeugnisse ihre Entstehung Setzers verdanken, streng genommen also Arbeiten, Form- und Flächenelementen, soweit sie als typogra baut» werden können. Negativätzungen und mehrfar zogen sein. Demgegenüber steht die zweite Gruppe, Gestaltung augenscheinlich die Hand des Gebrauch Diese Arbeiten beziehen ihre Wirkungskraft aus dem scher Mittel, unter denen der typographische Anteil die Funktion der unbedingt notwendigen Textwieder techniken soll im Rahmen dieser Zeilen nicht berührt stellen, daß der Anteil der reinen Typographie im Laufe verloren hat, ja, daß der offenkundige Einbruch der freie ausschließlich dem Setzer vorbehalten war, eine stürmische Aufwärtsentwicklung von Industrie und Wir die Auseinandersetzung um Absatzmärkte und Käufer die die Einbeziehung immer neuer und phantasievolle wenn man «im Geschäft bleiben will». Die aufgewe mäßige Werbung sind bekanntlich so lange richtig Resonanz beim Empfänger zur Folge haben. Eine Werb ungewöhnlich phantasievoll sein, um das Interesse

Setzers verdanken, streng genommen also Arbeiten, di Form- und Flächenelementen, soweit sie als typogra baut» werden können. Negativätzungen und mehrfarb zogen sein. Demgegenüber steht die zweite Gruppe, Gestaltung augenscheinlich die Hand des Gebrauchs Diese Arbeiten beziehen ihre Wirkungskraft aus dem die Funktion der unbedingt notwendigen Textwiederg techniken soll im Rahmen dieser Zeilen nicht berührt stellen, daß der Anteil der reinen Typographie im Lau verloren hat, ja, daß der offenkundige Einbruch der freie ausschließlich dem Setzer vorbehalten war, eine stürmische Aufwärtsentwicklung von Industrie und Wi die Auseinandersetzung um Absatzmärkte und Käufer die die Einbeziehung immer neuer und phantasievoller wenn man «im Geschäft bleiben will». Die aufgewe mäßige Werbung sind bekanntlich so lange richtig Resonanz beim Empfänger zur Folge haben. Eine Werb Wer sich der Fülle von Druckerzeugnissen aller Art be notwendig eine strenge Trennung versuchen und unterscheiden dabei nach Art und Anlage vor allem zw men dabei einmal zu dem Anteil der reinen Typograph Druckerzeugnissen, bei denen das rein Typographis ausgesprochen sekundärer Bedeutung ist. Die erstere schließt für uns Arbeiten, die in ihrer Gesamtkonzeption sind, gleichviel ob diese Erzeugnisse ihre Entsteh Form- und Flächenelementen, soweit sie als typograph baut» werden können. Negativätzungen und mehrfarb zogen sein. Demgegenüber steht die zweite Gruppe, Diese Arbeiten beziehen ihre Wirkungskraft aus dem die Funktion der unbedingt notwendigen Textwiederg techniken soll im Rahmen dieser Zeilen nicht berührt stellen, daß der Anteil der reinen Typographie im Lau verloren hat, ja, daß der offenkundige Einbruch der freie ausschließlich dem Setzer vorbehalten war, eine stürmische Aufwärtsentwicklung von Industrie und die Auseinandersetzung um Absatzmärkte und Käufer die die Einbeziehung immer neuer und phantasievoller wenn man «im Geschäft bleiben will». Die aufgewe mäßige Werbung sind bekanntlich so lange richtig Resonanz beim Empfänger zur Folge haben. Eine Werb Wer sich der Fülle von Druckerzeugnissen aller Art be notwendig eine strenge Trennung versuchen und unterscheiden dabei nach Art und Anlage vor allem zwe men dabei einmal zu dem Anteil der reinen Typograph Druckerzeugnissen, bei denen das rein Typographische ausgesprochen sekundärer Bedeutung ist. Die erstere schließt für uns Arbeiten, die in ihrer Gesamtkonzeption sind, gleichviel ob diese Erzeugnisse ihre Entsteh Setzers verdanken, streng genommen also Arbeiten, jedem Falle schon bei der Verwendung einer zweiten

Umfang ließt Fülle von Druckerze
er Sichtung gegenübersieht, wird
Trennung versuchen und das Ma
m zwei Gruppen der Gestaltung u
al zu dem Anteil der reinen Typog
zu der Gruppe von Druckerzeug
n Typographische gering, ja sein
sgesprochen sekundärer Bedeu
pe der reinen Typographie umsc
ie in ihrer Gesamtkonzeption aus
n erstellt sind, gleichviel ob diese
Wer sich der Fülle von gesproche
m zwei Gruppen der Gestaltung u
Trennung versuchen und das nac
n erstellt sind, gleichviel ob diese
ie in ihrer Gesamtkonzeption aus
pe der reinen Typographie umsc

3 4

61 圖 3／4
依照每格的底線位置，畫出橫跨雙欄
的橫線，即可清晰地展示出字行是
如何與每個格對齊的。圖片的頂邊
應該與字行中大寫字高對齊，圖片的
底邊應該與字行中小寫字母的下伸線
對齊。
這頁版心為雙欄，正文採用 10 點
medium 字重的無襯線體，行距為
3 點，左齊、右不齊。欄寬與字級
比例協調，也有足夠的行距保證舒適
的閱讀。
四邊的頁邊距大小不同，令頁面設計
更有張力。
圖中紅線畫出了此頁的網格系統，

共 18 格，各格之間有一個空行，
可留作餘白或者放置圖說。

網格中 7 點、10 點和
20 點的字體

Wer sich der Fülle von Druckerzeugnissen aller Art bei einer Sic strenge Trennung versuchen und das Material in Gruppen unterteile lage vor allem zwei Gruppen der Gestaltung und kommen dabei ei und zum zweiten zu der Gruppe von Druckerzeugnissen, bei denen Umfang nach von ausgesprochen sekundärer Bedeutung ist. Die e schließt für uns Arbeiten, die in ihrer Gesamtkonzeption aus typo ob diese Erzeugnisse ihre Entstehung der Skizze eines Graphikers also Arbeiten, die unter Verwendung von Schmuck, Form- und Fläch Material vorhanden sind, „gebaut" werden können. Negativätzunge einbezogen sein. Demgegenüber steht die zweite Gruppe, deren Ha scheinlich die Hand des Gebrauchsgraphikers und freien Künstler: kungskraft aus dem überlegenen Einsatz freier graphischer Mittel, u bar gering ist, ja, wo der Satz nur die Funktion der unbedingt notw der Drucktechniken soll im Rahmen dieser Zeilen nicht berührt we der Anteil der reinen Typographie im Laufe der letzten Jahre erhebl kundige Einbruch der freien Graphik in eine Domäne, die früher au nicht wegzuleugnende Tatsache ist. Die stürmische Aufwärtsentwick sich gebracht, daß die Auseinandersetzung um Absatzmärkte und die die Einziehung immer neuer und phantasievoller Mittel in schäft bleiben will". Die aufgewendeten finanziellen Mittel für ein lange richtig angelegt, wie sie eine entsprechende Resonanz beim unter den hier aufgezeigten Bedingungen, die z. B. typographisch ist, muß schon ungewöhnlich phantasievoll sein, um das Interesse c Falle schon bei Verwendung einer zweiten Farbe für die gleiche Ar tersuchungen in den USA, die zu der Feststellung kamen, daß Werb Wer sich der Fülle von Druckerzeugnissen aller Art bei einer Sic strenge Trennung versuchen und das Material in Gruppen unterteile lage vor allem zwei Gruppen der Gestaltung und kommen dabei ei und zum zweiten zu der Gruppe von Druckerzeugnissen, bei denen Umfang nach von ausgesprochen sekundärer Bedeutung ist. Die e schließt für uns Arbeiten, die in ihrer Gesamtkonzeption aus typo ob diese Erzeugnisse ihre Entstehung der Skizze eines Graphikers also Arbeiten, die unter Verwendung von Schmuck, Form- und Fläch Material vorhanden sind, „gebaut" werden können. Negativätzunge scheinlich die Hand des Gebrauchsgraphikers und freien Künstler: kungskraft aus dem überlegenen Einsatz freier graphischer Mittel, u bar gering ist, ja, wo der Satz nur die Funktion der unbedingt notw der Drucktechniken soll im Rahmen dieser Zeilen nicht berührt we der Anteil der reinen Typographie im Laufe der letzten Jahre erhebl kundige Einbruch der freien Graphik in eine Domäne, die früher au nicht wegzuleugnende Tatsache ist. Die stürmische Aufwärtsentwick sich gebracht, daß die Auseinandersetzung um Absatzmärkte und die die Einziehung immer neuer und phantasievoller Mittel in schäft bleiben will". Die aufgewendeten finanziellen Mittel für ein lange richtig angelegt, wie sie eine entsprechende Resonanz beim unter den hier aufgezeigten Bedingungen, die z. B. typographisch letztere in ihrer Anlage weitgehend den Bereichen der modernen Kun zum Schmuck der Wände bestimmt, wird von der Mehrzahl der Betra dagegen in dieser oder jener Form als formaler Effekt in der Werbu tiert. Es gibt dafür eine einfache Erklärung: Die moderne Graphik eine gewisse optische Schockwirkung aus und hat deshalb der Vor werden. Es ist logisch, daß damit bei kurzer Formulierung des beg geworben wird, zur Kenntnis genommen wird. Hier setzt das Problem nicht wunder, daß ein gut Teil dieser Aufgaben dem Setzer aus der nicht nur die Schwarz-Weiß-Arbeit in der Graphik und Typographie mehr noch als diese ist es die mehrfarbige Gestaltung von Drucks herangezogen wird. Auch hier ist das Farbempfinden und der Gesch ist, muß schon ungewöhnlich phantasievoll sein, um das Interesse c Falle schon bei Verwendung einer zweiten Farbe für die gleiche Ar tersuchungen in den USA, die zu der Feststellung kamen, daß Werb erfolgreicher sind als schwarz-weiße. Doch bleiben wir bei der Schv objekten noch vorherrschend ist (Zeitungen, Inserate, Zeitschriften oder die Einbeziehung einer freien Zeichnung ist in den vorgenann Mehrzahl der Fälle überlegen. Überlegen deshalb, weil solche Arbe rein bildliche Darstellung eine umfangreiche Textbegabe überflüssi jekt schon durch die Bildwirkung anschaulich erläutert. Diese Schw daß das Photo der Zeichnung immer dann im Werbegut unterlegen nicht wegzuleugnende Tatsache ist. Die stürmische Aufwärtsentwick sich gebracht, daß die Auseinandersetzung um Absatzmärkte und die Einbeziehung immer neuer und phantasievollerer Mittel in schäft bleiben will". Die aufgewendeten finanziellen Mittel für ein lange richtig angelegt, wie sie eine entsprechende Resonanz beim unter den hier aufgezeigten Bedingungen, die z. B. typographisch ist, muß schon ungewöhnlich phantasievoll sein, um das Interesse Falle schon bei Verwendung einer zweiten Farbe für die gleiche Art tersuchungen in den USA, die zu der Feststellung kamen, daß Werb erfolgreicher sind als schwarz-weiße. Doch bleiben wir bei der Schv

Wer sich der Fülle von Druckerzeugnissen aller Art bei notwendig eine strenge Trennung versuchen und das unterscheiden dabei nach Art und Anlage vor allem zwe men dabei einmal zu dem Anteil der reinen Typographie Druckerzeugnissen, bei denen das rein Typographische ausgesprochen sekundärer Bedeutung ist. Die erstere schließt für uns Arbeiten, die in ihrer Gesamtkonzeption sind, gleichviel ob diese Erzeugnisse ihre Entstehung Setzers verdanken, streng genommen also Arbeiten, d Form- und Flächenelementen, soweit sie als typographi baut" werden können. Negativätzungen und mehrfarl zogen sein. Demgegenüber steht die zweite Gruppe, Gestaltung augenscheinlich die Hand des Gebrauchsgr Diese Arbeiten beziehen ihre Wirkungskraft aus dem scher Mittel, unter denen der typographische Anteil de die Funktion der unbedingt notwendigen Textwiederg techniken soll im Rahmen dieser Zeilen nicht berührt stellen, daß der Anteil der reinen Typographie im Laufe verloren hat, ja, daß der offenkundige Einbruch der frei ausschließlich dem Setzer vorbehalten war, eine nicht stürmische Aufwärtsentwicklung von Industrie und Wir die Auseinandersetzung um Absatzmärkte und Käuferg die die Einbeziehung immer neuer und phantasievolle wenn man «im Geschäft bleiben will». Die aufgewende Resonanz beim Empfänger zur Folge haben. Eine Wert Wer sich der Fülle von Druckerzeugnissen aller Art bei notwendig eine strenge Trennung versuchen und das unterscheiden dabei nach Art und Anlage vor allem zwe men dabei einmal zu dem Anteil der reinen Typographie Druckerzeugnissen, bei denen das rein Typographische ausgesprochen sekundärer Bedeutung ist. Die erstere schließt für uns Arbeiten, die in ihrer Gesamtkonzeption sind, gleichviel ob diese Erzeugnisse ihre Entstehung Setzers verdanken, streng genommen also Arbeiten, d Form- und Flächenelementen, soweit sie als typographi baut" werden können. Negativätzungen und mehrfarl zogen sein. Demgegenüber steht die zweite Gruppe, Gestaltung augenscheinlich die Hand des Gebrauchsgr Diese Arbeiten beziehen ihre Wirkungskraft aus dem scher Mittel, unter denen der typographische Anteil de die Funktion der unbedingt notwendigen Textwiederg techniken soll im Rahmen dieser Zeilen nicht berührt stellen, daß der Anteil der reinen Typographie im Laufe verloren hat, ja, daß der offenkundige Einbruch der frei ausschließlich dem Setzer vorbehalten war, eine nicht stürmische Aufwärtsentwicklung von Industrie und Wir die Auseinandersetzung um Absatzmärkte und Käuferg die die Einbeziehung immer neuer und phantasievolle wenn man «im Geschäft bleiben will». Die aufgewende Wer sich der Fülle von Druckerzeugnissen aller Art bei notwendig eine strenge Trennung versuchen und das

Wer sich der Fülle von Dr
n aller Art bei einer Sichtu
eht, wird notwendig eine
g versuchen und das Mat
unterteilen. Wir untersche
Art und Anlage vor allem
er Gestaltung und komm
zu dem Anteil der reinen
d zum zweiten zu der Gru
rzeugnissen, bei denen c
phische gering, ja seinem
on ausgesprochen sekur
g ist. Die erstere Gruppe
ihrer Gesamtkonzeption
chen Mitteln erstellt sind,
Wer sich der Fülle von Dr
n aller Art bei einer Sichtu
eht, wird notwendig eine
g versuchen und das Mat
unterteilen. Wir untersche
Art und Anlage vor allem
er Gestaltung und komm
zu dem Anteil der reinen
d zum zweiten zu der Gru
rzeugnissen, bei denen c
phische gering, ja seinem

5

圖 5

此圖展示了 3 欄不同字級大小的
文字，第 4 欄則添加了橫線。
第 1 欄為 7 點的字加 1 點行距；
第 2 欄為 10 點的字加 2 點行距，
第 3 欄為 20 點的字加 4 點行距。
紅色橫線將字行平分為若干組，
在每組中，7 點字有 3 行，10 點字
有 2 行，20 點字有 1 行。
每兩條紅色橫線之間的距離是 24
點，相當於 7 點字加 1 點行距的
3 行（3 × 8=24 點）、或 10 點字加
2 點行距的 2 行（2×12=24 點），
或 20 點字加 4 點行距的 1 行。
現在，假設一張與文本欄寬度一樣

的圖片，其高度相當於從第 1 條紅色
橫線到第 7 條紅色橫線。無論是這 3
欄裡的任何 1 欄，這張圖片的頂邊與
底邊都能與字行水平對齊。
如果在這張圖片下面還要放一張同樣
尺寸的圖片，那麼我們就會在兩張
圖片之間留出一個相當於兩條紅色橫
線之間的距離，這樣兩張圖片就不會
直接碰觸，而且這張圖片的頂邊與
底邊也將與字行對齊，即在同一個水
平線上。

將版心劃分為大小相等的格

將版心劃分為 9 格網格系統和
6 格網格系統

6

7

圖 6／7
53 行的版心可以劃分為 9 格網格
系統，每格中有 5 行，每格之間空一
行。它還可以劃分為 6 格網格系統，
每格有 8 行，每格之間空一行。
如上所述，格之間的空行是為了
間隔圖片，並給圖說或圖示留有一定
的空間。字行的數量也決定了格的
數量。一個 59 行字行的版心可以
有 5 種劃分方式：
a.
12 格網格系統，每格有 4 行，每格
之間空一行。
b.
10 格網格系統，每格有 5 行，每格
之間空一行。
c.
6 格網格系統，每格有 9 行，每格
之間空一行。
d.
5 格網格系統，每格有 11 行，每格
之間空一行。
e.
4 格網格系統，每格有 14 行，每格
之間空一行。

36 格網格系統的版心

36 格網格系統

8

圖 8

圖 1 至圖 3 的例子中採用了雙欄的
圖文設計。而上圖的網格則是將雙欄
進一步分為 4 欄。這個網格既可以
用於雙欄設計，也可用於 4 欄設計。

9

圖 9

粗紅線標示出了圖 10 至圖 13 的
圖文區域，上方的自由空間預留
給標題。頁碼位於下方，空兩行，
與第 2 欄左側對齊。

網格系統中 2 種字型大小的
標題和正文

帶有圖片網格的版心

Research and Development

During the year, IBM's research scientists and development engineers continued to study new scientific phenomena and to incorporate ideas and improvements into existing equipment or into entirely new products. The Company's research and systems development are both organized on an integrated worldwide basis with laboratories in the United States and Europe contributing according to their main area of competence. Much of the development effort during the year was in the area of computer programming, an area in which almost every laboratory was involved. The laboratory in Hursley, England, for instance, has Company-wide responsibility for the continuing development of programming language PL/I. The Hursley laboratory gets important assistance from other laboratories in the United States, Austria, Germany and France on this work. IBM laboratories also develop and construct special devices for particular customer requirements. One of these, the IBM Photo Digital Storage System, was installed at the University of California Lawrence Radiation Laboratory at Livermore, California. This system can store more than one trillion bits of information, and is the largest digital storage and retrieval device ever developed and built for use in data processing. This special device records data by means of a beam of electrons directly exposing small film strips, develops them within the system and transports them pneumatically to and from the storage area in protective plastic cells. Each cell, smaller than a cigarette package, holds 32 strips and can store enough information to process a complete payroll for a 30,000-man company. Any item of information in the file is quickly retrieved upon request of a computer and read by a scanner for computer processing. In another development project, a joint effort by IBM and the Canadian Government led to the development of the IBM Cartographic Scanner. This device reads maps of up to 16 square feet and reduces them to numerical data for analysis by a

Livermore, California. This system can store more than one trillion bits of information, and is the largest digital storage and retrieval device ever developed and built for use in data processing. This special device records data by means of a beam of electrons directly exposing small film strips, develops them within the system and transports them pneumatically to and from the storage area in protective plastic cells. Each cell, smaller than a cigarette package, holds 32 strips and can store enough information to process a complete payroll for a 30,000-man company. Any item of information in the file is quickly retrieved upon request of a computer and read by a scanner for computer processing. In another development project, a joint effort by IBM and the Canadian Government led to the development of the IBM Cartographic Scanner. This device reads maps of up to 16 square feet and reduces them to numerical data for analysis by a During the year, IBM's research scientists and development engineers continued to study new scientific phenomena and to incorporate ideas and improvements into existing equipment or into entirely new products. The Company's research and systems development are both organized on an integrated worldwide basis with laboratories in the United States and Europe contributing according to their main area of competence. Much of the development effort during the year was in the area of computer programming, an area in which almost every laboratory was involved. The laboratory in Hursley, England, for instance, has Company-wide responsibility for the continuing development of programming language PL/I. The Hursley laboratory gets important assistance from other laboratories in the United States, Austria, Germany and France on this work. IBM laboratories also develop and construct special devices for particular customer requirements. One of these, the IBM Photo Digital Storage System, was installed at the University of California Lawrence Radiation Laboratory

10

11

圖 10
標題和雙欄正文都是按照網格系統
排列。標題和正文之間留有大量
空白，產生了停頓，發揮了強調標題
的效果。

圖 11
只有當設計師想通過相互關係創造
某種氛圍而不是突出單張圖片時，
才能將多張圖片上下左右相鄰排列
而不加任何間隔元素 *。

＊　此處圖說是按照英文版翻譯。
德文版譯文為：這些實例中的圖片
和文字是任意的，之間沒有任何
關係，目的僅在於展示在圖文資訊
組織中網格的應用和視覺效果，
讀者只需關注網格設計的原則即可。

網格系統中的照片、
正文與圖說

網格系統中的標題、
圖片與圖說

12

13

圖 12
圖片、圖說按照網格配置。圖片
之間及圖片與文字之間的大小對比，
能營造出更吸引人的版面。圖說應
與圖片縱向對齊。這樣的頁面設計
需要以優秀、充足的圖片為前提。
圖片必須從留白中創造出視覺性的
躍動感，否則頁面會顯得沉悶和
乏味。

圖 13
根據需要解決的問題，使用網格能
夠非常簡單地找到正確的解決辦法。
舉此例的主要目的是，希望盡可能
以最簡單的方式展示網格與圖文的
關係。通過大小、縱橫以及方形圖片
的簡單組合，就足以給人 1 種生動的
印象，但前提條件是，圖文本身要
生動並富有信息量。

8 格網格的圖文排版

接下來的幾頁是一些實例，按照 1：1 的原尺寸展示如何
在一個 A4（29.7×21cm）的版面中以 8 格、20 格和
32 格網格設置圖文區域。讀者可以通過這些圖例去審視
自己的作品。版面中的尺寸是用西塞羅和點來計算的，
這種度量單位一般用於傳統的鉛活字排印，照相排版採用
的則是公制。

8 格網格系統的版面經常用於廣告宣傳單和宣傳冊的設計。
在很多情況下，設計師只需通過對 8 種不同尺寸的圖片
進行組合，就可以解決許多簡單的問題。如果再有想像力
一點，就可以設計出一個更加生動、豐富的版面，尤其是
設計師可以敏銳地將版面中的留白（未被印刷的區域）
也做為一個重要元素來運用的時候。

這個網格系統儘管只有 8 格，但也能進一步劃分為 16 格。
在例子裡縱向分割水平方向的直立矩形，可以按照小格的
寬度排圖說。

8 格網格系統與 16 格網格系統的結合運用會給設計師
創造出更多的可能性。

69／70 頁圖
右頁展示了在 8 格網格系統中版心
與圖片網格的具體尺寸。版心與
圖片網格的精確尺寸是印刷廠能够
進行精細印刷不可或缺的前提。
如果使用傳統鉛印，度量單位可
採用西塞羅和點（或派卡和英美點）；
如果使用雷射排版印刷，則可用
公分。

12 Cic. 9˙

>12˙<

19 Cic.

>15˙<

12 Cic. 9˙

>15˙<

12 Cic. 9˙

12˙

>15˙<

12 Cic. 9˙

Gestaltung und kommen

Gesamtkonzeption

Wer sich der Fülle von Druckerzeugnissen aller Art bei (
notwendig eine strenge Trennung versuchen und das I
unterscheiden dabei nach Art und Anlage vor allem zwe
men dabei einmal zu dem Anteil der reinen Typographie
Druckerzeugnissen, bei denen das rein Typographische
ausgesprochen sekundärer Bedeutung ist. Die erstere (
schließt für uns Arbeiten, die in ihrer Gesamtkonzeption
sind, gleichviel ob diese Erzeugnisse ihre Entstehung
Setzers verdanken, streng genommen also Arbeiten, di
Form- und Flächenelementen, soweit sie als typographi
baut» werden können. Negativätzungen und mehrfarb
zogen sein. Demgegenüber steht die zweite Gruppe, (
Gestaltung augenscheinlich die Hand des Gebrauchsgr
Diese Arbeiten beziehen ihre Wirkungskraft aus dem
scher Mittel, unter denen der typographische Anteil de
die Funktion der unbedingt notwendigen Textwiederg
techniken soll im Rahmen dieser Zeilen nicht berührt \
stellen, daß der Anteil der reinen Typographie im Laufe (
verloren hat, ja, daß der offenkundige Einbruch der freie
ausschließlich dem Setzer vorbehalten war, eine nicht
stürmische Aufwärtsentwicklung von Industrie und Wir
die Auseinandersetzung um Absatzmärkte und Käuferge
die die Einbeziehung immer neuer und phantasievoller
wenn man «im Geschäft bleiben will». Die aufgewende
mäßige Werbung sind bekanntlich so lange richtig an
Wer sich der Fülle von Druckerzeugnissen aller Art bei (
notwendig eine strenge Trennung versuchen und das I
unterscheiden dabei nach Art und Anlage vor allem zwe
men dabei einmal zu dem Anteil der reinen Typographie
Druckerzeugnissen, bei denen das rein Typographische
ausgesprochen sekundärer Bedeutung ist. Die erstere (
schließt für uns Arbeiten, die in ihrer Gesamtkonzeption
sind, gleichviel ob diese Erzeugnisse ihre Entstehung
Setzers verdanken, streng genommen also Arbeiten, d
Form- und Flächenelementen, soweit sie als typographi
baut» werden können. Negativätzungen und mehrfarb
zogen sein. Demgegenüber steht die zweite Gruppe, (
Gestaltung augenscheinlich die Hand des Gebrauchsgr
Diese Arbeiten beziehen ihre Wirkungskraft aus dem
scher Mittel, unter denen der typographische Anteil de
die Funktion der unbedingt notwendigen Textwiederg

Gestaltung augenscheinlich die Hand des Gebrauchsgr
Diese Arbeiten beziehen ihre Wirkungskraft aus dem
scher Mittel, unter denen der typographische Anteil dei
die Funktion der unbedingt notwendigen Textwiederg
techniken soll im Rahmen dieser Zeilen nicht berührt \
stellen, daß der Anteil der reinen Typographie im Laufe (
verloren hat, ja, daß der offenkundige Einbruch der freie
ausschließlich dem Setzer vorbehalten war, eine nicht
stürmische Aufwärtsentwicklung von Industrie und Wir
die Auseinandersetzung um Absatzmärkte und Käuferge
die die Einbeziehung immer neuer und phantasievoller
wenn man «im Geschäft bleiben will». Die aufgewende
mäßige Werbung sind bekanntlich so lange richtig an
Resonanz beim Empfänger zur Folge haben. Eine Werb
Wer sich der Fülle von Druckerzeugnissen aller Art bei (
notwendig eine strenge Trennung versuchen und das I
unterscheiden dabei nach Art und Anlage vor allem zwe
men dabei einmal zu dem Anteil der reinen Typographie
Druckerzeugnissen, bei denen das rein Typographische
ausgesprochen sekundärer Bedeutung ist. Die erstere (
schließt für uns Arbeiten, die in ihrer Gesamtkonzeption
sind, gleichviel ob diese Erzeugnisse ihre Entstehung
Setzers verdanken, streng genommen also Arbeiten, di
Form- und Flächenelementen, soweit sie als typographi
baut» werden können. Negativätzungen und mehrfarb
zogen sein. Demgegenüber steht die zweite Gruppe, (
Gestaltung augenscheinlich die Hand des Gebrauchsgr
Diese Arbeiten beziehen ihre Wirkungskraft aus dem
scher Mittel, unter denen der typographische Anteil dei
die Funktion der unbedingt notwendigen Textwiederg
techniken soll im Rahmen dieser Zeilen nicht berührt \
stellen, daß der Anteil der reinen Typographie im Laufe (
verloren hat, ja, daß der offenkundige Einbruch der freie
ausschließlich dem Setzer vorbehalten war, eine nicht

在 8 格網格系統中，
8 種不同大小的格式

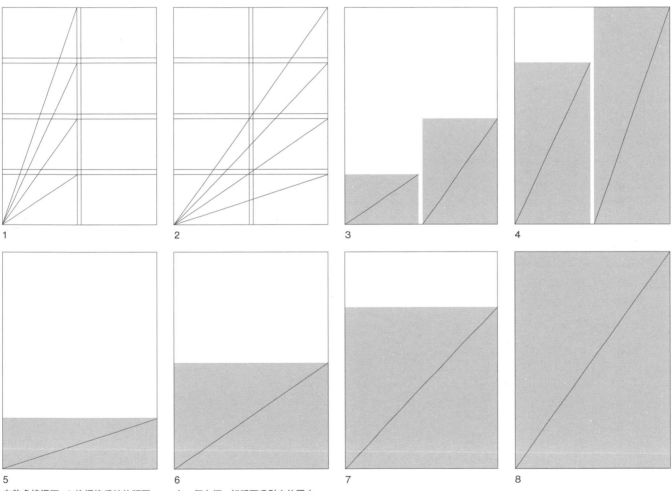

1

2

3

4

5

6

7

8

71　在許多情況下，8 格網格系統的版面
足以容納各種大小的插圖。圖例中，
有 4 種窄長的圖片和 4 種寬幅的
圖片。根據實際的工作，設計師可以
在同一個頁面中組合相同或不同尺寸
的圖片，或與文字結合來豐富版面。
但使用 8 格網格系統也會有 1 種
風險，除非設計師能持有 1 種謹慎的
態度來對待不同尺寸的圖片，否則
效果將變得雜亂無章。
即使是在最簡單的排版中，設計師也
需要具備 1 種良好的判斷力，並對
圖文的結構和節奏保持一個良好的
感覺。網格系統之於設計師，只是一
個優秀、有用的工具而已，讓他能做

出一個有趣、鮮明而吸引人的圖文
排版，但它並不能保證精美的排版。
圖例中用紅色斜線標示的格可以用
於繪畫、圖片、圖表、插圖和色塊
等元素。

20 格網格的圖文排版

Satz- und Bildspiegel
mit 20 Rasterfeldern

我利用 20 格網格系統來編排文字與圖片，並產生了 42 種
排版的可能性。這麼做就是希望向設計師傳達出更開闊的
思路。無論是誰都應該多做這類練習，在草圖中嘗試更多的
排版方式，你將會發現網格的創造力是無窮的。

這裡展示的一些創意不是根據某個具體專案，文本是隨意
杜撰的，圖片也是任意添加的，與文字沒有關係。後面的
案例主要想傳達 1 種印象，就是通過標題、正文、插圖和
圖說的相互作用來創造出 1 種令人滿意的視覺關係。重要
的資訊應該要易於被讀者注意到，讀者的目光應該自動被
引導到特別擺放和強調的圖文元素上。後面幾頁也展示出
我們期待設計師能發揮更大的想像力。

實際上，運用相對少的網格就足以實現大量的優秀方案，
困難之處在於，設計師必須根據印刷品每頁的不同主題，
使用不同圖片、彩色及黑白照片做出富於變化的圖文排版，
而且還要生動有趣、富有邏輯並保證美觀。

73／74 頁圖
右頁展示了在 20 格網格系統中版心
與圖片網格的具體尺寸。
與 8 格網格系統的版面一樣，20 格
網格系統也應該提供精確的尺寸。
只有這樣，設計師才能在設計中有效
地避免不確定的地方，同時防止在
印刷時出現問題。與 8 格網格系統的
版面相比，20 格網格系統極大地擴展
了排版的可能性。

9 Cic. 10˚ >16˚< 8 Cic. 10˚ >16˚< 8 Cic. 10˚ >16˚< 8 Cic. 10˚

>14˚<

9 Cic. 10˚

>14˚<

9 Cic. 10˚

>14˚<

9 Cic. 10˚

>14˚<

9 Cic. 10˚

73

Art und Anlage vor allem zwei Gruppen

Wer sich der Fülle von Druckerzeugnissen aller Art bei e
notwendig eine strenge Trennung versuchen und das M
unterscheiden dabei nach Art und Anlage vor allem zwei
men dabei einmal zu dem Anteil der reinen Typographie
Druckerzeugnissen, bei denen das rein Typographische
ausgesprochen sekundärer Bedeutung ist. Die erstere G
schließt für uns Arbeiten, die in ihrer Gesamtkonzeption a
sind, gleichviel ob diese Erzeugnisse ihre Entstehung
Setzers verdanken, streng genommen also Arbeiten, di
Form- und Flächenelementen, soweit sie als typographis
baut» werden können. Negativätzungen und mehrfarb
zogen sein. Demgegenüber steht die zweite Gruppe, c
Gestaltung augenscheinlich die Hand des Gebrauchsgra
Diese Arbeiten beziehen ihre Wirkungskraft aus dem
scher Mittel, unter denen der typographische Anteil der
die Funktion der unbedingt notwendigen Textwiederga
techniken soll im Rahmen dieser Zeilen nicht berührt v
stellen, daß der Anteil der reinen Typographie im Laufe d
verloren hat, ja, daß der offenkundige Einbruch der freier
ausschließlich dem Setzer vorbehalten war, eine nicht
stürmische Aufwärtsentwicklung von Industrie und Wirt
die Auseinandersetzung um Absatzmärkte und Käuferge
die die Einbeziehung immer neuer und phantasievollere
wenn man «im Geschäft bleiben will». Die aufgewendet
mäßige Werbung sind bekanntlich so lange richtig ang
Resonanz beim Empfänger zur Folge haben. Eine Werbu
dingungen, die z. B. typographisch nur einfarbig, also scl
ungewöhnlich phantasievoll sein, um das Interesse des
jedem Falle schon bei der Verwendung einer zweiten Far
Wer sich der Fülle von Druckerzeugnissen aller Art bei e
notwendig eine strenge Trennung versuchen und das M
unterscheiden dabei nach Art und Anlage vor allem zwei
men dabei einmal zu dem Anteil der reinen Typographie
Druckerzeugnissen, bei denen das rein Typographische
ausgesprochen sekundärer Bedeutung ist. Die erstere G
schließt für uns Arbeiten, die in ihrer Gesamtkonzeption a
sind, gleichviel ob diese Erzeugnisse ihre Entstehung
Setzers verdanken, streng genommen also Arbeiten, di
Form- und Flächenelementen, soweit sie als typographis
baut» werden können. Negativätzungen und mehrfarb
zogen sein. Demgegenüber steht die zweite Gruppe, d
Gestaltung augenscheinlich die Hand des Gebrauchsgra
Diese Arbeiten beziehen ihre Wirkungskraft aus dem
scher Mittel, unter denen der typographische Anteil der
die Funktion der unbedingt notwendigen Textwiederga
techniken soll im Rahmen dieser Zeilen nicht berührt v
stellen, daß der Anteil der reinen Typographie im Laufe d

verloren hat, ja, daß der offenkundige Einbruch der freier
ausschließlich dem Setzer vorbehalten war, eine nicht
stürmische Aufwärtsentwicklung von Industrie und Wirt
die Auseinandersetzung um Absatzmärkte und Käuferge
die die Einbeziehung immer neuer und phantasievollere
wenn man «im Geschäft bleiben will». Die aufgewendet
mäßige Werbung sind bekanntlich so lange richtig ang
Resonanz beim Empfänger zur Folge haben. Eine Werbu
dingungen, die z. B. typographisch nur einfarbig, also sc
Wer sich der Fülle von Druckerzeugnissen aller Art bei e
notwendig eine strenge Trennung versuchen und das M
unterscheiden dabei nach Art und Anlage vor allem zwe
men dabei einmal zu dem Anteil der reinen Typographie
Druckerzeugnissen, bei denen das rein Typographische
ausgesprochen sekundärer Bedeutung ist. Die erstere G
schließt für uns Arbeiten, die in ihrer Gesamtkonzeption
sind, gleichviel ob diese Erzeugnisse ihre Entstehung
Setzers verdanken, streng genommen also Arbeiten, di
Form- und Flächenelementen, soweit sie als typographis
baut» werden können. Negativätzungen und mehrfarb
zogen sein. Demgegenüber steht die zweite Gruppe, c
Gestaltung augenscheinlich die Hand des Gebrauchsgra
Diese Arbeiten beziehen ihre Wirkungskraft aus dem
scher Mittel, unter denen der typographische Anteil der
die Funktion der unbedingt notwendigen Textwiederg
techniken soll im Rahmen dieser Zeilen nicht berührt v
stellen, daß der Anteil der reinen Typographie im Laufe d
verloren hat, ja, daß der offenkundige Einbruch der freier
ausschließlich dem Setzer vorbehalten war, eine nicht
stürmische Aufwärtsentwicklung von Industrie und Wirt
die Auseinandersetzung um Absatzmärkte und Käuferge
die die Einbeziehung immer neuer und phantasievoller
wenn man «im Geschäft bleiben will». Die aufgewende
mäßige Werbung sind bekanntlich so lange richtig an
Resonanz beim Empfänger zur Folge haben. Eine Werbu

Gestaltung und kommen dabei zu
nissen, bei denen das rein Typograp
erstere Gruppe der reinen Typograpl
erstellt sind, gleichviel ob diese E
genommen also Arbeiten, die unter
Material vorhanden sind, „gebaut" w
Demgegenüber steht die zweite Gr
brauchsgraphikers und freien Künst
freier graphischer Mittel, unter den
unbedingt notwendigen Textwiederg
werden. Bleibt uns zunächst festzust
verloren hat, ja, daß der offenkundi
behalten war, eine nicht wegzuleugi
es mit sich gebracht, daß die Ause
Einbeziehung immer neuer und pha
Die aufgewendeten finanziellen Mitt
entsprechende Resonanz beim Empf

Anteil der reinen Typographie und
e gering, ja seinem Umfang nach v
schließt für uns Arbeiten, die in ihr
nisse ihre Entstehung der Skizze e
endung von Schmuck, Form- und F
können. Negativätzungen und mehr
deren Hauptakzent in der formaler
verrät. Diese Arbeiten beziehen ih
r typographische Anteil denkbar g
darstellt. Die Wahl der Drucktechni
daß der Anteil der reinen Typograph
bruch der freien Graphik in eine D
Tatsache ist. Die stürmische Aufw
rsetzung um Absatzmärkte und Kä
evollerer Mittel in der Werbung b
eine planmäßige Werbung sind be
zur Folge haben. Eine Werbung un

在 20 格網格系統中，
20 種不同大小的格式

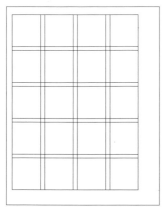

1

2　　　　　　　　3　　　　　　　　4　　　　　　　　5

75　左頁為我們展示了一個使用 20 格
網格系統的版面。正如本書在第一
部分闡述的那樣，正文的字級大小
不僅需要與格的大小協調，而且還
影響著標題、副標題以及圖說的
字級大小。
圖 2 至圖 5 展示了 20 格網格系統
中 20 種不同大小的格式，可用於
展示照片、插畫或者圖表。這 20 種
格式的組合，就能為設計在處理
實際案例時提供足夠豐富變化了。
對於書籍或產品目錄，如果設計師想
自行拼版圖文，那麼建議設計師向
印刷廠訂一些對開頁，預先用淡灰色
調印好網格。網格紙的數量，要比最

終實際的對開頁數至少多 25%
做為耗損，這樣即使有版式變動，
也能保證有足夠紙張。這種方法
不僅能讓版式更為精確，設計師
也能對成品有更清晰的概念，
而印刷廠也會有一個更能信賴的
原稿用於比對。而且，排版工作所
需時間也更短。

6 種不同形式的文字版式

1

2

3

4

5

6

7

此頁中的幾個案例向我們展示了一些
利用 20 格網格系統來編排文字的
解決方案。

圖 1 中的網格系統被應用於圖 2 至
圖 7 的版面中。標題與正文、正文與
注釋、正文的章節之間需要留白時，
留白必須是一行、多行或是一整格。
只有這樣才能保證不同欄裡的字行能
够互相對齊。

字行可以設置成兩端對齊、齊左、齊
右或者中心對齊。留白在版面中有著
十分重要的視覺和美學作用，只要
適當地利用它，就可以使整個版面變
得輕盈、通透甚至更容易辨識。

8 種不同尺寸的橫圖與
豎圖的排版方式

1

2

3

4

5

6

7

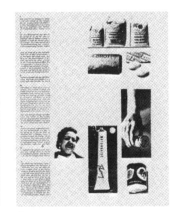

77　圖 2 至圖 7 都採用圖 1 中的網格
系統。
與左頁的圖 1 相比，此頁圖 1 的
網格系統使用了最小的格來組成
各種不同大小的橫圖與豎圖。
要讓印刷品看起來更有說服力，
就需要讓設計清晰易認、富有
功能性並聚焦於本質。上面這些
以及接下來幾頁中的圖例，都是
採用剪貼文字和特別製作的圖版
設計的。

4 種不同寬度的豎圖的
排版方式

1

2

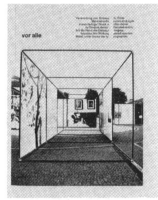

3

4

5

6

7

圖 2 至圖 7 都採用了圖 1 中的網格
系統。
豎圖給人 1 種力量感以及活力。如果
在設計時想要利用豎圖來表達這些特
性，就必須使用適合的圖片。
其次，還要注意圖片與圖片之間以及
圖片與文本之間的留白。如果清晰地
分隔版面中的視覺元素，讀者的眼睛
就更容易識別和理解版面中的內容。
這樣也可以防止某張圖片的形狀在
視覺上與相鄰圖片的形狀混在一起。
設定間隔空間時，要保證大圖小圖
看起來都合適。設計師在決定最終網
格之前，必須通過實驗來理清這些
關鍵的問題。

78

4 種不同寬度的方形圖片的
排版方式

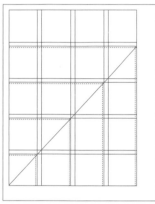

1　　　2　　　3　　　4

5　　　6　　　7

79　上述圖例都是在 20 格網格系統的
基礎上，利用方形圖片與文本結合的
版面設計案例。
20 格網格系統使版面產生了大量
有趣的變化。
圖 2 至圖 7 中都採用了圖 1 中的
方形網格。當然，一個令人滿意的
設計方案不僅僅取決於如何用好網格
系統，同時還需要高品質的文本和
圖片。
是否需要對照片進行合成、拼貼和
裁切，也都取決於工作的性質。透過
照片的處理，版面設計也能呈現出
諸多可能性。
視覺傳達領域中許多優秀作品的

成功，都在於其簡潔，並簡化圖片
至最必要的版面。總而言之，我們
可以說，網格系統可以帶來多樣
變化與組合的可能性，而只有了解
這一點的設計師，才能在其專業
創作中，做出豐富多樣且令人滿意
的作品。

4 種不同尺寸的橫圖的
排版方式

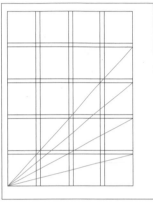

1

2

3

4

5

6

7

圖 2 至圖 7 都採用了圖 1 中的
網格系統。在這些例子中，正方形
和長方形圖片占據了頁面的整個
寬度。這樣的版面設計給人感覺
很大氣。當然，是否採用這種設計
方式還要取決於圖片和文本的品質。
使用網格來協助組織圖片，說明它
不過是一個在多數情況下都奏效的
優秀工具而已。

更多 20 格網格系統的實例

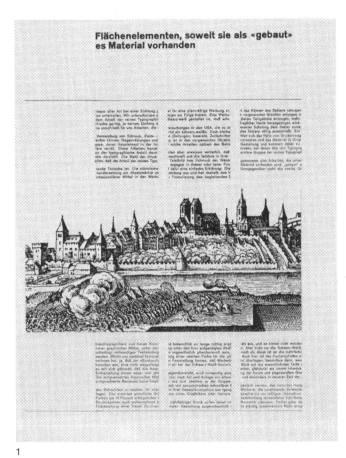

1

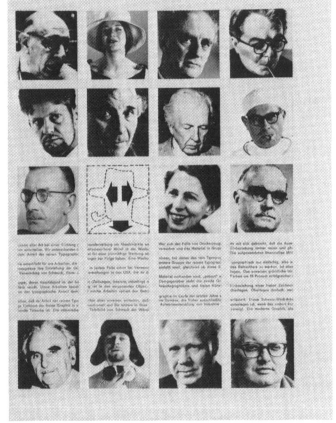

2

81 接下來的 4 個圖例展示了設計師 片和字級大小、粗細、羅馬正體或
 可以用 20 格網格系統延展出更多 義大利體的字體款式選擇，同時
 排版方式。 這些元素也給設計師提供了一個
 在圖 1 中，文本占據了版面中 4 欄 發揮才能的空間。
 右邊的 3 欄，而只有插圖橫跨 4 欄。
 這種排版形式給讀者 1 種視覺印象，
 即插圖左端上下的留白也成了 1 種
 版面元素。
 和之前的圖例一樣，版面設計得
 十分簡潔。這個出色的視覺效果很
 大程度上要歸功於主題圖片和文本
 內容的選擇。這些圖例也進一步
 展示了如何借助 20 格網格系統來
 創造更多的設計可能性。
 總之，豐富的版面變化離不開優質圖

更多 20 格網格系統的實例

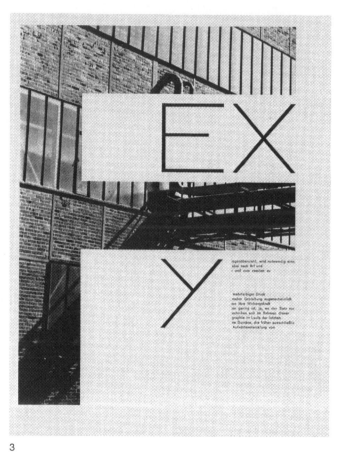

3

還有一個設計項目我們就不在
這裡討論了，那就是版面中的
色彩。在攝影和排版中運用色彩
可以為設計創造出另一個視覺
的維度。

4

82

將照片切割成字母的形狀是 1 種
極端而罕見的設計形式。F 具有
雙重功能，既代表建築物，又是
字母本身，這樣通常會減弱我們
預期的效果，因為眼睛要麼先看到
做為建築物的 F，要麼先看到做為
字母的 F，留在讀者腦海中的往往
是由圖像的不確定性和模糊所造成
的 1 種模稜兩可的印象。
在另一個例子中，調整後的圖片和
文字被十分精確地排在版面中。
右面纖細管狀物的照片與文本欄
對齊，與粗大的彈簧狀物體形成
強烈的對比。這個圖例中，設計師
把圖片和文字視為一個整體來設計。

32 格網格的圖文排版

前面那些 20 格網格系統的例子表明其能提供多樣的排版
可能性，而 32 格網格系統則能將其進一步擴展，提供幾乎
無限種設計方案。隨著格數的增加，圖片的層級以及其大小
區別能夠更精細地表現出來。同時，它還可以為設計師的
畫面帶入更大的躍動感，導入更為複雜的節奏。圖片的大小、
彩色與黑白、明暗變化等各種相互作用，對於每位充滿智慧
和想像力的設計師來說，都是富有魅力的創意源泉。
從設計素材的角度來看，32 格網格系統為圖片提供了更為
豐富的空間布局。這對於那些需要展示更多產品圖片的
公司，或者那些想為其假日路線增加更多景點照片的旅行社
來說尤為重要。
32 格網格系統提供了非常多的編排方案，幾乎涵蓋了所有
類型的版面設計。儘管如此，它也要求設計師要有更強的
自律性，否則清晰易懂、富有秩序的設計難免陷入混亂狀態。
值得一提的是這本名為《平面設計中的網格系統》的書也是
在標準 A4 的開本上利用 32 格網格系統設計的。原版的
標題採用了無襯線字體 Helvetica，標題的字重使用 12 點
的 semi-bold；正文則採用 9 點的 roman 加 3 點行距；
圖說採用 7 點的 roman 加 1 點行距。
版心有雙欄的 9 點正文，以及 4 欄的 7 點圖說。

84／85 頁圖
下一頁標明了在 32 格網格系統中
版心與圖片網格的具體尺寸。
與 20 格網格系統一樣，32 格網格
系統也需要精確的尺寸。這樣能讓
設計師在設計和在與印刷廠溝通時
避免不明確的地方。與 20 格網格
系統相比，32 格網格系統更有效地
擴展了版面的變化。

5 Cic. 9˙	>12˙<	9 Cic.	>12˙<	9 Cic.	>12˙<	9 Cic.

>15˙<

5 Cic. 9˙

>15˙<

5 Cic. 9˙

>15˙<

5 Cic. 9˙

>15˙<

5 Cic. 9˙

>15˙<

5 Cic. 9˙

>15˙<

5 Cic. 9˙

>15˙<

5 Cic. 9˙

5 Cic. 9˙	>12˙<	9 Cic.	>12˙<	9 Cic.	>12˙<	9 Cic.

Gestaltung und kommen dem Anteil

Wer sich der Fülle von Druckerzeugnissen aller Art bei e
notwendig eine strenge Trennung versuchen und das N
unterscheiden dabei nach Art und Anlage vor allem zwe
men dabei einmal zu dem Anteil der reinen Typographie
Druckerzeugnissen, bei denen das rein Typographische
ausgesprochen sekundärer Bedeutung ist. Die erstere C
schließt für uns Arbeiten, die in ihrer Gesamtkonzeption
sind, gleichviel ob diese Erzeugnisse ihre Entstehung
Setzers verdanken, streng genommen also Arbeiten, di
Form- und Flächenelementen, soweit sie als typographis
baut» werden können. Negativätzungen und mehrfarb
zogen sein. Demgegenüber steht die zweite Gruppe, c
Gestaltung augenscheinlich die Hand des Gebrauchsgra
Diese Arbeiten beziehen ihre Wirkungskraft aus dem
scher Mittel, unter denen der typographische Anteil der
die Funktion der unbedingt notwendigen Textwiederg
techniken soll im Rahmen dieser Zeilen nicht berührt v
stellen, daß der Anteil der reinen Typographie im Laufe d
verloren hat, ja, daß der offenkundige Einbruch der freier
ausschließlich dem Setzer vorbehalten war, eine nicht
stürmische Aufwärtsentwicklung von Industrie und Wirt
die Auseinandersetzung um Absatzmärkte und Käuferge
die die Einbeziehung immer neuer und phantasievoller
wenn man «im Geschäft bleiben will». Die aufgewende
mäßige Werbung sind bekanntlich so lange richtig an
Resonanz beim Empfänger zur Folge haben. Eine Werbu
die Funktion der unbedingt notwendigen Textwiederg
techniken soll im Rahmen dieser Zeilen nicht berührt v
stellen, daß der Anteil der reinen Typographie im Laufe d
verloren hat, ja, daß der offenkundige Einbruch der freier
ausschließlich dem Setzer vorbehalten war, eine nicht
stürmische Aufwärtsentwicklung von Industrie und Wirt
die Auseinandersetzung um Absatzmärkte und Käuferge
die die Einbeziehung immer neuer und phantasievoller
wenn man «im Geschäft bleiben will». Die aufgewende
mäßige Werbung sind bekanntlich so lange richtig an
Resonanz beim Empfänger zur Folge haben. Eine Werb
Wer sich der Fülle von Druckerzeugnissen aller Art bei e
notwendig eine strenge Trennung versuchen und das N
unterscheiden dabei nach Art und Anlage vor allem zwe
men dabei einmal zu dem Anteil der reinen Typographie

Wer sich der Fülle von Druckerzeugnissen aller Art bei e
notwendig eine strenge Trennung versuchen und das N
unterscheiden dabei nach Art und Anlage vor allem zwe
men dabei einmal zu dem Anteil der reinen Typographie
Druckerzeugnissen, bei denen das rein Typographische
ausgesprochen sekundärer Bedeutung ist. Die erstere C
schließt für uns Arbeiten, die in ihrer Gesamtkonzeption
sind, gleichviel ob diese Erzeugnisse ihre Entstehung
Setzers verdanken, streng genommen also Arbeiten, di
Form- und Flächenelementen, soweit sie als typographis
baut» werden können. Negativätzungen und mehrfarb
zogen sein. Demgegenüber steht die zweite Gruppe, c
Gestaltung augenscheinlich die Hand des Gebrauchsgra
Diese Arbeiten beziehen ihre Wirkungskraft aus dem
scher Mittel, unter denen der typographische Anteil der
die Funktion der unbedingt notwendigen Textwiederg
techniken soll im Rahmen dieser Zeilen nicht berührt v
stellen, daß der Anteil der reinen Typographie im Laufe d
verloren hat, ja, daß der offenkundige Einbruch der freier
ausschließlich dem Setzer vorbehalten war, eine nicht
stürmische Aufwärtsentwicklung von Industrie und Wirt
die Auseinandersetzung um Absatzmärkte und Käuferge
die die Einbeziehung immer neuer und phantasievoller
wenn man «im Geschäft bleiben will». Die aufgewende
mäßige Werbung sind bekanntlich so lange richtig an
Resonanz beim Empfänger zur Folge haben. Eine Werb
Wer sich der Fülle von Druckerzeugnissen aller Art bei e
notwendig eine strenge Trennung versuchen und das N
unterscheiden dabei nach Art und Anlage vor allem zwe
men dabei einmal zu dem Anteil der reinen Typographie

unterscheiden dabei nach Art und Anlage vor allem zwe
men dabei einmal zu dem Anteil der reinen Typographie
Druckerzeugnissen, bei denen das rein Typographische
ausgesprochen sekundärer Bedeutung ist. Die erstere C
schließt für uns Arbeiten, die in ihrer Gesamtkonzeption
sind, gleichviel ob diese Erzeugnisse ihre Entstehung
Setzers verdanken, streng genommen also Arbeiten, di
Form- und Flächenelementen, soweit sie als typographis
baut» werden können. Negativätzungen und mehrfarb
zogen sein. Demgegenüber steht die zweite Gruppe, c
Gestaltung augenscheinlich die Hand des Gebrauchsgra
Diese Arbeiten beziehen ihre Wirkungskraft aus dem
scher Mittel, unter denen der typographische Anteil de

unter den hier aufgezeigten Be
ist, muß schon ungewöhnlich pha
Falle schon bei Verwendung eine
tersuchungen in den USA, die zu
erfolgreicher sind als schwarz-we
objekten noch vorherrschend ist
oder die Einbeziehung einer frei
Mehrzahl der Fälle überlegen. Ü
rein bildliche Darstellung eine u
jekt schon durch die Bildwirkung
daß das Photo der Zeichnung im
letztere in ihrer Anlage weitgehe
zum Schmuck der Wände bestim
dagegen in dieser oder jener For
tiert. Es gibt dafür eine einfache
eine gewisse optische Schockwir
werden. Es ist logisch, daß dami
geworben wird, zur Kenntnis gen
nicht wunder, daß ein gut Teil di

jungen, die z. B. typographisch
sievoll sein, um das Interesse de
veiten Farbe für die gleiche Arbe
r Feststellung kamen, daß Werb
. Doch bleiben wir bei der Schw
situngen, Inserate, Zeitschriften
Zeichnung ist in den vorgenannt
egen deshalb, weil solche Arbei
ngreiche Textbeigabe überflüssig
schaulich erläutert. Diese Schwa
dann im Werbegut unterlegen i
den Bereichen der modernen Kuns
vird von der Mehrzahl der Betrac
ls formaler Effekt in der Werbun
klärung: Die moderne Graphik l
g aus und hat deshalb den Vorz
si kurzer Formulierung des begle
nen wird. Hier setzt das Können
r Aufgaben dem Setzer aus den

由 4 個分欄、每欄 8 格組成的
32 格網格系統

1

2

3

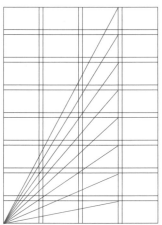

4

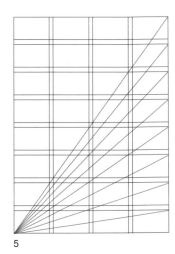

5

這裡展示了由 4 個分欄、每欄 8 格
組成的 32 格網格系統。圖 2 展示了
在第 1 欄中不同的圖片格式，範圍
從最下方最小的一格開始，直到占滿
整個版心高度的 8 格，其中 7 格為
豎圖。
圖 3 示意了 8 種不同的橫跨第 1 欄
和第 2 欄的圖片格式。
圖 4 展示了 8 種不同的橫跨左側 3
欄的圖片格式，從最下方最小的網格
開始垂直往上，3 欄中的圖片越變
越大。圖 5 展示了 8 種不同的橫跨
整個版心寬度（4 欄）的圖片格式。
如果將圖 2 至圖 5 中所有的圖片
格式進行組合，那麼就會產生非常

多的可能性。另外，如果我們將文字
編排中的若干因素一併納入設計的思
考中，比如字級（從 4 點至 72 點）、
字重（light、medium、semi-bold、
bold、roman 和 italic），那麼視覺
傳達設計的範圍將被進一步擴大。
再加上設計師在攝影和插圖上可以
借助色彩的表現力，如此創造力幾乎
是無窮的。

86

單欄和雙欄，
8 種不同高度的網格組合

1

2

3

5

6

87　如果版面設計需要更多樣的靈活性，
我們就要利用「複合網格」來進行
設計。書籍、圖冊、雜誌都會用到
大量小尺寸的圖片給讀者提供資訊，
這就需要更精細的網格。格數越多，
確定和使用網格的難度就越大。
這可能需要花大量的時間去決定
使用哪種字體，以及適合的字級和
行距。而且，所有不同字級的字體
還必須與每個格對齊。
本頁和接下來的幾頁將重點介紹 32
格網格系統中不同圖片尺寸的變化。

橫跨 3 欄，8 種不同高度
的圖片尺寸

7

8

9

10

11

12

13

14

如果需要將大量小尺寸的圖片置入
一個限定的版面中，32 格網格系統
就會顯得十分有用。

在 32 格網格系統中，將最小的格
進行合併形成更大的格，可以為
文本和圖片提供更多變化。版面中
比較狹窄的區域可以容納其他不同
類型的資訊。同時，這也對設計師
提出了更高的要求。設計師應預先
畫好草圖，包括圖文資訊的優先
順序，一旦定好了優先順序，即可
在 32 格的輔助之下在可用空間中
進行排版。

設計師需要克服的難點是，要創建
一個能貫穿始終且可被理解的秩序

系統，同時還要使特徵能够被識別，
而且還要讓整體設計維持其功能，
充滿活力又令人滿意。

橫跨 4 欄，8 種不同高度
的圖片尺寸

15　16　17　18

19　20　21　22

設計師可能會遇到的風險就是利用
不同大小的格時缺乏限制。設計師
必須理性自持，作品才會強而有力又
打動人心。平面設計與其他相關的
視覺藝術領域，如建築、繪畫、雕塑、
產品設計一樣，縮減到最基本的
要素，聚焦對本質的表現，這才是
能够創作出真正傳世佳作的關鍵。
本書的目的就是希望透過網格系統，
清晰地向設計師們展示標準化是
多麼有用。實際上，網格系統的知識
及其運用是每一個視覺設計師必備
的專業知識。沒有網格系統這樣規畫
和構建的方法論，就不會有設計品質
的發展和提升。

32 格網格系統的
版面草圖

在畫網格草圖時，設計師必須保證
草圖的比例盡可能地接近最終的
印刷格式。特別是文本欄和字行的
設置都應該盡可能地精確。
一張好的草圖看上去就應該像縮小
版的印刷品。這就意味著草圖中要
用線條代表字行，而圖片輪廓應該與
最終印刷品具有相似比例。從這樣
的草圖應該能看出文本數量、字級、
行長，以及區域中有多少字、多少
圖等資訊。設計師往往只會用一些
粗大、不甚精密的線條隨便勾勒一下
文字部分，而不指定字級、欄寬。
設計師需要更專注和敏感，並通過大
量的練習，才能使草圖逐漸成形為

印刷商們能够信賴的精準原稿。
在以上圖例中，草圖的原始高度為
5.6cm，與真實的印刷稿只相差
幾公厘。

32 格網格系統的
版面草圖

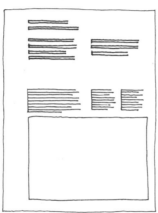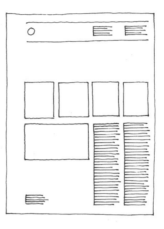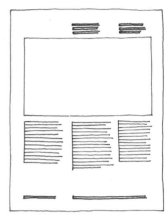

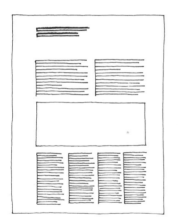

91　這些草圖只是展示了使用 32 格
網格來進行編排的幾種方式，主要
是為了說明設計師該如何繪製草圖，
從而自草圖推測出最終的版面效果。
對於設計師來說，草圖繪製得越
潦草，他就越難設想出印刷品最終
呈現的效果。相應地，草圖繪製得
越精確，設計師就越能夠從草稿中
驗證自己的創意是否在版面中可行。
有些設計師擅長繪製草圖，甚至連
海報設計都能繪製清晰的縮略圖，
這樣設計師就能準確地從中推測到
最終的印刷結果。而這樣的草圖更
容易放大成真實的印刷尺寸，最後
再進行一些細部修改即可。

從未接觸過網格的設計師需要認真
學習這幾頁的內容，並通過不斷地
練習來深入了解網格是如何發揮
作用的。只有這樣，才能基於網格
思維、數學思維更有成效地獲益。

網格系統中的照片

在印刷品的排版中，照片往往都沒有按照網格設計。
這是因為很少有設計師了解網格，或者是想避免使用
網格的一些麻煩。而且攝影師也很少能預先知道他們
拍的照片將被如何使用，因此也無法根據網格中的
使用尺寸在拍攝時進行構圖。很多時候照片會被用於
各式各樣的用途，攝影師無法預先確定使用時的大小。
所以，攝影師只有在與設計師的密切配合下，才會有
意識地將設計師設計的網格系統結合到自己攝影的
圖像作品當中。攝影師可以將繪製的網格覆在相機的
對焦屏上，再通過網格來對拍攝對象進行構圖。或者，
攝影師還可以製作一個與網格比例一致的木質或金屬
框架，把要拍攝的物件放在框架上並將其與框架一起
拍攝下來。這些方式都已經被成功實踐，儘管這增加
了工作的難度且費時。

網格中的圖片裁切　　　　　　　　　　　　　　　在網格中的圖片和色彩區域

1

2

如果要給裁切後的照片增添一些
視覺穩定性，就像給插圖加框線
一樣，可以在照片下襯一個色塊。
這樣照片就被牢牢地固定在網格中，
它的高度和寬度也與網格完全吻合。
還有 1 種可行的方法就是，給照片
加上一個符合網格的邊框。也可以
在插入裁切完的照片後，用線條
標出網格上下邊線（如圖 1 所示）。

圖 2 展示的方法經常用於工業設計
產品的廣告宣傳中。在圖片上覆蓋
一層顏色可以使圖片從周圍環境中
脫穎而出。尤其在那些受到成本
限制而不能使用四色印刷的設計中，
用一個顏色來與原圖進行疊印是
一個提升設計品質不錯的辦法。

網格系統中的插圖　　　　　　　　　　Die Illustration im Rastersystem

插圖、繪畫、統計圖、表格等素材與照片一樣，應該與
網格匹配調整。被裁切後沒有矩形邊框的圖片，在擺放
時可以讓其背景與網格對齊。設計師通常會加上一個
淺色點狀網點背景襯底，這樣不但能讓插圖保持其自身
的活力，又能讓其更明確地嵌入網格版式。
在這裡，插圖的尺寸和形狀並不是特別重要。按照網格
秩序統合插圖，可以強調設計師組織素材的意圖。如果
是彩印，則可以採用一個色塊來代替點狀網點背景。

95

裁切插圖 封閉式插圖

Wer sich der Fülle von Druckerzeugnissen aller Art bei
notwendig eine strenge Trennung versuchen und das I
unterscheiden dabei nach Art und Anlage vor allem zwe
men dabei einmal zu dem Anteil der reinen Typographie
Druckerzeugnissen, bei denen das rein Typographische
ausgesprochen sekundärer Bedeutung ist. Die erstere
schließt für uns Arbeiten, die in ihrer Gesamtkonzeption
sind, gleichviel ob diese Erzeugnisse ihre Entstehung
Setzers verdanken, streng genommen also Arbeiten, d
Form- und Flächenelementen, soweit sie als typographi
baut» werden können. Negativätzungen und mehrfarl
zogen sein. Demgegenüber steht die zweite Gruppe,
Gestaltung augenscheinlich die Hand des Gebrauchsgr

ausschließlich dem Setzer vorbehalten war, eine nicht
stürmische Aufwärtsentwicklung von Industrie und Wir
die Auseinandersetzung um Absatzmärkte und Käuferge
die die Einbeziehung immer neuer und phantasievoller
wenn man «im Geschäft bleiben will». Die aufgewende
mäßige Werbung sind bekanntlich so lange richtig an

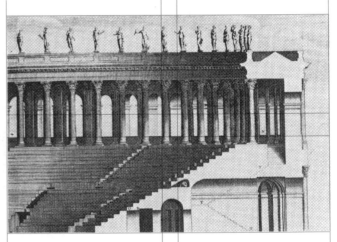

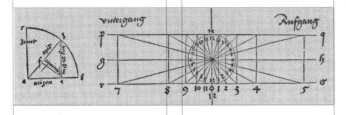

Diese Arbeiten beziehen ihre Wirkungskraft aus dem
scher Mittel, unter denen der typographische Anteil de
die Funktion der unbedingt notwendigen Textwiederg
techniken soll im Rahmen dieser Zeilen nicht berührt
stellen, daß der Anteil der reinen Typographie im Laufe c
verloren hat, ja, daß der offenkundige Einbruch der freie

Wer sich der Fülle von Druckerzeugnissen aller Art bei e
notwendig eine strenge Trennung versuchen und das N
unterscheiden dabei nach Art und Anlage vor allem zwe
men dabei einmal zu dem Anteil der reinen Typographie
Druckerzeugnissen, bei denen das rein Typographische
ausgesprochen sekundärer Bedeutung ist. Die erstere C

1

2

一幅裁切後的插圖放到文字方塊內，
其所占空間容易顯得很不明確。
所以，為了增加插圖的視覺穩定性，
設計師可以用一塊灰色或者彩色色塊
做為插圖的襯底。如果有網格，襯底
必須與網格對齊，如果沒有，則必須
與字行對齊。這樣，灰色或者彩色的
襯底連同插圖一起才能成為整體設計
中的一部分，如圖 1 所示。
一幅幾何封閉式形狀的插圖通常能
更容易以令人滿意又美觀的形式融入
文本。將插圖寬度設置成與欄寬相
同，就更容易讓其與文本形成一個
整體。
通常，插圖在頁面中的布局安排需要

顯得更緊湊一些。設計師可以運用
灰色塊襯底，讓插圖平穩地吻合字行
構造，如圖 2。如果插圖具有更強烈
的視覺含義，則可以用彩色色塊的
襯底強調。

網格系統中的色塊 Die Farbfläche im Rastersystem

印刷中有一個棘手的問題，那就是在一個有文本的網格中
加上一個與網格大小一致的色塊。這樣的話，文本的開始
和結束都與色塊的邊緣重疊，顯然不是一個令人滿意的
視覺效果。
解決這個問題的方法有 2 種：
a.
色塊與網格保持一致，文字方塊不用排滿，而是根據文本
的字級兩側同時縮進幾個點，與色塊邊緣保持一定的距離，
這樣文字就被包括在色塊之中了。
b.
將色塊的寬度向四周延長，超過文字框，這樣文字就被
包括在色塊之中了。
2 種方法都並非十全十美，而具體選擇取決於相對前後行
如何對齊的個人偏好，如果注重文字對齊可用第 2 種方法，
而注重色塊對齊則可用第 1 種方法。

色塊與排版

Wer sich der Fülle von Druckerzeugnissen aller Art be
wird notwendig eine strenge Trennung versuchen ur
teilen. Wir unterscheiden dabei nach Art und Anlage
staltung und kommen dabei einmal zu dem Anteil (
zweiten zu der Gruppe von Druckerzeugnissen, bei
gering, ja seinem Umfang nach von ausgesprocher

Diese Arbeiten beziehen ihre Wirkungskraft aus der
phischer Mittel, unter denen der typographische An
Satz nur die Funktion der unbedingt notwendigen Te
der Drucktechniken soll im Rahmen dieser Zeilen ni
nächst festzustellen, daß der Anteil der reinen Typog
erheblich an Boden verloren hat, ja, daß der offenkur
in eine Domäne, die früher ausschließlich dem Setzer
zuleugnende Tatsache ist. Die stürmische Aufwärtser
schaft hat es mit sich gebracht, daß die Auseinand
Käufergewinnung Formen angenommen hat, die die
phantasievollerer Mittel in der Werbung bedingen,
will". Die aufgewendeten finanziellen Mittel für ein
kanntlich so lange richtig angelegt, wie sie eine ents

erstere Gruppe der reinen Typographie umschließt
samtkonzeption aus typographischen Mitteln erstellt
nisse ihre Entstehung der Skizze eines Graphikers
genommen also Arbeiten, die unter Verwendung vo
elementen, soweit sie als typographisches Material v
können. Negativätzungen und mehrfarbiger Druck s

1

Wer sich der Fülle von Druckerzeugnissen aller Art be
wird notwendig eine strenge Trennung versuchen ur
teilen. Wir unterscheiden dabei nach Art und Anlage
staltung und kommen dabei einmal zu dem Anteil (
zweiten zu der Gruppe von Druckerzeugnissen, bei
gering, ja seinem Umfang nach von ausgesprocher

Diese Arbeiten beziehen ihre Wirkungskraft aus der
phischer Mittel, unter denen der typographische An
Satz nur die Funktion der unbedingt notwendigen Te
der Drucktechniken soll im Rahmen dieser Zeilen ni
nächst festzustellen, daß der Anteil der reinen Typog
erheblich an Boden verloren hat, ja, daß der offenkur
in eine Domäne, die früher ausschließlich dem Setzer
zuleugnende Tatsache ist. Die stürmische Aufwärtser
schaft hat es mit sich gebracht, daß die Auseinand
Käufergewinnung Formen angenommen hat, die die
phantasievollerer Mittel in der Werbung bedingen,
will". Die aufgewendeten finanziellen Mittel für ein
kanntlich so lange richtig angelegt, wie sie eine ents

erstere Gruppe der reinen Typographie umschließt
samtkonzeption aus typographischen Mitteln erstellt
nisse ihre Entstehung der Skizze eines Graphikers
genommen also Arbeiten, die unter Verwendung vc
elementen, soweit sie als typographisches Material v
können. Negativätzungen und mehrfarbiger Druck s

2

有時應內容的需求，某一部分文本需
要比其他部分更突出。解決這類問題
的方法有很多種：可以用黑色或彩色
的底線強調文本，或者在文本下面
增加一個灰色或彩色的色塊。使用
這些方法時，設計師也需要注意一些
問題：
如圖 1 所示，色塊大小與首行和末
行文字完全一致。字行的首字母和末
字母觸碰到文字方塊邊緣。文字被
色塊三面包圍，只有一側有留白，
影響易辨性。這樣的視覺效果無法
令人滿意。文本和色塊的區域都不
清晰。
圖 2 同樣也是利用色塊做為襯底來

凸顯文字的重要性。每一行文本寬度
都與格保持一致，色塊向四周延伸，
溢出文本區域。

色塊與排版　　　　　　　　　　　　　排版中的彩色字體

Demgegenüber steht die zweite Gruppe, deren Hau
tung augenscheinlich die Hand des Gebrauchsgraph
Diese Arbeiten beziehen ihre Wirkungskraft aus der
phischer Mittel, unter denen der typographische An
Satz nur die Funktion der unbedingt notwendigen Te
der Drucktechniken soll im Rahmen dieser Zeilen nic

Wer sich der Fülle von Druckerzeugnissen aller A
wird notwendig eine strenge Trennung versuche
teilen. Wir unterscheiden dabei nach Art und An
staltung und kommen dabei einmal zu dem An
zweiten zu der Gruppe von Druckerzeugnissen
gering, ja seinem Umfang nach von ausgespro
erstere Gruppe der reinen Typographie umschl
samtkonzeption aus typographischen Mitteln er
nisse ihre Entstehung der Skizze eines Graphi
genommen also Arbeiten, die unter Verwendur
elementen, soweit sie als typographisches Mate

nächst festzustellen, daß der Anteil der reinen Typog
erheblich an Boden verloren hat, ja, daß der offenkur
in eine Domäne, die früher ausschließlich dem Setzer
zuleugnende Tatsache ist. Die stürmische Aufwärtser
schaft hat es mit sich gebracht, daß die Auseinand
Käufergewinnung Formen angenommen hat, die die

3

Demgegenüber steht die zweite Gruppe, deren Hau
tung augenscheinlich die Hand des Gebrauchsgraph
Diese Arbeiten beziehen ihre Wirkungskraft aus der
phischer Mittel, unter denen der typographische An
Satz nur die Funktion der unbedingt notwendigen Te
der Drucktechniken soll im Rahmen dieser Zeilen nic

Wer sich der Fülle von Druckerzeugnissen aller Art b
wird notwendig eine strenge Trennung versuchen u
teilen. Wir unterscheiden dabei nach Art und Anlag
staltung und kommen dabei einmal zu dem Anteil
zweiten zu der Gruppe von Druckerzeugnissen, be
gering, ja seinem Umfang nach von ausgesproche
erstere Gruppe der reinen Typographie umschließt
samtkonzeption aus typographischen Mitteln erstell
nisse ihre Entstehung der Skizze eines Graphikers
genommen also Arbeiten, die unter Verwendung v
elementen, soweit sie als typographisches Material
können. Negativätzungen und mehrfarbiger Druck
Demgegenüber steht die zweite Gruppe, deren Hau

nächst festzustellen, daß der Anteil der reinen Typog
erheblich an Boden verloren hat, ja, daß der offenkur
in eine Domäne, die früher ausschließlich dem Setzer
zuleugnende Tatsache ist. Die stürmische Aufwärtser
schaft hat es mit sich gebracht, daß die Auseinand
Käufergewinnung Formen angenommen hat, die die

4

圖 3 色塊中的字行上下空一行，兩邊
內縮。每行文本的首尾字母都不會與
色塊的邊緣重合。
紅色色塊的色調越淡，文本的易辨性
就越高。如果因為技術因素不能控制
色塊的色調，致使紅色很深，可以疊
加點狀網點以降低色調深度。
為了避免色塊色調不可控制等問題，
圖 4 去掉色塊，直接把需要突出顯示
的文本設置為彩色。這也是一個不錯
的解決辦法。

實際案例 **Beispiele aus der Praxis**

接下來將舉一些實際的例子為大家展示網格系統如何有效
及其廣泛的應用。

然而，這些案例不能完全展示基於各種豐富多樣的主題，
採用網格系統的方法進行的一些美觀的出色呈現。同時，
它們也不足以展示全世界使用網格系統的概貌。我們知道，
在歐洲之外，如北美、南美洲、加拿大、日本、澳洲都有
很多利用網格系統設計出來的優秀作品。

不過，遺憾的是還沒有幾所設計院校能把應用網格系統的
正確方法全面地傳授給學生。一方面是老師自身對網格
系統缺乏興趣，另一方面是他們對網格系統的應用並不是
很了解。還有一個普遍的誤解，就是「網格系統」限制了
設計師的創造力。

我們希望在這裡呈現的實例能够駁倒這些誤解。

上圖／書籍：《平面設計師的造形問題》
（*Gestaltungsprobleme des Grafikers*）
對開頁的網格

下圖／《平面設計師的造形問題》
對開頁的網格

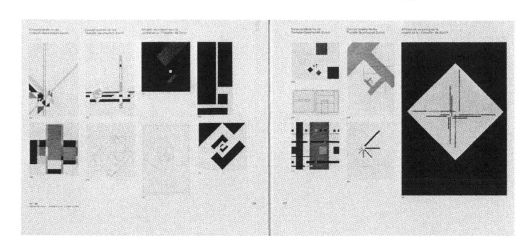

101 該書於 1968 年修訂至第 3 版。
版面設計了 4 欄和 8 格網格系統，
圖片網格的上下分別留出 3 行和
8 行的區域來排標題和圖說。
文本和圖例使用 2 種字級。字行、
圖說行數都與插圖保持對齊。
全書共有 710 幅插圖，部分四色，
部分黑白。
開本：22.5×26.5cm，橫向開本
總頁數：186 頁

瑞士汽巴精化公司米蘭辦事處
的月刊《RotoC》

對開頁的網格

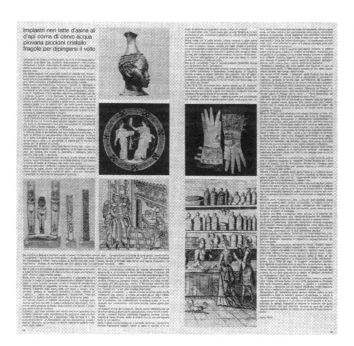

該雜誌的版面設計是以 8 格網格
系統為基礎。小標題和正文使用了
相同字級大小。小標題與正文之間
被空行分開,顯得格外醒目。這些
空行與正文的行距高度一致,不是
行距的二分之一或四分之一。因此,
在第 1 欄中正文的第一行可與其他
欄的字行對齊。
醒目的標題字級大小,與正文字級
大小形成了鮮明的對比。文本與
圖片的排版也掌控得恰到好處。
有趣的是,設計師亦利用八分之一
版面、四分之一版面、二分之一
版面以及整版來形成圖片的節奏
變化。所有標題被安置在第 1 欄的
頂部,當文本較短時,標題下方總有
幾行空行做為留白。圖片的編排讓
版面顯得十分寬敞,同時也強調了
重點。
印刷:單色
開本:42.2 × 22cm,豎向
頁數:20

德意志銀行年報 德意志銀行年報的網格

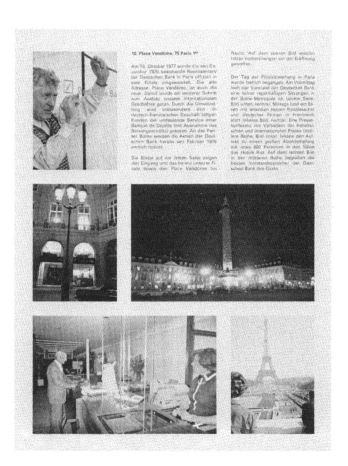

103 德意志銀行年度報告的網格結構基於
德意志銀行的企業識別形象系統，
它將文字、圖片、資料和插圖等元素
全部整合在一個 9 格網格系統之中。
該企業所有印刷品，無論是對外的
還是對內的，都利用了網格系統來
設計。
如果需要一個更為精細的網格系統，
9 格還可以再細分成 18 格，甚至再
分成 36 格。當然，還可以把目前的
3 欄垂直細分為 6 欄。
年報中的插圖為複色印刷。
開本：27 × 21cm
總頁數：150

上圖／書籍：《瑞士工業的平面設計》
（*Schweizer Industrie Grafik*）

下圖／《瑞士工業的平面設計》
對開頁的網格

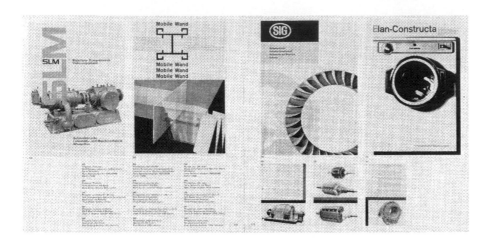

這本書的版面結構是基於 12 格網格
系統設計的。
文本與圖片相互對應，字行與圖片的
頂邊和底邊對齊。正文的字行從版心
頂部開始，圖說的設置卻是從欄的
底線對齊，並往上延伸。
全書 200 頁的內容都是嚴格按網格
系統來規畫和設計的。插圖有四色和
黑白。
開本：25.5 × 26cm，橫向開本
印刷：凸版印刷
總頁數：200

上圖／《海伍德工業區》
(*Heywood Industrial Estate*) *

下圖／《海伍德工業區》的網格

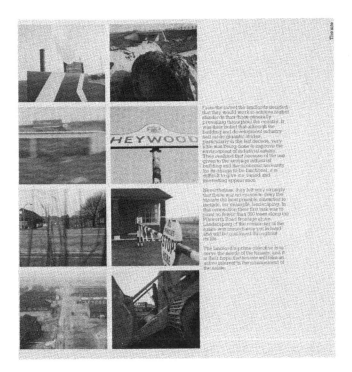

105 該圖錄的版面是由 12 格網格系統
構成。在版面編排上，文本與圖片
的位置交替出現。所有圖片彩印，
文字使用 2 種字級大小。
12 格網格圖右側的分隔號表示該
圖錄後續頁面不斷增加的頁面寬度。
格之間的間距相對來說比較小。
圖片必須認真搭配，否則容易導致
圖片在視覺形式上受相鄰圖片的
干擾。
開本：30 ×（25.5-30）cm
開本高度不變，寬度遞增
總頁數：20

＊　原書中注明為加拿大，但海伍德
（Heywood）實際位於英國曼徹斯特。

雜誌：《Casabella》　　　　　　　　　　　　《Casabella》的網格系統

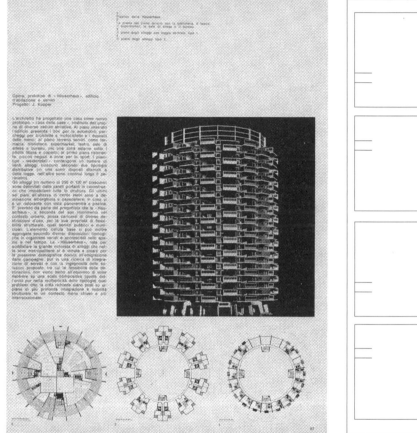

建築設計雜誌《Casabella》的版式
設計採用 12 格（3×4）網格系統。
根據內容的需求，還可再細分為 18
格網格系統，即從 3 × 4 的格局變
為 3×6。
文本和圖片對齊天頭排列，標題和
文本及插圖間間隔 2 個空行，標題、
正文和圖說採用了 3 種不同的字級
大小。雜誌中的專業插圖都是黑白
的，而廣告則是四色的。
開本：31 × 24.5cm，豎向開本
總頁數：108

海報：《musica viva》 《musica viva》的網格系統

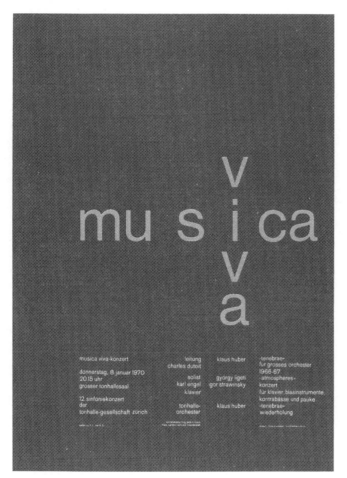

107　《Musica viva》海報被建構在一個
橫向為 4.5 格和縱向 4 格（4.5×4）
的網格系統上。海報主題 musica
viva 兩個單詞排列成十字交叉；
單詞 musica（意為「音樂」）的字母
以不規則的間隔排列產生節奏感。
節目單中的文本採用小字級，並與
musica viva 的字母分欄對齊，這種
文字編排的結構給人 1 種既嚴謹又
優雅的感受。
海報尺寸：128 × 90.5 cm，直立
印刷色：藍、綠、白

雜誌：《Oppositions》　　　　　　　　　　　　《Oppositions》的網格系統

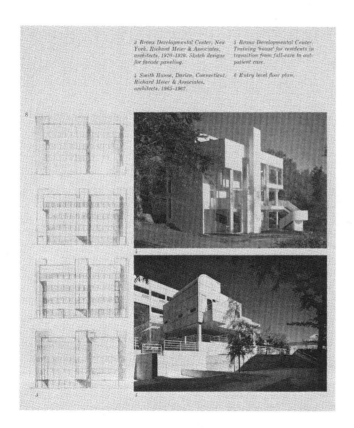

建築評論誌《Oppositions》的版面
是以 15 格網格系統為基礎。在特殊
的排版需求下，中間的格可以再次
細分。

文本排版是從第 2 欄開始，與圖片
垂直對齊，結束於圖片的右側基線。
文本和圖說採用了 2 種字級大小，
只有主標題採用 semi-bold，圖說
採用義大利體。

雜誌內容多為建築的實體圖、平面
圖、立面圖、立體正投影圖，以及
過去幾個世紀的建築圖片素材，從各
角度對建築進行比對性分析。雜誌
採用的網格系統可以滿足上述各種
內容的編排需求。雜誌使用的插圖

均為黑白。
開本：25×21cm，豎向開本
總頁數：120

上圖／期刊：《Ottagono》 下圖／《Ottagono》對開頁的網格

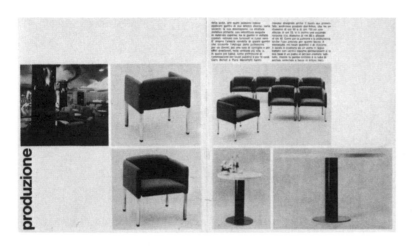

109 《Ottagono》是致力於刊登建築和
產品設計的雜誌，版面上使用了 20
格網格系統。文本採用了 3 種字級
大小，同時使用了義大利體。插圖
的尺寸從滿版到格大小交替，部分
插圖是四色。
20 格網格系統可以為插圖的大小
提供更為豐富的變化。一個規畫
合理、布局精密的網格系統在很大
程度上有利於雜誌向讀者傳達各色
主題內容，並輔以不同圖片説明。
開本：24 × 21.3 cm，豎向開本
總頁數：122

書籍：《Louis Soutter》 《Louis Soutter》的網格系統

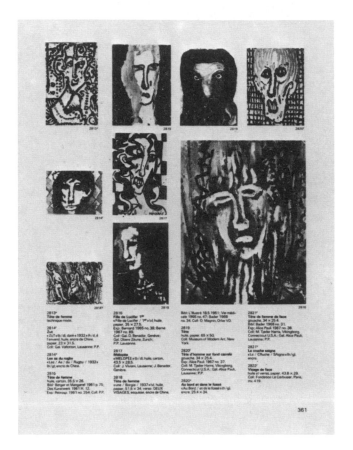

《Louis Soutter》這本圖集，全書
382 頁一共收錄了 2844 幅插圖。
版面設計採用 16 格網格系統。正文
分雙欄，圖說分 4 欄。文本採用了
3 種字級大小，每種字級大小都能
與圖片網格對齊。
圖片格式有豎圖和橫圖。儘管各種
不同大小的圖片可以豐富版面的
變化，但仍需注意視覺的整體協調
和統一，以便讓讀者查閱。插圖的
尺寸從滿版到十六分之一版面不等，
大部分是黑白，有一部分是彩色。
開本：30×23.5cm
印刷：膠版印刷
總頁數：382

宣傳手冊：
《慕尼黑：1972 奧運之城》

《慕尼黑：1972 奧運之城》
的網格系統

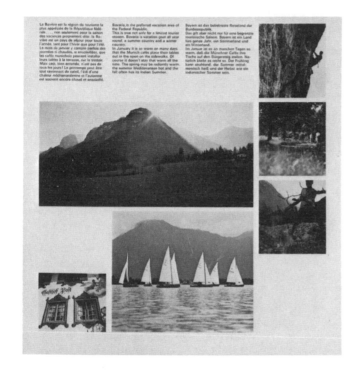

111　這本宣傳手冊的版面設計採用 16 格
和 20 格的複合網格系統。文本和
插圖嚴格對齊。內文只用了 1 種字級
大小，所有插圖均為四色。插圖的
編排非常具有節奏感，圖與圖之間的
間隔和留白也更加突出了這種視覺
美感。
一些特殊的頁面，根據插圖的需要，
可以同時使用 16 格與 20 格這 2 種
網格系統。從上圖的手冊樣張可以
看出：頁面右邊的 3 幅正方形插圖
由上至下被排進 16 格網格系統中，
頁面左下方兩幅大的插圖和一幅小的
插圖則被放置在 20 格網格系統中。
如要在同一個版面中複合應用 2 種

網格系統，那就不得不要求設計師
更加熟練地掌握網格系統。
開本：29.7×28cm，豎向開本
總頁數：34

日本的思想季刊誌：
《Episteme》（エピステーメー）
杉浦康平作品 *

《Episteme》的網格系統

自網格系統在 20 世紀 60 年代大放
異彩以來，不少日本設計師便開始
在自己的設計作品中嘗試。日文的
文字與中文漢字一樣，是構建在一個
個正方形中，因此特別適合採用網格
的版式。此例中，需要將含有歐文、
阿拉伯數字的各式名詞及圖說與日文
混排。設計師將這部分注釋放到上下
2 格的日文正文之間。用這個版式
貫穿本書。書中插圖均為黑白。
本書為該季刊特輯：《數學的美學》，
1976 年 11 月刊，東京朝日出版社
開本：25.3×15.2cm，豎向開本
總頁數：248

＊ 杉浦康平（1932–），日本平面設
計師。在《季刊 Paideia》（竹內書
店、1968–1973）中，以 8 點活字為
基礎組成了細密多樣的段落。
《Visual Communication》（講談社、
1976）與《全宇宙誌》（工作舍、
1979）等作品中，則是使用網格使得
相異的元素動態共存，擴充了網格
系統日語排版的可能性。上述圖片為
刊物《Episteme》（エピステーメー），
原文誤作《Design》，在此修正。

藝術月刊（現為隔月刊）：
《美術手帖》

《美術手帖》的網格系統

135——図示表現の意味　1979・9

113 日本藝術雜誌《美術手帖》呈現了
利用網格系統來編排文字和插圖的
另 1 種嘗試。設計師將插圖與文字
行對齊。3 欄文本之間的間隙明顯。
頁面底部的頁碼和篇章名，與正文
和插圖之間保持一定的距離。書中
大部分插圖為黑白，部分插圖則為
雙色或四色。
開本：21×14.6cm，豎向開本
總頁數：366 頁

右邊展示的是一個對頁。頁面中設置
了 16 排直行，每行 43 個字，每個字
用方框表示。日文的文字與中文漢字
一樣，是構建在一個個正方形中。
傳統的日文書籍頁面都是直排閱讀，
因此字行之間距離較遠，而每個表意
文字順次往下緊密排列（密排）。

上圖／漢莎航空（Lufthansa）
宣傳手冊

下圖／漢莎航空宣傳手冊
對開頁的網格

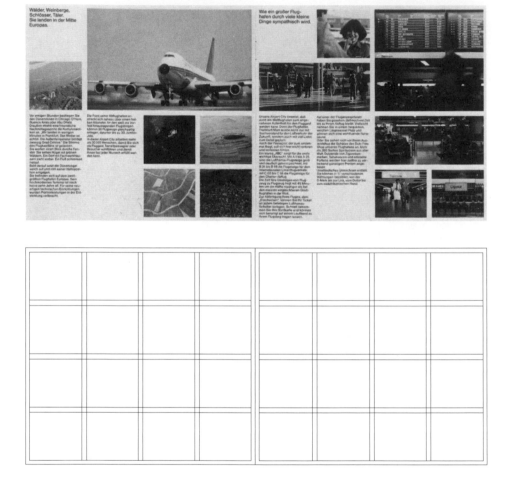

漢莎航空的宣傳手冊版面設計採用了
16 格網格系統。在這個清晰簡潔的
設計中，插圖和文本編排極為整齊。
各種尺寸的彩色插圖錯落有致。標題
和正文使用了 2 種字級大小。
開本：19.7×21cm，橫向開本
總頁數：8

上圖／宣傳手冊：《La macchina》，
IBM，義大利

下圖／《La macchina》
對開頁的網格

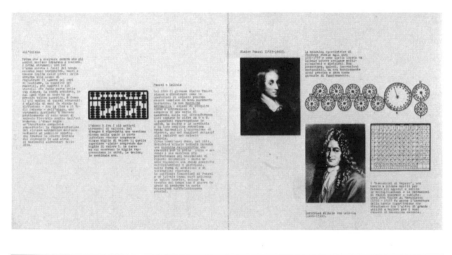

115 《La macchina》的版面設計採用了
18 格網格系統。設計師在文本、圖說
和插圖的編排上傾注了獨特的構想。
標題、正文和圖說都使用了相同的字
級大小，但圖說是紅色的，以便能和
正文區分。插圖多為黑白，部分插圖
採用了黑紅雙色印刷。
開本：21 × 21cm
總頁數：70

書冊：《瑞士藝術地貌史》
（*Geschichte der Schweizer Kunsttopographie*）

瑞士藝術研究所出版的
系列畫冊的網格

瑞士藝術研究所出版的系列畫冊。
開本：23×21cm
印刷：單色印刷，黑色
封面：雙色印刷，黑色和一個專色
（代表每一本畫冊的顏色）。
本系列畫冊的版面採用了18格網格
系統，整幅版面被分為3欄，兩寬
一窄。寬欄用來排正文，窄欄用於排
注釋和圖注。而插圖的排版則沒有
限制，3欄都可以使用。
多年來，瑞士藝術研究所在出版物、
報表和展覽的設計上都一直保持著
統一的風格。在這裡介紹的畫冊，
內容體例包括了文本、插圖、注釋、
參考書目和圖表等等。

116

《19 世紀與 20 世紀的藝術》
（*Kunst des 19. und 20.
Jahrhunderts*）

畫冊《瑞士高等教育的藝術研究》
（*Kunstwissenschaft an Schweizer
Hochschulen*）中的一頁

117　這套關於藝術學的畫冊，採用了同樣
的網格、字體和字級大小。封面設計
也基於同樣的系統。儘管文字排印的
理念保持不變，但每本的封面顏色都
不同。
相同的開本、紙張品質、網格系統、
封面以及字級大小保證了整個系列
畫冊的統一性和關聯性。封面顏色與
設計的差異，以避免混淆同系列中的
其他單冊。
在設計風格上保持高度統一能讓讀者
對該系列出版物保持深刻的印象。

宣傳手冊：《羅夫·哈德與
恩斯特·洛許的平面設計》（*Graphic
Design by Rolf Harder and
Ernst Roch*）

《羅夫·哈德與恩斯特·
洛許的平面設計》的網格

該案例是一個平面設計工作室的宣傳
手冊。圖片與文本被編排在一個 20
格網格系統的結構裡。手冊前幾頁的
序言部分用的是雙欄。
圖片尺寸從 1 格到 16 格不等。插圖
分為四色和黑白。
開本：26.7 × 21cm，豎向開本
印刷：膠版印刷
總頁數：52

年報：IBM 公司年報

IBM 公司年報的網格

119 IBM 年度報告的版面設計，採用 21
格網格系統來滿足文本和圖片的編
排需求。第一橫排的格高於下面所
有的格，主要用於在頁面的天頭放置
標題，並預留出足夠的空間來滿足
一些長標題的排列。
文本和圖說使用了 4 種字級大小，
圖片為四色。
開本：26.7 × 23cm
總頁數：36

上圖／展覽摺頁 下圖／摺頁對開頁的網格

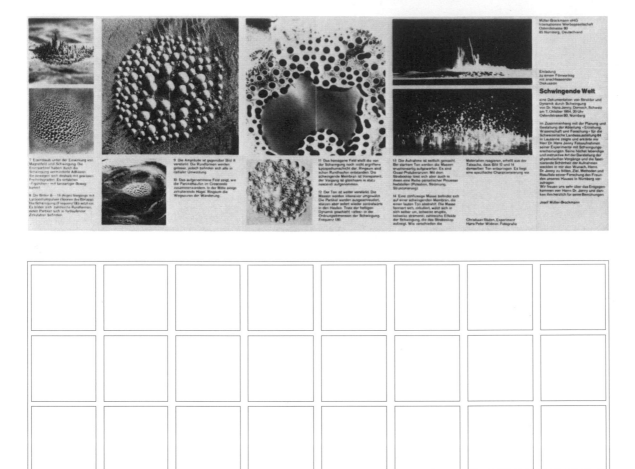

手冊型式為風琴摺形式，共摺 7 次，
版面的網格基於 8 個摺頁，每頁均分
為 3 個同樣大小的方格。字行與照片
對齊。

正文與圖說的字級大小一致，只有
標題用了粗體，字級大小也比其他
文字大了 4 點。

設計摺頁時，一定要注意在圖片和
文本之間留有足夠的空間，以不受
摺痕的影響。

將 2 個或 2 個以上的正方形合併成
更大的單元，可以讓設計更大氣。

文本與插圖之間隔一個空行。圖文的
編排方式具有實用清晰的秩序，而大
部分圖片形式的選擇也遵循這樣的
規則。

該摺頁雙面印刷，折疊 7 次後可以
放入標準的 A5、A6 信封內。

印色：黑白

開本：56×21cm

120

倍耐力集團的宣傳手冊　　　　　　　　　　　　　手冊對開頁的網格

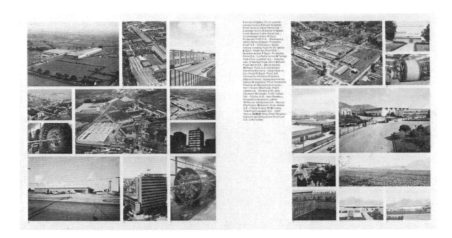

121　手冊的版面設計採用了 24 格網格
　　　系統。手冊中的插圖共分為 10 種
　　　尺寸，大小相間，產生了 1 種生動的
　　　對比。
　　　文本欄的第一行和最後一行與頁面
　　　頂部和底部的插圖對齊。段落中的
　　　其他字行與圖片沒有特定的關係。
　　　此例也體現了很多作品在使用網格
　　　時的一項特點，即精密的網格只用來
　　　固定圖片，而不去規範字行（首末行
　　　除外）。文本採用了 2 種字級大小。
　　　圖片部分彩印，部分黑白。
　　　開本：29.7×28cm，豎向開本

雜誌:《fodor 24》, 荷蘭

《fodor 24》的網格系統

博物館雜誌《fodor 24》* 的版面
設計採用了 48 格網格系統。
有趣的是, 所有文本都是用電動打字
機排的。因此, 網格範本用點的形式
在格子裡所標註的鍵位, 是用於觀察
確認網格是否正確。
開本:25 × 20cm, 豎向開本
總頁數:8

✳ 圖片的製作者為維姆・克魯維爾
(Wim Crouwel, 1928–2019), 為當
代荷蘭代表平面設計師。從為阿姆斯
特丹市立博物館所進行的設計項目、
設計字體 New Alphabet、至共創
的跨領域設計事務所 Total Design
(1963) 而為人所知。他利用在阿姆斯
特丹市立美術館能自由使用的電動打
字機, 為佛多爾 (Fodor) 美術館定期
刊物排版, 並以網格為基礎的幾何學
設計等寬字型 Fodor。

圖錄：《日內瓦總藥店》
（Pharmacie Principale Genève）

《日內瓦總藥店》的網格系統

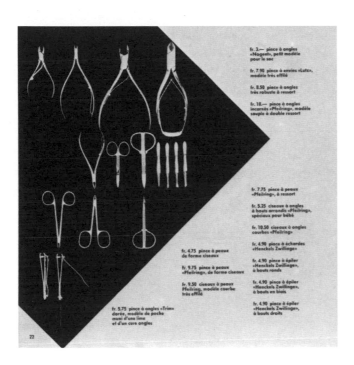

123　該圖錄的圖片編排是以 49 格網格
　　　系統為基礎。文本分 4 欄。產品
　　　圖片的背景色塊在每一頁上的形狀
　　　和尺寸都不同。所有圖片均為黑白，
　　　文本部分採用紅色來印刷。
　　　開本：20.5×20.5cm
　　　總頁數：32

宣傳手冊：瑞士燈具公司的
《照明設備產品手冊》

《照明設備產品手冊》的
網格系統

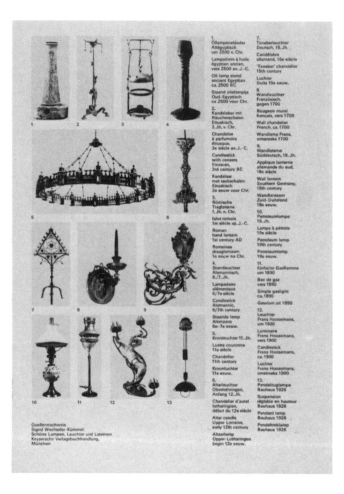

54 格網格系統和 6 欄的版面結構
可以滿足各種產品資料和繪圖的
排版。大多數圖片尺寸較大，而技術
規格的文字較小。正文使用了 2 種字
級大小，配圖講述的是照明燈具
簡史。封面是一張將檯燈支臂轉動後
經過多重曝光拍攝而成的照片。
開本：29.8 × 21cm
印刷：四色

圖錄：《Rosenthal》 《Rosenthal》的網格系統

125　這是一本關於 Rosenthal 工作室
　　的圖錄，其版面設計採用了 60 格
　　網格系統。如此細密的網格可以為
　　組織圖文提供很大的自由度，但也
　　必須要求設計師要足夠自律，使用
　　資源時要有限度。所有圖文都放置
　　於黑色背景中，雖然可以讓圖片的
　　表現力更強，但另一方面，太長或
　　排得過密的文字會影響閱讀。因此，
　　正如這個案例的處理，反白的文字
　　較簡短，行距也比較鬆。
　　插圖分為黑白和彩色。
　　開本：30 × 30cm
　　總頁數：62

雜誌：《CCA Today》，美國 《CCA Today》的網格系統

美國雜誌《CCA Today》需要一個更
為強大的網格系統來滿足各類版面的
功能需求，所以它的格數量也達到了
65 格。

大量尺寸不一的圖片並存，3 種字級
大小和 2 種字重（medium 和 semi-
bold）用於標題、正文和圖說。標題
字體的顏色根據其內容的主次分為
黑色和藍色。圖片的裁切與字行精確
地對齊。

通常，雜誌類的版面需要更精細的網
格系統才能滿足不斷變化的文本與
圖片，同時這也要求設計師在排版時
要具有較高的靈活度。

但從另一個角度看，雖然 65 格網格

系統可以提供更豐富的版面變化，
但也更容易使設計師忽視版面的
清晰和邏輯。所有插圖均為黑白。
開本：43.1×28cm，豎向開本
總頁數：4

126

海報：《新瑞士電影》
(The New Swiss Film)

《新瑞士電影》的網格系統

海報的版面設計是以 72 格網格系統
為基礎，黑白印刷。雖然同系列海報
的編排風格一致，但圖片的組合豐富
多變，每張海報又各具特色。
圖片之間的橫向間隔大於縱向，因為
圖片上下之間都需要留出 4 行的空間
來排圖說。版面四周的頁邊距留得比
較寬裕，這樣就可以使在黑色背景中
的攝影插圖顯得更加穩定。
海報尺寸：59.3 × 41.8cm

企業形象設計中的網格系統

Das Rastersystem im Erscheinungsbild

企業形象的設計，必須做為企業處理內外部所有資訊及事務的媒介，旨在尋求一個基本思路，以便能以統一、有邏輯、功能性的方式解決所有相關問題。不僅如此，這個形象一經確立，還要能發展成一套方案，隨著時間的推移，在實踐中保持其獨特性，並成為公司理念的特徵。

企業形象的功能是否能在未來企業發展的過程中發揮重要作用，確實是在設計企業形象時的一大難題。網格系統的規畫也需要同時考慮到字體和顏色的設計。所以，一個企業形象的設計必須具有很強的靈活性，這樣才能在資訊的傳遞中應對那些未知的問題。無論企業形象應用在何處，都必須傳達出企業的生命力與革新。這考驗著設計師自身的智慧、知識、能力和想像力。

即使是一個中型規模的公司，它的企業形象中也包括大量的資訊。尤其是從廣告宣傳的角度來講，這些資訊全部都能够起到推廣公司形象的作用。比如公司對內和對外使用的各類辦公用品，包括信紙、票據表單、提貨單、訂貨單、商標、標誌、訪客卡、各式尺寸信封、制服、公司貨車貼紙、標籤、包裝、手冊、圖冊、媒體廣告、展覽宣傳、門上和廠區外的立面字體和雕刻等，全都在有形無形中詮釋著該公司的企業形象。很多大型公司已經意識到企業形象設計的重要性，並聘請業界資深的設計師來設計。

現代文字排印要求設計師有邏輯、系統地組織頁面中的圖片和文字：

a
大標題的字級大小及其在所有頁面上的位置應保持一致，從始至終都應使用同一款字體。

b
副標題統一字級大小，並與頁面中的上下文保持相同距離。

c
圖說的字級大小一致，與插圖保持相同的編排關係。

d
所有版面中的文本和插圖應使用統一的網格系統。

e
小標題的字級大小一致，並與文字保持相同的編排關係。

f
旁注的設計同上。

g
所有插圖元素，如圖片、圖表、統計圖等等都應按照格的大小來編排。

h
所有照片應有統一的拍攝風格。

i
就插圖必須客觀來說，風格要一致。

j
統計資料的表現形式應保持一致。

k
同類型文本的字體和顏色應保持一致。

l
字級大小相同的文本，行距應保持一致。

m
分隔文本應該使用一行、兩行或者更多的整行空行，而不是半行，否則相鄰兩欄中的字行會錯位不齊。

如果想要使設計達到整體統一，那麼封面和內頁需使用相同的網格系統和字級大小。這種統一的設計形式要求從一開始就要一起構思封面設計與內文設計。

以此目的配置的網格系統要能滿足所有需求，不僅要讓封面引人入勝，還要讓內文如實、有效地呈現。這向設計師提出了更多的要求，要求他更細緻地思考，尋求一個既有功能性又美觀富說服力的解決方案。

然而，我們經常見到的封面設計多是獨立於正文，這似乎是意料之中的現象。因為脫離了正文的約束，封面設計可以在形式、數量和用色上更加自由。大部分設計師都會選擇這種簡單直接的方法。

129

1
圖錄、手冊、宣傳單的網格系統
2
某產品宣傳手冊的對開頁

3／4
某公司系列產品手冊的封面封底
5／6
配件產品手冊的內外頁

1

3

4

2

5

6

一些大企業會從造形和色彩兩方面
明確定義自己的形象，並製作成設計
相關規範供公司專門人員參考。
在企業形象設計運用網格系統之前，
設計師必須要考慮到將來與公司相關
的所有檔案和資料，以便網格系統
可以適用於他們。
即使公司想要設計全新的圖形標誌，
或是一個字體標誌，那麼這個新標誌
也需要依據已有的企業形象法則來
進行設計。
這些設計法則必須全面考量統一性，
從印刷品、出版物、報表單據、對外
廣宣、電視媒體傳播，到展覽等都
應該完整貫徹。

另外值得一提的是，色彩的設計對
企業形象也有著重要的影響。

130

7–14
產品手冊的封面頁面

Das Weishaupt-Programm　　1970/71

7

Das Weishaupt-Programm　　1976/77

8

Weishaupt-Ölbrenner Typ U

9

Weishaupt-Gasbrenner Typ G
Zweistoffbrenner Öl/Gas Typen GL und RGL

10

Weishaupt-Gasbrenner Typ WG

11

Weishaupt-Ölbrenner Typ W

12

Weishaupt Ölbrenner Typen Monarch und R

13

Weishaupt-Gasbrenner Typ UG
Zweistoffbrenner Typ UGL

14

131　網格設計為所有印刷品的設計奠定
了基礎，包括所有宣傳手冊的封面和
內頁。字體和字級大小也保持一致。
針對包含所有產品的手冊，其封面會
採用一個特殊攝影主題，與單款產品
的手冊封面採用大圖的作法有明確
的區別。每個系列產品都介紹了其
應用領域，如家庭住宅、房產開發、
街區、學校建設、工廠重工等等。
在內頁中，左頁的圖片與右頁展示的
產品插圖、標題對齊。
30 格網格系統
字體：Akzidenz-Grotesk
開本：A4，29.7×21cm
印刷：四色

17
公司宣傳手冊的封面封底
18
貼有公司商標和標準色的送貨車

15／16
公司宣傳手冊的對開頁

15

17

16

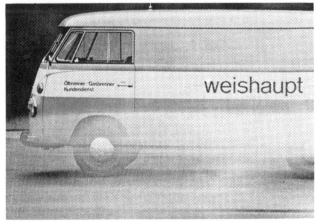

18

圖 15／16
其他與公司相關的宣傳手冊和宣傳單
的設計也採用了同樣的網格系統。
本頁案例中的版面標題和前頁案例的
位置一樣，也使用了相同的字體和
字級大小。插圖、正文和圖說的編排
方式也很統一。
圖 17／18
紅色的文字商標「weishaupt」被用
在所有的出版物上，同時還被用於該
公司所有的貨車和商務車上。文字的
排列和色彩方案也保持統一，紅色的
字體標識印在白色色帶上，上下再添
加黃色色塊。

所有其他廣告媒介都採用了統一的
文字和色彩方案，比如旗幟、櫥窗展
示、燈箱等。

132

19
公司週年紀念冊的封面和封底
20
紀念冊中的對開頁

21／22
紀念冊中的兩個對開頁

19

21

20

22

133　公司週年紀念冊的設計遵循了同樣
的設計原則。正文和圖說都採用了
Helvetica。每頁標題都排在正文之
上的空白區域。書背的字體和書名頁
的文字排印都與內文的版心相匹配。
為了突顯週年慶氣氛，所有圖片和
攝影作品全都整頁印刷，即「滿版」。
相應地，開本也從常規的 A4 尺寸
（29.7×21cm）擴至 30×25.5cm。
紀念冊的圖片都是依照美觀、實質的
原則挑選的。圖片均為四色印刷。

三維空間設計中的網格系統

網格系統不僅用於二維平面設計，還可以應用於三維空間
設計。它可以有系統性地組織空間中的視覺元素，讓觀眾
易於理解。同時，它還能集合經濟效益、時間效率和美學
感官等多方面的優勢。

以一個展覽空間的設計為例，網格系統將應用於室內牆壁、
地板和天花板的設計。這與二維平面設計中的應用相似，
網格的結構即格的尺寸取決於：

a

房間的大小，

b

需要展出物品的文字和圖示的訊息量，

c

需要展出物品的尺寸和數量，

d

展覽需要用到的室內家具，如桌椅、展架、展牆、燈具等。
在展覽空間中，務必把文字和圖片資訊的量體降到最低。
在網格系統的輔助下，清晰易讀的文字介紹和圖片、合理
的展品布局、與主題相關的色彩設計以及帶有建築概念的
空間設計能讓觀眾快速地掌握展覽內容，從而更容易理解
展品的優點。

在放置文本和圖片時，一定要注意視線的高度，適合觀眾
的合理視線高度，通常是170cm。

如果文本和圖片的位置過高，觀眾就不得不仰頭觀看，容易
疲累；如果太低，同樣也會讓觀眾產生疲累。輕微頷首平視
的觀賞姿勢對於肌肉的壓迫最小。在三維立體設計中，除了
需要提前考慮到材料、照明和觀眾流動等一些額外的空間
因素外，使用網格系統的基本原理其實與二維平面的思維
非常相似。

系統地規畫三維空間中的平面和立面可以更好地利用空間
來呈現主題展品。
同樣，空間設計得成功與否，再一次取決於設計師能否達到
以下這些前提：
研究任務，
研究展區的空間尺寸；
研究展覽的整體環境，以及影響展覽效果的各種因素；
研究在充斥視覺感官的展覽會場，觀眾的觀看習慣；
研究觀眾動線和行走的方向；
研究展覽的燈光照明狀況；
研究能閱讀展覽說明的最遠距離；
研究與相鄰參展者的距離；
研究展覽場地的硬體設施，如供水、供電以及地面特性等。
公司名稱、標誌、產品資訊、服務條款等有用的文字、
圖片和色彩資訊務必根據其重要性清晰、準確地展示出來。

三維空間設計中的網格系統

Der Raster in der dreidimensionalen Gestaltung

文本與圖片草圖在
三維空間外部立面上
的網格劃分

文本與圖片草圖在
三維空間內部立面上
的網格劃分

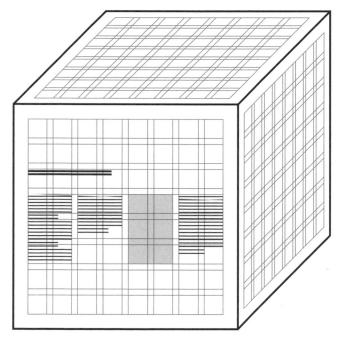

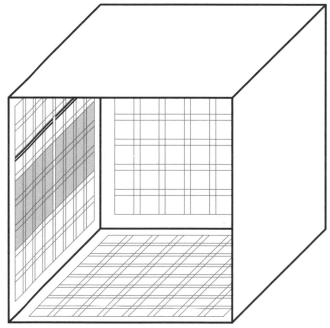

137　三維設計就是為了在有限的空間中
解決問題，其中對於網格系統的
應用原理與二維平面設計並無差別。
基本上網格系統很容易應用在一個
立方體上。空間設計涵蓋了內部和
外部，所以在立方體的內外面都鋪設
了網格。文本、圖片和展覽設備的
擺放，以及牆壁開口、門窗和燈光
照明都要按網格的結構來進行布局。
格的大小要由現場的實際考量而定，
比如占用牆體面積的文字和圖片等
展品的訊息量、展品的數量和尺寸、
及展品陳列所需要的家具，如貨架、
桌椅、櫥窗等。

三維空間內部 6 個面的
網格劃分：
地板、4 個牆面、天花板

把一個立方體的內部展開，設計師就
能更容易地規畫這個空間的每個面。
即使空間不是一個規則 6 面體，上述
方法依然能幫助設計師「剖析」空間
結構，並找到合理的網格系統。
設計師首先在展開的平面上嘗試各種
網格草圖，直到找到合適的空間分隔
方案。然後，再利用這套網格系統來
解決空間規畫的問題。如果這套網格
系統不能更好地呈現展覽內容，設計
師則需要繼續嘗試，直到找到一套符
合空間結構的網格系統。

想要找到一套最佳的網格設計方案，
確實是一件非常不容易的事情。尤其
是這套方案能適用於解決空間中的
各種問題。

三維空間內部的
網格劃分：門、地板、
天花板頂燈、文本和圖片

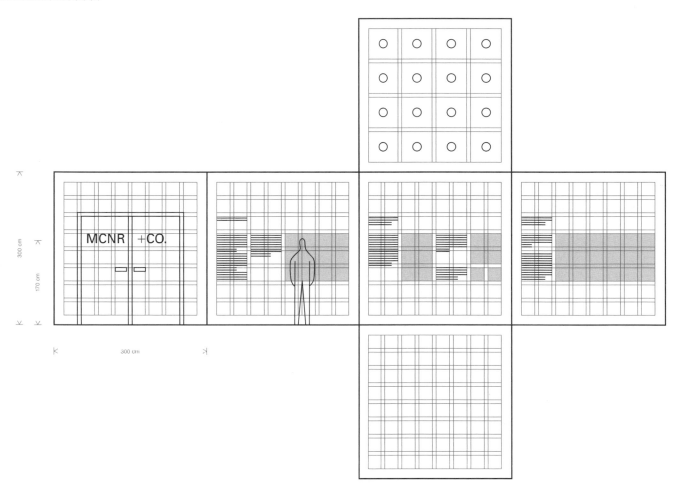

上圖展示了三維空間是如何借助網格
系統來設置門、文本、圖片和頂燈，
以及如何使彼此協調。
需要注意的是，空間設計需要著重考
慮觀眾的視平線。比如，觀眾讀取展
品資訊的視線高度。
所有形式元素的尺寸都應符合網格系
統的規畫。
文本、圖片、圖表等可讀取資訊不宜
設置在過高的地方，因為長時間保持
抬頭姿勢會使觀眾產生疲累感。

將三維空間內部的 6 個面再平分成
相同尺寸的單元

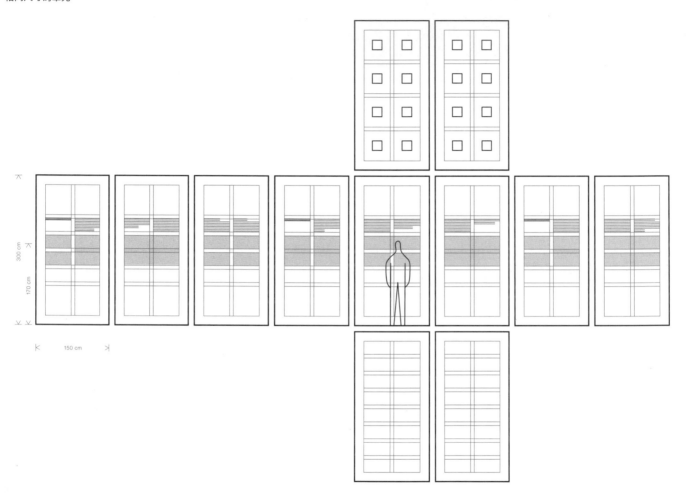

上圖中的牆面、地板和天花板被劃分
成等大的單元。將大面積分割成更小
的單元是出於實用考慮。小單元能用
預製組件，這樣一來還能便於運輸、
安裝和拆卸。
這種等大的單元構建結構堅固，便於
包裝和儲放，所以可重複使用多年，
只需在設計上更換其中更新部分的
資訊。

在相同尺寸的格中設置
文本和圖片

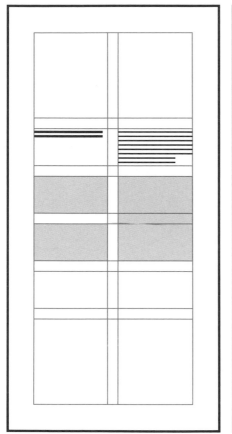

141　上圖是左頁單元構建的細節放大圖。
　　我們可以更清楚地看到在版面上設置
　　的標題、文本和圖片。上圖演示了如
　　何利用網格就可以簡單、明確地解決
　　設計上的問題。
　　其實，設計師只要掌握了網格系統的
　　原則，就不難找到 1 種令人信服的解
　　決方案。

在三維空間中，網格與頂燈、地板、
家具、文本和圖片的關係

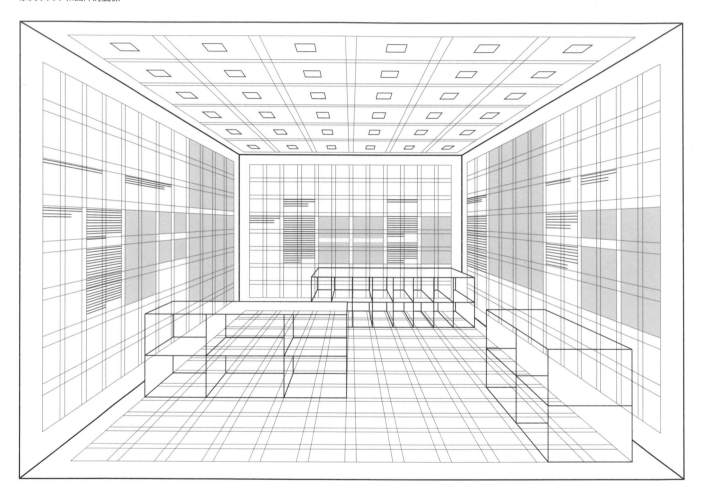

這張透視圖向我們展示了三維空間是
如何借助網格來組織和表達各種平面
和立體元素。家具、頂燈、文字編排
和圖片在空間上的設置都能與網格互
相配合。地板上還可以鋪裝與格大小
相等的地磚或地墊，或者用地毯鋪滿
整個地板。單色的地板可以很好地襯
托出其他形式的元素。

142

1851 年，倫敦水晶宮的建成是展館建築發展史上的轉捩點。直至今日，它的影響依然深遠。水晶宮是建築設計史上首次使用預製組件，因為其建築結構的創新性，施工週期幾乎是創紀錄的。可在當時的社會背景下，這項劃時代的創舉並未得到平面設計師們的注意，至少沒有引起明顯的轟動。直至二戰之後，這類的展館設計才現身義大利，並以類似網格狀的結構著稱。但是，文字和圖片卻依然沿用了以往設計理念，即按照展品元素的尺寸單獨設計，並未利用網格系統來統一設計。

1950 年代，在瑞士博覽會上首次將展臺、文字、圖片、產品等展覽元素組成一個整體，並按彼此的比例關係進行系統化設計。這種設計方式很快就被進步的德國設計師模仿。可惜的是，直至今天，這種設計理念仍然不受國內 ＊ 和國際展覽的重視。

造成這種情況的原因有很多：首先，使用網格系統需要更多的知識和實踐，也更花時間，而大部分展覽設計師缺乏必要知識；另一方面，展覽設計通常是在很緊的時間內完成的，設計師無法冷靜下來去規畫建設性的工作。

還有另外一點也很重要。如今有很多新的廣告宣傳媒介。幻燈片展示、影片、產品展示、品鑑區等方式成為新的重點。聲光特效已經發展成熟。傳統的圖片、文本以及產品的展示手段在很多場合下已經逐漸被現代的、更加有吸引力的廣告媒體所取代。儘管如此，這些媒體手段仍然從屬於一個整體設計的概念。

＊　此處的國內是指 1980 年代的瑞士。

總之，一個得到時間驗證的設計總能給人們留下深刻印象。
因為它反映了設計師解決問題的能力，即如何精心地把所有
的視覺媒介整合到一個設計裡。
現代的三維空間設計師必須一人身兼多職。他除了是一個
空間設計師，還是建築設計師、文字排印師、平面設計師、
攝影師、色彩心理學家和專業顧問。
做為設計師，他必須熟悉材料和結構；做為建築設計師，
他必須具備功能性地規畫和組織空間的能力；做為文字排印
師和平面設計師，他必須懂得如何將文本、圖片、製圖和
色彩等資訊富邏輯且具功能性地聯繫到空間中，並反映出各
部分的比例關係；做為室內設計師，他必須能將燈光照明、
貨架、展櫃、家具、會議室融入整體空間。最後，設計師還
要負責組織安排展覽日程、監控工程品質、取得招標以及
最後的預算等等。
如今，國內和國際的展覽逐年增加，展覽對於經濟和商業的
影響也日益突顯，一些平面設計師也成為名副其實的展覽
設計專家。
自 1970、80 年代至今，1 種新式的展覽空間體系已經發展
成形，它基於建築構造的組合體系，使用統一尺寸的結構
元素，通過裝配和組合達到不同的空間格局。這種新式展覽
空間體系極大地簡化了建築過程，並縮短了建築週期，結構
材料還能被多次使用。

1：20 的展覽空間模型

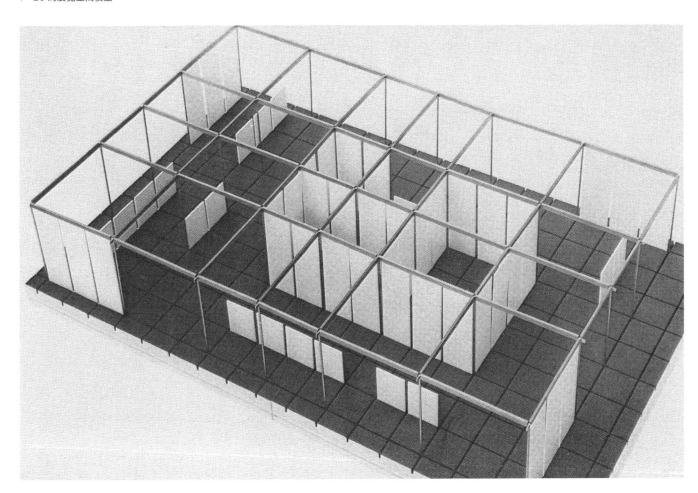

145　　這是一個按照真實比例製作的展廳
模型，設計師能以此構想實際布置
展廳。下一步將以同樣的縮小比例
引入展示所需的展品、圖文等等。
這對於與客戶溝通來說，提供了極
大方便。透過這樣的模型，設計師的
構思及實現都能變得更精確，也方便
進行調整改動，最大限度地減少設計
師與客戶之間的誤解。

「體育」（Sport）展，由等大的
預製展板搭建而成

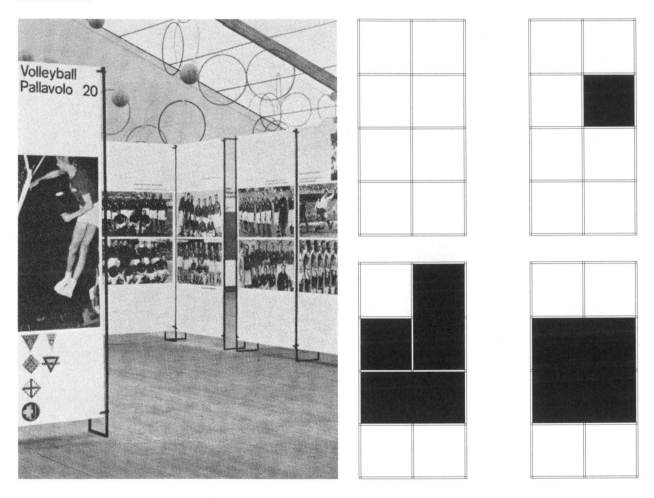

在規畫空間時網格一次次地證明了
其在實踐中的價值。
本案例展示了設計師是如何嚴格地
組織文本和圖片資訊，並把觀眾的
注意力引導到展覽主題上，同時還
不會被展覽的其他裝飾物件所干擾。
這樣嚴謹的設計不但可以確立展覽
主題，還使觀眾很容易觀看到展板
上的圖片視覺資訊。
上圖右側 4 塊展板展示了圖片資訊
是如何有效地融入網格系統。

「瑞士」（Schweiz）巡迴展，由等大的
預製展板搭建而成

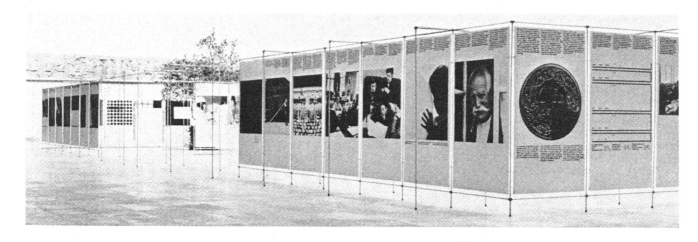

147　「瑞士」是一個與旅遊有關的巡迴展，
它不僅可以在室內展出，還可以在
露天展出。所以預製展板使用了防水
材料。
展板設計必須考慮到安裝的靈活性，
以便可以適應不同的空間。
展板上的文字分為 3 種語言。整個
展覽的設計得益於網格系統，所有的
插圖、圖形、文本資訊能夠相互關聯，
使得展覽呈現出 1 種統一、清晰且
涵蓋面廣泛的印象。

好利獲得公司
（Ing.C.Olivetti & C., S.p.A.）的展覽
1
展覽網格設計草圖
2
展覽屋頂設計草圖

3／4
標準的支架結構和
標準的文字版面
5
展覽框架結構和
屋頂支撐結構

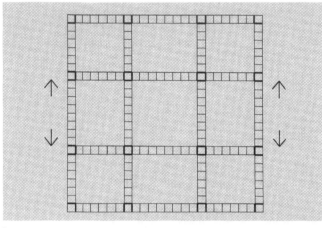

1

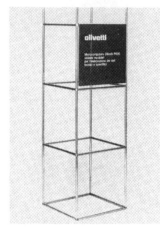

3 4

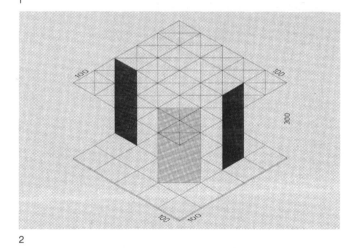

2

5

好利獲得公司的展臺設計邏輯清晰、
功能合理，這些都脫離不了網格系統
的協助。
圖 1 展示了 9 個格。
圖 2 展示了支撐屋頂的平面元素。
屋頂的設計也是基於地面的網格，
承重牆的寬度與格的長度或對角線
長度相同。
圖 3 和圖 4 展示了展架結構的設計
和搭建過程。展架橫桿與垂直立桿
之間使用了固定夾鎖。文字展板的
頂部向後彎曲，呈半圓形，像鉤子
一樣掛在展架的橫桿上。
圖 5 立體地展示了本次展覽的空間
設計是如何運用網格系統解決問題。

燈光照明也被整合到屋頂的結構中。
通過細節我們還可以看到空間的
承重和連接支架也都是基於網格的
結構。

148

6
展位和展品的展示全貌

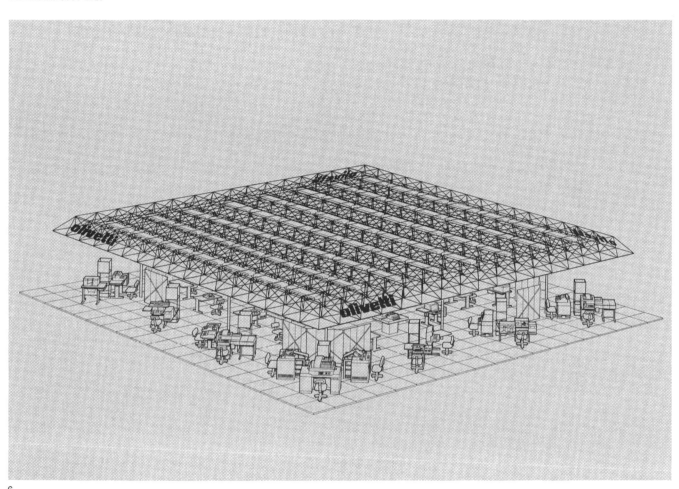

6

圖 6 是一張精確的展覽空間設計圖，
我們可以從觀眾的角度清楚地看到
整個展覽空間的結構。
若從心理學的角度來看，邏輯嚴謹和
功能突出的空間設計有助於突顯展品
的特徵和優勢。

「德國之路」(Deutschlands Weg)
巡迴展，由等大的預製展板搭建而成

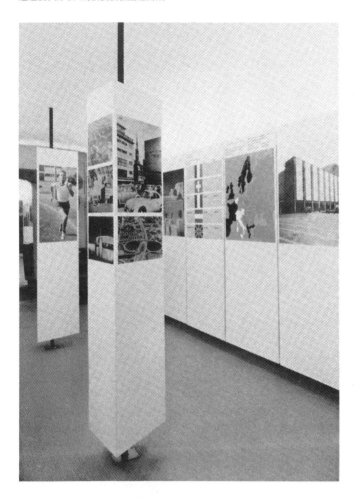

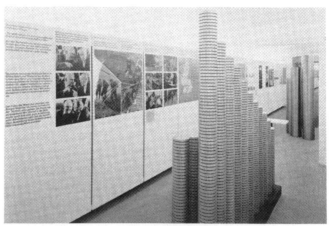

150

與前幾頁案例類似，這個展覽的空間
設計同樣也使用了簡單的網格和等大
的預製展板。這個展覽搭建於 6 節
火車車廂內，並在多個城鎮之間巡迴
展出。

由於車廂空間狹窄，展覽的主體內容
被設置在展板的上半部。這樣一來，
觀眾只需沿著車廂走廊移動，不必屈
身觀看。展板上可利用的區域被劃分
成小的格，用於編排文字與圖片。

為了看起來更輕鬆優雅，展板被懸掛
在空中，與地面保持著一定的距離。

古代和現代的秩序系統

Ordnungssysteme im Altertum und in der Neuzeit

「秩序也是生命的鑰匙。」
勒・柯比意《模度》(Le Corbusier, *Modulor* I, p.77)

在自然界裡，秩序系統主導著生命和物質的生長和構造。對秩序的不斷探尋，使得人類與其他物種區別開來，就連最原始的人類也曾創造出令人歎為觀止的幾何裝飾圖案。這種通過秩序來統治混亂的欲求反映了人類的深層精神需求。

畢達哥拉斯 (Pythagoras，西元前 580-500)[1] 認為簡單的數字及它們之間的相互關係，和簡單的幾何圖形及其構造是大自然最深處的祕密。他發現音程的和諧取決於豎琴琴弦或長笛笛腔空間距離上簡單的數字關係。

古希臘人發現了黃金比例，並發覺人體本身也蘊含著這樣的比例關係。建築師、畫家和雕塑家也崇尚這種比例，並運用到他們的創作之中。

文藝復興時期的藝術家奠定了用測量和數學比例來進行創作的基礎。杜勒 (Albrecht Dürer)[2] 在義大利進修時，研究了當時的藝術家如何通過數學來構思作品，並將他所學到的知識帶回德國。

哲學家、建築師和藝術家，包括畢達哥拉斯、維特魯威 (Vitruvius)[3]、維拉爾・德・奧內庫爾 (Villard de Honnecourt)[4]、杜勒和勒・柯比意[5]，他們在創作時對比例原理的研究都給我們留下了寶貴的經驗，讓我們可以輕鬆地領略到他們各個時期的數學魅力。

本章列出了各類與數學有關的插圖，並對照了古代和現代的案例，旨在向讀者演示秩序的數學原理是如何超越時間，並對人類的藝術創作影響深遠。

1 畢達哥拉斯
(Pythagoras，西元前 582-496)，希臘數學家、哲學家。他視數學為萬物的根本，發現由數學與比例貫穿的秩序原則。為後世留下幸運數字、完全數、親和數、數學比例等理論，並發現了畢達哥拉斯原理、三角形內角和定理、尺規作圖法等幾何學研究、畢達哥拉斯音律等偉大功績。

2 阿爾布雷希特・杜勒
(Albrecht Dürer,1471-1528)，為德國文藝復興最重要的畫家、版畫家。代表作為木版畫系列作《啓示錄》(1497-1498)，宗教畫

《東方三賢士來拜》(1504)、銅版畫《憂鬱 I》(1514) 等。也著有含網格透視法的《度量法教程》(1525)、《人體比例四書》(1528) 等理論書籍。

3 馬爾庫斯・維特魯威
(Marcus Vitruvius Pollio，生卒年不詳)，羅馬共和時期建築師。著有獻給皇帝奧古斯都的著作《建築十書》。1486 年付梓以來，翻譯為各國語言，並影響了文藝復興時期的建築師。全十書中的第三書第一章為人體比例，第四章為建築之秩序與均衡。

4 維拉爾・德・奧內庫爾
(Villard de Honnecourt, 1200-1250)，法國建築師、藝術家。關於哥德最早的史料《畫帖》，展示了中世紀建築物、動植物、機械、建築設計圖等圖示。曾留下以幾何學的分割法排版的記述。標準的圖示在奇肖爾德《紙面與版面清晰的比例》(暫譯，*Willkürfreie Maßverhältnisse der Buchseite und des Satzspiegels*, 1962) 一書中也有提及。

5 勒・柯比意
(Le Corbusier, 1887-1965) 出生於瑞士，後於法國活動的建築師、

建築理論家。從住宅與都市規畫領域展開廣泛的活動，著有提出「家是以居住為目的的機械」一語的著作《走向新建築》(暫譯，*Vers une Architecture*, 1923)、提出鋼筋混凝土結構的「多米諾系統」、確立當代建築五原則 (底層架空柱、水平連續窗、自由平面、自由立面、屋頂花園)，也透過他自行倡議的度量體系《模度》(1950／1955) 奠定了當代建築的基礎。代表作為薩伏伊別墅 (Villa Savoye, 1931)、廊香教堂 (Notre-Dame-du-Haut, 1955) 等。

冬季的木賊

蜂巢的細節

153　在植物界，各種稀奇漂亮的對稱圖案
隨處可見。這些圖案從粗獷的立體
構造到精緻優雅的平面扇形，其形態
之豐富，簡直窮極人類的想像力。
在動物界，不同動物展示的幾何圖案
精美得讓我們驚訝。它們不僅具有
功能性，形式還近乎完美。
現存已知最早的人體比例標準出土於
曼菲斯（約西元前 3000 年）的一座
墳墓。是由托勒密（Ptolemaeus）[1]、
古希臘人、古羅馬人傳承下來。
諸多藝術大師也在創作過程中制定
了自己的標準，比如波留克列特斯
（Polycletes）、維特魯威、李奧納多·
達文西 [2]、米開朗基羅 [3] 和杜勒。

1　克勞狄烏斯·托勒密
（Claudius Ptolemaeus, 83–168），
希臘天文學家、數學家、地理學家。
倡議地心說的著作《天文學大成》
（Almagestum）對後世產生了重大
的影響。他還發現了光的折射現象
「大氣折射」、留世有地理學上的大作
《地理學》、經緯線地圖等功績。

2　李奧納多·達文西
（Leonardo da Vinci, 1452–1519），
義大利文藝復興時期代表藝術家、
科學家、技師。代表作有《蒙娜麗莎》
（1503）、《最後的晚餐》（1498）等。
至今為止，仍留有 5000 頁他的科學

研究手稿。繪有以維特魯威人體比例
為基礎的《維特魯威人體圖》（約為
1487）。

3　米開朗基羅
（Michelangelo Buonarroti, 1475–
1564），義大利文藝復興時期雕刻家、
畫家、建築師。代表作有西斯汀教堂
的天頂畫（1508–1512）、美第奇小
聖堂的墓碑（1521–1534）、聖伯多祿
大殿的《聖殤像》（1499）、《摩西像》
（1513–1515）。

人體比例標準，維特魯威／勒‧柯比意

維特魯威《建築十書》，卷三，第一章
(*The Ten Books on Architecture,*
Book 3, Chapter 1)

勒‧柯比意《模度》，卷一

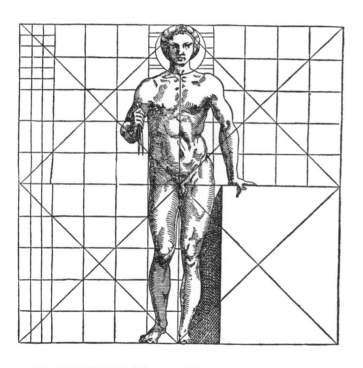

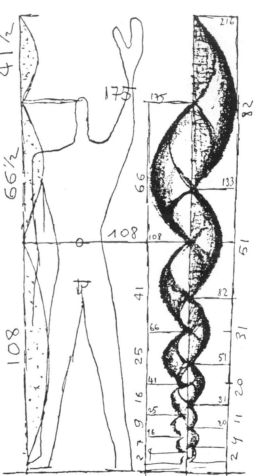

19 世紀，根據黃金比例塑造出的
人體被認為是美的標準。
勒‧柯比意在他的著作《模度》中
這樣描述道：「⋯⋯以精確的尺度
建造出來的建築，例如帕德嫩神廟、
印度廟宇及哥德式教堂，構成了一
個規則、一個嚴密的體系，展示了
1 種本質上的一致性。進一步來說，
所有年代和地區的未開化之人，
及高度文明的持有者，埃及、迦勒
底、希臘等，皆因建造而測量。
他們擁有什麼樣的工具呢？那些
恒久且珍貴的工具，因為這些工作
與人類自身有所連結：肘、手指、
拇指、腳、跨度、步幅等。我們直接

進入主題：它們是人類身體不可
分割的一部分，因此從一開始就相當
適合做為建造茅屋、別墅及廟宇的
測量工具＊。勒‧柯比意的《模度》
是他依據數學邏輯與人體比例的關係
發展出來的一套測量體系。

＊ 肘是古代長度單位；法語的
doigt 既是手指的意思，也是一指寬
的單位；法寸（pouce）這個單詞也
是拇指的意思；法尺（pied）、英尺
（foot）這些單詞都是腳的意思；
跨度（span）是拇指到小指的距離。

154

繪製字體時的度量系統

約翰・諾伊德費爾（Johann
Neudörffer）大寫拉丁字母的
結構設計，約 1660 年

好利獲得公司
7×9 點陣印表機的字母，
1972 年

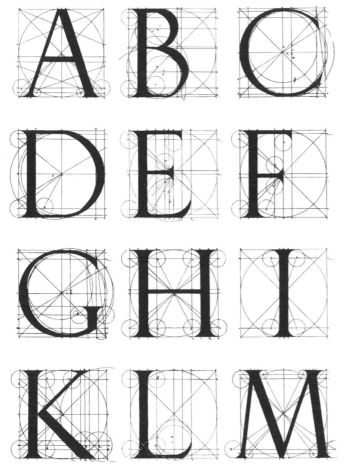

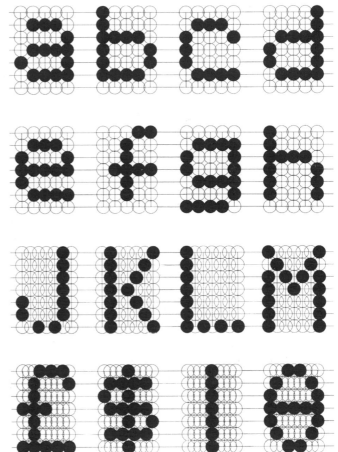

正如漢字是按方格書寫一樣，拉丁
字母也是按照嚴格的標準來設計的。
大約 1660 年，約翰・諾伊德費爾 *
設計了一套很有趣的拉丁字母。
方格做為字母的構架基礎，縱向分
為十等份，每一等份相當於字母的
豎筆劃的厚度。杜勒也曾以十等份
方格為基礎設計過一套拉丁字母。
1972 年，好利獲得公司在義大利
設計了一套用於 7×9 點陣印表機
的字母表，並把這個點陣字的方案
提交給歐洲電腦製造協會（ECMA）。
字母表中的所有字母，包括阿拉伯
數字 1 到 9，都顯示在由 35、49
或 63 個等圓組成的正方形格中。

一些字母的傳統形態被修改，但易
辨性並沒受到太大損害。
在圓形網格系統的基礎上設計出來
的一套字母具有統一的識別特徵，
這些字母的造形和美學特性給人留
下了 1 種統一、無個性的印象。

＊　約翰・諾伊德費爾
（Johann Neudörffer, 1497–
1563），德國書法家、教育家。在倫
堡設立書寫學校。為德文尖角體
（Fraktur）設計的發展做出貢獻而
知名。著有《一般手寫文字教本》（暫
譯，*Anweijsung einer gemeiner
hanndschrift*, 1538）等書。原書圖
片雖在 1660 年代有記載，但非諾伊
德費爾的活動期間。圖片出處不詳，
但做為羅馬大寫幾何學規範的著作，
可見 16 世紀義大利建築師、數學
家西吉斯蒙多・范蒂（Sigismondo
Fanti, 1472–1530）的著作《書法
的理論與實踐》（暫譯，*Theorica
et Pratica. . .de modo Scribendi*,
1514）。

圖形符號和標誌
（Signs and emblems）

14–19 世紀的圖形符號

20 世紀的標誌

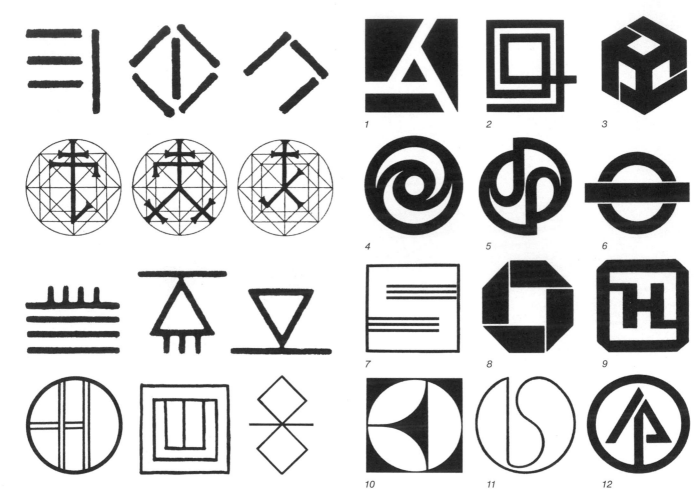

1
2
3
4
5
6
7
8
9
10
11
12

很多古老的圖形符號之所以能够引人注目，是因為它們奉行形式的本質。這些圖形符號通常基於圓形、方形、三角形或者這些基本形狀的組合。哥德時期的石匠們使用的圖形符號多由這些基本的形狀分割重組而成。例如左側圖，圓圈內繪有大小不一的水平和對角方形。橫線、直線、斜線及它們的交點決定了構成符號部件的長度和方向。

右側圖展示了 12 個不同形態特徵的現代標誌，它們運用的設計概念與石匠們相同。正負空間（黑色與白色部分）相互關聯，並形成一個有機的整體。標誌之所以能將概念轉化為 1

種視覺傳達，一是遵循了嚴格的幾何結構，二是從情感上我們更容易接受勻稱的形態。標誌傳達的是 1 種高品質的形式法則，它不僅可以獨立存在，還能超越時間的限制。

156

圖形標誌（Pictograms）

古埃及象形文字
從左至右，從上至下分別為：
人／王／神／天／星／日／水
／牛／屋／路／鎮／地

瑞士聯邦鐵路的圖形標誌，
1980 年

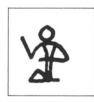

圖形符號代表著我們周圍世界的
物件，在蘇美人、西臺人、埃及人和
中國人的書寫系統中都可以找到。
他們用象形符號來代表語言或文字。
這些象形符號有的是模仿人類日常
生活用品的形態，有的是由一些傳統
觀念逐漸發展演化而成。
不過，每一個象形符號無論是模仿
還是演化，它們都必須在保持本質細
節的前提下，最大程度地簡化形態。
左邊的案例展示了古埃及人書寫系統
裡的一些象形文字。
右邊的案例是本書作者的工作室為
瑞士聯邦鐵路設計的一套以方形網格
為基礎的圖形標誌。這些圖形標誌的

基本元素是通過特定的長度和寬度
被設計出來的，從而形成了一個完整
統一的視覺系統。
這套系統的視覺統一性非常重要：
一方面，人們要通過各種不同的圖形
標誌讀取諸多必要資訊；另一方面，
無論旅客到何地都能見到同樣標誌，
避免誤解。

文字排印

約翰尼斯・古騰堡，《42 行聖經》的
其中一頁，約 1455 年

約瑟夫・穆勒－布洛克曼，
展覽海報，1980 年

從古騰堡時期開始，文字排印就有一
套約定俗成的規則，應用於印刷品。
遵守這些規則有利於保證印刷品的
功能和美感。文字排印的規則不僅
包括字距、詞距、行距、字級大小
等，還包括版心比例、分欄、頁邊距
和頁面開本。許多人也曾嘗試用黃金
分割來設計版面的比例。
優秀的文字排印作品始終秉持著 1 種
高度規整有序的樣式。
現代文字排印也應滿足對秩序結構
和審美品質的需求，不能受時尚潮流
的影響而主觀濫用。

158

音樂

約翰・塞巴斯蒂安・巴赫
（Johann Sebastian Bach, 1685–1750），
《無伴奏小提琴奏鳴曲第一號奏鳴曲》

毛裡西奧・卡赫爾
（Mauricio Raúl Kagel），
Sonant, Fin I, 第 2 頁

159 音樂和藝術就像是數學的兩姊妹。與藝術一樣，音樂也以自然規律為基礎。

畢達哥拉斯提出了整數與協和音程有相互關係。柏拉圖 [1] 也認為數字是和音的基礎。正如建築、繪畫和雕塑等視覺藝術要遵循造形、顏色和比例的法則一樣，音符、節拍、旋律和樂句等音樂元素，也同樣要依照樂律的標準。

在過去的 3 個世紀裡，音樂一直對和絃、調性有追求，而 12 音作曲家們的出現改變了這一切。連續的節奏將旋律的動機展開昇華為 1 種對稱美。

12 音技法代替了和絃旋律的體系，它有一套全新的法則，使得在序列音樂 [2] 的想像力世界中，能够產生音樂秩序的新統一。

1　柏拉圖
（Plato, 西元前 427–347），古希臘觀念論哲學家。創立了柏拉圖學院。師事於蘇格拉底，繼承並發展了問答法，樹立了名為柏拉圖主義的哲學體系。代表作有《蘇格拉底的申辯》、《會飲篇》、《理想國》等。他與畢達哥拉斯學派有所交流，在後期對話篇《蒂邁歐篇》（Timaeus）中，遵照畢達哥拉斯的數學觀，闡述賦予混沌秩序、形成巨匠造物主（Demiurge）之理念。

2　序列音樂為 1950 年代前衛音樂主流的作曲技法。發展自 12 音技法體系，原則是在 8 度內均等地使用 12 音，不僅限於音高的操作，還包含以音的時間（音價）、音色、強度這四個要素來組織音樂。

建築外觀裝飾

柱形宮殿的外表浮雕，
米特拉遺址，墨西哥

蘇黎世 Höngg 區市政中心的混凝土浮雕，
吉川靜子，1973 年

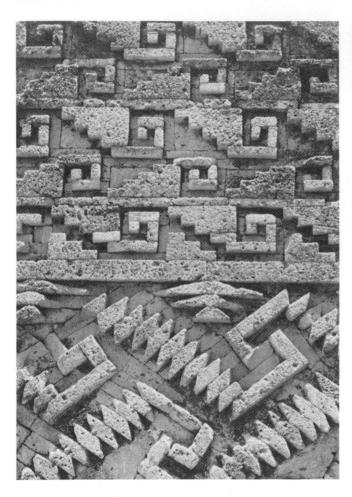

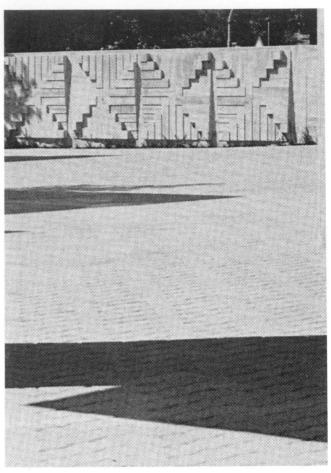

建築的裝飾可以從各種不同的角度
來考察和評判。有些裝飾採用了和
建築本體相同的材料和顏色，而有些
裝飾則採用和建築其他部分不一樣
的材料和顏色。
同樣，建築外觀的裝飾既可以源於
建築的設計風格，也可以有自己獨特
的風格。
如果能採用與建築本身同樣的材質，
以 1 種結構元素、結構單元的形式
嵌入主體，在建築外觀上以正負形的
方式凸出或凹陷，對建築的比例以
吸收、演繹、變化的形式去匹配整體
理念、適應建築的風格，這樣的裝飾
才是最有說服力的。

雕塑

亞述軍官，
豪爾薩巴德浮雕

花崗岩石柱，
橫截面由三角形演變為八邊形，
馬克斯·比爾，1966 年

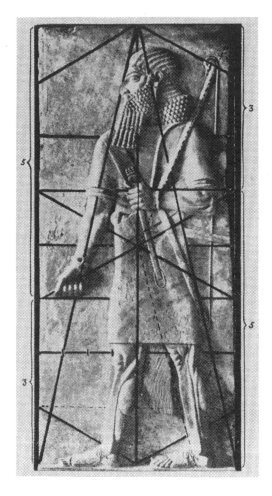

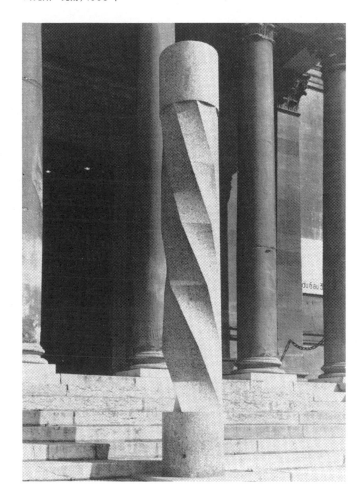

161　與二維設計一樣，三維立體雕塑的
設計在一定程度上也與構圖和比例
息息相關。
所有偉大的文明都創造了它們自己
的審美標準。事實上，結構主義比
現實主義更加強調雕塑的構圖和
比例關係。

馬克斯·比爾的雕塑作品，直徑
60cm，高 420cm，橫縱比為 1：7。
在上下兩個圓柱之間，石柱的橫截面
從三角形由下而上演變成八邊形。
這件雕塑作品的設計完全基於數學
概念，技術上採用花崗岩材質完美地
呈現出來。雕塑表面有節奏地旋轉，
精緻有序，如此有革新精神的藝術
創作實在令人心悅誠服。

繪畫

錫耶納圖書館的壁畫，
平圖里喬（1454–1513）[1]

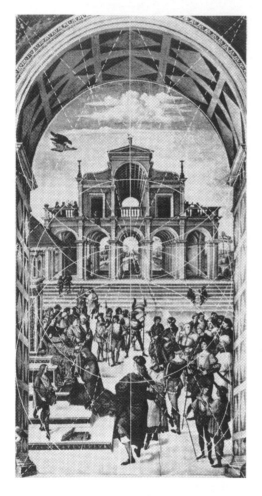

《百老匯爵士樂》及其比例圖示，
皮特・蒙德里安（1872–1944）[5]

就像建築和雕塑一樣，繪畫也受到美學法則的支配。它的目的不止要表現出畫面的張力，還要使畫面和諧。從很多繪畫作品中，我們都可以看到其構圖都是利用黃金分割來獲得1種和諧的比例關係。很多藝術大師，如曼特尼亞[2]、拉斐爾[3]、皮耶羅・德拉・弗朗切斯卡[4]、李奧納多・達文西、杜勒，他們在藝術創作中都非常嚴格地遵循這種比例法則。畫面中所有重要的元素都服從於1種數學原理，這是確定畫面構成以及動靜節奏的決定性因素。20世紀結構主義學派和結構主義藝術家完全是運用數學思維來創作

繪畫和雕塑的。例如抽象繪畫先驅皮特・蒙德里安[5]，其作品體現的就是1種純粹的數理關係。從那時起，1種以數學為思維導向的藝術流派逐漸成長起來，並受到人們廣泛地關注。他也是20世紀唯一一個一直堅定自我創作路線的藝術流派。

1 平圖里喬
（Pinturicchio, 1454–1513），義大利文藝復興時期畫家。代表作為宗座宮的《波吉亞寓所》（*Appartamento Borgia*, 1492–1494）。

2 安德烈亞・曼特尼亞（Andrea Mantegna, 1431–1506），義大利文藝復興時期畫家、版畫家。代表作為《耶穌受難畫》（約1455–1459）、影響了杜勒的銅版畫《海神之戰》（約1475）。

3 拉斐爾・聖齊奧
（Raffaello Sanzio, 1483–1520），

義大利文藝復興時期畫家、建築師。代表作有宗座宮「拉斐爾房間」的濕壁畫《雅典學堂》（1509–1510）。

4 皮耶羅・德拉・弗朗切斯卡
（Piero della Francesca, 1412–1492），義大利文藝復興時期畫家。代表作有《基督受洗》（1450）。

5 皮特・蒙德里安
（Piet Mondrian, 1872–1944），荷蘭畫家。透過成立追求抽象藝術新造形主義的團體（1917），與創立前衛美術運動的荷蘭風格派運動，影響了歐洲的結構主義風潮。

162

建築

桂離宮，京都，日本

《單元住宅》，1947–1952 年
馬賽，勒・柯比意（1887–1965）；

163 建築設計就是將數學轉化到空間裡。
在亞洲、地中海地區和中美洲，
其偉大的建築成就足以證明 1 種高度
的秩序系統的存在。即使在它們的
原始時期，簡單的建築結構也能體現
出人類對和諧比例的理解和追求。
在日本，住宅和寺廟建築的比例都是
基於榻榻米的大小，即 1：2 的長寬
（90×180cm）比例。建築平面圖
也是由這個單位繪製而成。即使是
分隔房間的滑動拉門，其高度和寬度
也都是通過這種單位換算出來的。
故而這種建築的美來自它的比例關係
和材料運用。

20世紀，勒・柯比意發現了「模度」
這是一套能「易於變美，難以變醜」
（愛因斯坦＊致勒・柯比意）的量度
系統。從那（1949 年）之後，勒・
柯比意便開始在「模度」這一基於
自然界和人體黃金風格的比例系統
的說明下設計建築。

＊ 阿爾伯特・愛因斯坦
（Albert Einstein,1879–1955），
出生於德國烏姆的美國物理學理
論家。為後世在物理學諸領域留下
狹義相對論（1905）、廣義相對論
（1916）諸多功績。於 1946 年在
普林斯頓與柯比意見面，討論了
「模度」相關的問題。

產品的形體

椅子，16 世紀中期，法國

旋轉躺椅《670》，查理斯・伊姆斯（Charles Eames），
美國，1955 年，赫曼米勒出品

人類日常使用的生活用具的造形往往受制於生產成本和實際用途這 2 種因素。比如，家居用品必須滿足特定的實用功能，這種實用功能體現在材料運用、使用方法和設計造形上。時至今日，「產品設計必須優先考慮其功能性」的這個原則從未動搖。不僅如此，技術的發展將會帶來全新的材料、生產方式、生活方式和工作方式，以及不同的審美標準和人體工學。所以，現代的設計師必須具備比前輩們更加廣泛的知識才能應對生活需求的變遷。

很多傑出的設計師總是能把握藝術與功能之間的平衡，並在造形設計、比例關係和材料運用上賦予產品 1 種迷人的氣質。

164

博覽會建築

第 70 屆世界博覽會的節日廣場，
大阪，日本
建築設計：丹下健三，東京

水晶宮，世界博覽會，倫敦，1851 年

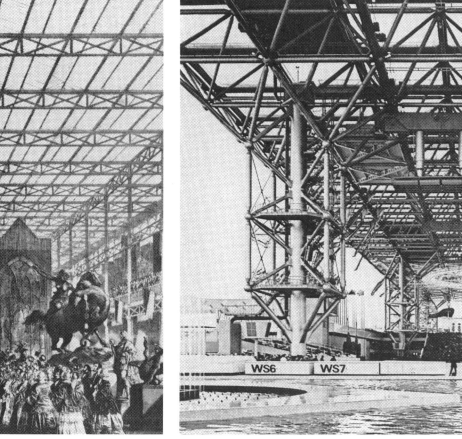

165　1851 年，約瑟夫・帕克斯頓爵士
（J. Paxton）[1] 為倫敦世界博覽會設
計建造的水晶宮是歷史上第一座採用
預製組件建造起來的建築。相同尺寸
的組件決定了建築的結構。
之後幾年，水晶宮不僅為展覽建築
帶來了革命性的設計風潮，還改變了
人與建築之間的審美關係。以往單獨
設計一棟建築物的傳統被 1 種實用、
整體的設計理念所取代，並規定了
預製組件的標準間距，使組件的垂直
部位按相同的模式重複。用這種小型
組件搭建出來的建築使得建築整體通
透，並有 1 種輕盈、流動的節奏感。
大阪世界博覽會的節日廣場也採用了

同樣的方式來搭建。與水晶宮相比，
節日廣場的設計模式更為開放，
承重柱之間的間隔也更大。這些柱子
的體積巨大，在整個建築中顯得非常
醒目。此外，水晶宮用的建築材料是
單色的，而丹下健三 [2] 在節日廣場使
用的則是彩色的。

1　約瑟夫・帕克斯頓
（Sir Joseph Paxton, 1801–1865），
英國建築師、園藝師。代表作除《水
晶宮》之外，還有查茨沃斯莊園以預
鑄工法建成的作品《溫室》（1840）。

2　丹下健三
（1913–2005），日本建築師、都市規
畫師。1961 年開設丹下健三＋都市建
築設計事務所。代表作有《廣島和平
紀念資料館》（1955）、《香川縣廳舍》
（1958）、《代代木競技場第一體育館》
（1964）、日本萬國博覽會總體設計
（1970）、《新東京都廳舍》（1991）等。

都市計畫

米利都城的城區規畫，
西元前 479 年

巴黎《Plan Voisin》（城區規畫）草圖，
勒・柯比意，1924 年

古代的遠東、近東地區的都市規畫
類似如今的歐洲和美洲，都是基於
1 種合理的網格式格局。 建於西元
前 479 年的古希臘米利都城就是從 2
種不同大小的網狀格局中發展而
成的。這座城市坐落在一個半島上，
所以城市格局也順應了這樣的地貌。
網格中留出了神廟、浴場及其他
公共設施的位置。每塊網格的面積
為 51.6m × 29.9m。
訴求合理性的設計方法讓米利都城
的都市規畫顯得相當成功。之後，
這種都市規畫設計也被稱為米利都
風格（Milesian style)[1]。

建成於 7 世紀的日本奈良和京都，
城市人口分別為 100 萬和 50 萬，
兩座城市的都市規畫也是基於網狀
格局 [2]。17 世紀，費城的城市建設
與美國的其他城市一樣，都是基於
這種格局。
右圖是勒・柯比意給巴黎新市中心
做的城區規畫（未曾實施），它也是
基於 1 種網格結構，並根據當時城
市發展的情況做出了相應的調整。

1 　米利都風格源自古希臘城邦米利
都的都市規畫師、建築師希波達莫斯
（Hippodamos，西元前 498–408）
發展的格狀都市計畫。他亦被尊為
「歐洲城市規畫之父」，網格都市規
畫亦常被稱作「希波達莫斯方式」
（Hippodamian Plan）。

2 　7 世紀奈良與京都人口推算，奈良
為 7 萬 4 千人到 10 萬人左右，京都
為 10 萬到 15 萬人左右。

166

後記

本書中所展示的案例清晰、易懂，這樣更便於經驗不足的
年輕設計師學習，並幫助他們運用到自己的設計中。
在實踐過程中，他們則可能會遇到更簡單或更複雜的各種
問題。不過，只要他們掌握了應用網格系統的基本原理，
便可以借助網格這個工具來處理更複雜的設計問題。
每當設計師借助這套規範系統成功解決了編排中出現的
新問題後，他們對網格的信任一定會提升。於此同時，
因作品獲得了更規範化和結構化的形式效果，設計師的
自信和滿足感也會增強。隨著網格駕馭能力的愈發純熟，
設計師的想像空間亦將不斷拓展。即使在文本和圖片內容
極其複雜的情況下，這種系統模組化的設計方式也會為
設計師提供創造性的解決方案。
現在越來越多的客戶希望設計師能夠完成邏輯嚴密、系統
科學的設計。這不止是出於經濟上的考慮，也出於對統一
的企業形象的塑造和維護的考量。僅憑純感性的創意，
難以實現統一的企業形象設計。設計需要同時兼具高度的
理性和感性，才能實現創造性的成就。

Theodor W. Adorno
Philosophie der neuen Musik
Verlag Ullstein GmbH, Frankfurt/
M–Berlin–Wien, 1972

Walter Amstutz
Japanese Emblems and Designs
Amstutz De Clivo Press, Zürich,
1970

René Berger
Die Spracher der Bilder
Verlag M. DuMont Schauberg,
Köln, 1958

Karl Blossfeldt
Urformen der Kunst
Verlag Ernst Wasmuth, Tübingen,
1933

Charles Bouleau
La géometrie secrète des peintres
Aux Editions du Seuil, Paris, 1963

A. E. Brinckmann
Platz und Monument
Ernst Wasmuth AG Berlin, 1923

Erich Buchholz
Schriftgeschichte als Kultur-
geschichte
Verlag des Instituts für Geo-
soziologie und Politik,
Belnhausen über Gladbach,
Hessen, 1965

Peter Croy
Grafik Form + Technik
Musterschmidt Göttingen,
Göttingen–Frankfurt–Zürich, 1964

Peter Croy
Die Zeichen und ihre Sprache
Musterschmidt Göttingen,
Göttingen–Frankfurt–Zürich, 1972

Leo Davidshofer/Walter Zerbe
Satztechnik und Gestaltung
Bildungsverband Schweiz. Buch-
drucker, 1952

Werner Doede
Schön schreiben eine Kunst
Johann Neudörffer und seine
Schule
Prestel Verlag, München, 1957

Albrecht Dürer
Unterweisung der Messung mit
dem Zirkel und Richscheit
Faksimiledruck von Josef Stocker-
Schmid, Dietikon–Zürich, 1966

Charles Eames
Furniture from the design
collection
The Museum of Modern Art,
New York

Ernst Egli
Geschichte des Städtebaues
Eugen Rentsch Verlag, Erlen-
bach–Zürich und Stuttgart, 1959

Wilhelm Fucks
Mathematische Musikanalyse und
Randomfolgen. Musik und Zufall.
Gravesaner Blätter, Gravesano,
1962

I. J. Gelb
Von der Keilschrift zum Alphabet
Kohlhammer Verlag, Stuttgart,
1958

Gutenberg Jahrbuch 1962
Gutenberg Gesellschaft, Mainz

Otto Hagenmaier
Der Goldene Schnitt
Heinz Moos Verlag, Heidelberg,
1963

Friedrich Herzfeld
Musica nova
Im Verlag Ullstein, Berlin, 1954

Oldrich Hlasvsa
A book of type and design
Peter Nevill, London
SNTL Publishers of Technical
Literature, Prag, 1960

Kosaku Itoh
Japanische Familienwappen
David Verlag, Tokyo, 1965

William M. Ivins, Jr.
Art and Geometry
Dover Publications, Inc.,
New York, 1964

Hans Jensen
Die Schrift in Vergangenheit und
Gegenwart
VEB Deutscher Verlag der
Wissenschaften, Berlin, 1958

Gyorgy Kepes
Modul, Proportion, Symmetrie,
Rhythmus
La Conaissance, Brüssel, 1969

Francis D. Klingender
Kunst und industrielle Revolution
VEB Verlag der Kunst, Dresden,
1974

Helmut Kreuzer und Rul Gunzen-
häuser
Mathematik und Dichtung
Nymphenburger Verlagshandlung
GmbH, München, 1965/67

Le Corbusier
Städtebau
Deutsche Verlags-Anstalt
Stuttgart, Berlin und Leipzig, 1929

Le Corbusier
Der Modulor
J. G. Cotta'sche Buchhandlung
Nachfolger Stuttgart, 1953

Ernö Lendvai
Bartók und die Zahl
Melos, Zeitschrift für neue Musik
November 1960

Richard Paul Lohse
Neue Ausstellungsgestaltung
Verlag für Architektur, Erlenbach–
Zürich, 1953

Richard Paul Lohse
Modulare und serielle Ordnungen
Verlag M. DuMont Schauberg,
Köln, 1973

Robert Meldau
Zeichen, Warenzeichen, Marken,
1967
Verlag Gehlen, Bad Homburg
v. d. H., Berlin, Zürich

Stanley Morison
Typenformen der Vergangenheit
und Neuzeit
Demeter Verlag, Hellerau bei
Dresden, 1928

Josef Müller-Brockmann
Gestaltungsprobleme des
Grafikers
Verlag Arthur Niggli Ltd.,
Teufen AR, Schweiz

Josef Müller-Brockmann
Geschichte der visuellen Kom-
munikation
Verlag Arthur Niggli Ltd.,
Teufen AR, Schweiz, 1971

Josef und Shizuko Müller-
Brockmann
Geschichte des Plakates
ABC Verlag, Zürich, 1971

Musiker Handschriften
Atlantis Verlag Zürich, 1960

Peter Omm
Messkunst ordnet die Welt
Heinz Moos Verlag, Heidelberg,
1963

Eberhard Orthbandt/Dietrich
Hans Teuffen
Ein Kreuz und tausend Wege
Friedrich Bahn Verlag Konstanz,
1962

Ewald Rathke
Konstruktive Malerei 1915–1930
Dr. Hans Peters Verlag, Hanau

Imre Reiner
Das Buch der Werkzeichen
Verlag Zollikofer & Co. St.Gallen,
1945

Raul M. Rosarivo
Divina Proportio Typographica
Scherpe Verlag, Krefeld, 1961

Willy Rotzler
Konstruktive Konzepte
ABC Verlag, Zürich, 1977

K. J. Schoen
Lineare Bildstrukturen
Galerie im Zentrum, Berlin, 1979

Andreas Speiser
Die mathematische Denkweise
Verlag Birkhäuser, Basel, 1952

Andreas Speiser
Elemente der Philosophie und
der Mathematik
Birkhäuser Verlag Basel, 1952

Max Steck
Mathematik und Kunst
Kunst und Kunsttheorie, Bd. 5,
Woldemar Klein Verlag, Baden-
Baden

André Studer
Architektur, Mensch, Mass
Kreis der Freunde von Hans
Kayser, Bern, Schriften über
Harmonik Nr. 2, Bern 1976

Systems
Arts Council 1972–3, London

Walter Szmolyan
Josef Matthias Hauer
Verlag Elisabeth Lafite, Wien,
1965

Theorie und Praxis der konstruk-
tiven Kunst heute
«Exakte Tendenzen» Verein für
konstruktive Gestaltung
Arbeitskreis für systematisch
konstruktive Kunst, Wien-Buch-
berg, 1979

Jan Tschichold
Schriftkunde, Schreibübungen
und Skizzieren
Verlag des Druckhauses Tempel-
hof, Berlin, 1942

Jan Tschichold
Was jedermann vom Buchdruck
wissen sollte
Verlag Birkhäuser, Basel, 1949

Adrien Turel
Mass-System der historischen
Werte, 1944
Europa Verlag Zürich, New York

W. Turner and H. Edmund Poole
Annals of Printing
Blandford Press, London, 1966

Walter Ueberwasser
Von Mass und Macht der alten
Kunst
Heitz & Co., Leipzig–Strassburg–
Zürich, 1933

Vitruve
Les dix livres d'architecture
Les Libraires Associés, France,
1965

Borissa M. Vlievitch
The Golden Number
Alec Tiranti, London, 1958

Wolfgang von Wersin
Das Buch vom Rechteck
Otto Maier Verlag, Ravensburg
1956

Heinrich Wessling
Das Gesetz der Baukunst, Plastik,
Malerei, Musik
Verlagsbuchhandlung Fr. Wilh.
Ruhfus, Dortmund, 1952

Clara Weyergraf
Piet Mondrian und Theo van
Doesburg
Wilhelm Fink Verlag München,
1979

ヒラギノ角ゴ W8

正文字體：
游ゴシック D ＋
Helvetica Now Text Regular
行距：
14.917-pt

使用字體
標題（12-pt）：Hiragino Sans W7
　＋ Helvetica Now Text Regular
正文（9-pt）：游ゴシック D
　＋ Helvetica Now Text Regular
圖說（7-pt）：游ゴシック D
　＋ Helvetica Now Text Regular
注釋（7-pt）：游ゴシック M
　＋ Helvetica Neue Light

ヒラギノ角ゴ W8

9 dtp pt
14.917 dtp pt

9 Cic.	12'	9 Cic.	12'	9 Cic.	12'	9 Cic.
40.5 mm	4.5	40.5 mm	4.5	40.5 mm	4.5	40.5 mm

5 Cic. 9'
15'
5 Cic. 9'

Zeigte bereits das Beispiel mit 20 Rasterfeldern eine fast unbegrenzte Zahl von Layout-Möglichkeiten, so erweitert der Raster mit 32 Feldern den Bereich der gestalterischen Lösungen nochmals um ein Beträchtliches. Bei der grösseren Zahl von Rasterfeldern können die Abstufungen, respektive die Grössenunterschiede zwischen den Abbildungen, differenzierter werden.

Ebenfalls vermag dadurch der Gestalter die Rhythmisierung und Dynamisierung der Bildfläche zu intensivieren und auszuweiten.

Das abwechslungsreiche Spiel von grossen und kleinen, farbigen und schwarz-weissen, dunkeln und hellen Bildern hat für jeden intelligenten und phantasiereichen Designer eine faszinierende Anziehungskraft.

Materiell gesehen bietet die Fläche mit 32 Rasterfeldern Raum für sehr viele Abbildungen. Dieser Umstand kann dann von grosser Wichtigkeit sein, wo ein Unternehmen mit einer grossen Produktpalette möglichst viele Produkte abgebildet haben möchte oder für Reiseunternehmen, die ihre Ferienangebote mit vielen Bildern vorstellen müssen.

Ein Bildraster mit 32 Feldern offeriert ein praktisch alle Aufgaben abdeckendes Angebot an Lösungen. Er verlangt vom Gestalter aber ein grösseres Mass an Selbstdisziplin, damit an Stelle von Übersichtlichkeit, Klarheit und Ordnung nicht Wirrwarr entsteht.

Auch dieses Buch «Rastersysteme für die visuelle Gestaltung» ist mit 32 Rasterfeldern im Format DIN A4 konzipiert. Die Titel sind in der Helvetica 12 Pt. halbfett, der Text in der 9 Pt. normal mit 3 Pt. Durchschuss, die Legenden in der 7 Pt. normal mit 1 Pt. Durchschuss gesetzt. Der Satzspiegel hat 2 Spalten mit 9 Pt. Text und 4 Spalten mit 7 Pt. Legenden.

Abb. S. 88/89
Massangaben für Satzspiegel und Bildraster mit 32 Feldern. Der Bildraster mit 32 Feldern soll, wie im Beispiel mit 20 Feldern, mit genauen Massangaben versehen sein. Damit erspart sich der Designer Unklarheiten in der eigenen Arbeit, aber auch im

Verkehr mit dem Drucker. Der Satzspiegel mit 32 Rasterfeldern erweitert gegenüber dem Satzspiegel mit 20 Rasterfeldern die Variationsmöglichkeiten mit Text und Bild ausserordentlich.

87

173

9 dtp pt
12 dtp pt

作者／

約瑟夫・穆勒－布洛克曼（Josef
Müller-Brockmann）於 1950 年代
至 1960 年代間興起的瑞士風格主義
設計中，穆勒－布洛克曼這位平面
設計師在其中扮演了重要的角色。
起初以插畫為主軸發展的他，於 1950
年前後大大轉變作風，發展出以
無襯線字體和幾何造形為基礎的結構
式設計。他的設計風格既冷靜又理智，
同時具備獨特的明亮與簡潔，成為
1 種典範，展現了平面設計與從具象
變為幾何學抽象的現代藝術之間有何
關聯，也提出「設計師應該在社會上
採取中立立場」的原則。
在以設計師身分活動的同時，他也投
入教育活動，曾經擔任蘇黎世應用
美術學校平面設計專班主任（1957–
1960 年）、烏爾姆造形大學講師
（1962–1963 年），並於 1960 年代
到 1970 年代之間於日本舉辦特別
課程與展覽會等。1970 年代後，他致
力於將從事設計多年所累積的經驗與
方法撰寫成書，其中尤其以 1981 年
的著作《平面設計中的網格系統》
（*Grid System in Graphic Design*）
最為經典，此作將視覺設計中的網格
系統技術與理念進行統整，如今依然
是全球設計師的參考典範。

選書、設計／

葉忠宜

平面設計師、卵形平面設計工作室
與重本書店（typography／graphic
design 為主軸的設計書店）獨立
創辦人。日本京都藝術大學研究所
畢業。曾創刊統籌華文圈首本字體
設計專業雜誌《Typography 字誌》，
並策畫設計教育書系《Zeitgeist》，
陸續引進國外平面設計大師經典著作、
如艾米爾・魯德《本質》、沃夫岡・
魏因加特《我的字體排印學之路》、
約瑟夫・穆勒－布洛克曼《我的人生：
玩得認真，認真的玩》和《網格系統》、
瑞士洛桑設計學院《瑞士字體排印
風格三十年》……等等。

監修協力／

楊林青

書籍設計師、出版人。畢業於清華
大學美術學院視覺傳達設計系和巴黎
國立高等裝飾藝術學院（ENSAD）
編輯設計專業。2007 年在北京成立
楊林青工作室，專注於中國原創出版物
的策畫、編輯與設計工作。

劉慶

文字排印師。生於中國福建，北京語言
大學日語專業畢業後赴日。《The Type》
編輯、《字談字暢》podcast
製作人和聯合主播。為國內外字體
廠商和公司擔任字體顧問，參與包括
思源字體家族等大型字體項目。
W3C 特邀專家、中文排版任務團聯職
主席。國際字體協會（ATypI）會員、
紐約 TDC 顧問理事。著有《孔雀計劃：
重建中文排版的思路》（中英雙語，The
Type2020）。譯作有簡體中文版《西文
字體》、《西文排版》、《排版造型》等。
曾在東京、北京、上海等地舉辦過多次
演講。

平面設計中的網格系統
平面設計、文字排印與空間設計的視覺傳達經典教本
Grid systems in graphic design:
A visual communication manual for graphic designers,
typographers and three dimensional designers
──約瑟夫・穆勒－布洛克曼
Josef Müller-Brockmann

一版一刷　2023 年 8 月

作者	約瑟夫・穆勒－布洛克曼
	Josef Müller-Brockmann
選書、設計統籌	葉忠宜
責任編輯	陳雨柔
監修協力	楊林青、劉慶
翻譯	徐宸熹、張鵬宇
繁中版編譯	臉譜出版編輯部
行銷企畫	陳彩玉、林詩玟
發行人	凃玉雲
總經理	陳逸瑛
編輯總監	劉麗真
出版	臉譜出版
	城邦文化事業股份有限公司
發行	英屬蓋曼群島商家庭傳媒
	股份有限公司城邦分公司
	台北市中山區民生東路 141 號 11 樓
	客服專線：
	02-25007718；25007719
	24 小時傳真專線：
	02-25001990；25001991
	服務時間：
	週一至週五上午 09:30–12:00；
	下午 13:30-17:00
	劃撥帳號：19863813
	戶名：書虫股份有限公司
	讀者服務信箱：
	service@readingclub.com.tw
	城邦網址：http://www.cite.com.tw
香港發行所	城邦（香港）出版集團有限公司
	香港灣仔駱克道 193 號東超商業中心 1F
	電話：852-25086231
	傳真：852-25789337
馬新發行所	城邦（馬新）出版集團 Cite (M) Sdn Bhd.
	41-3, Jalan Radin Anum,
	Bandar Baru Sri Petaling,
	57000 Kuala Lumpur, Malaysia.
	電話：+6(03) 90563833
	傳真：+6(03) 90576622
	讀者服務信箱 :services@cite.my
ISBN	978-626-315-319-6　FZ2010C
售價	850 元（本書如有缺頁、破損、倒裝，
	請寄回更換）
	版權所有．翻印必究（Printed in Taiwan）

國家圖書館出版品預行編目資料
Cataloging in Publication, CIP

平面設計中的網格系統：
平面設計、文字排印與空間設計的視覺傳達經典教本／
約瑟夫・穆勒 - 布洛克曼（Josef Müller-Brockmann）作
—初版—臺北市：臉譜出版，
城邦文化事業股份有限公司出版：英屬蓋曼群島商
家庭傳媒股份有限公司城邦分公司發行, 2023.08
176 面；21×29.7 公分（臉譜書房；FZ2010C）
譯自：Grid systems in graphic design :
a visual communication manual for graphic designers, typographers and three
dimensional designers
ISBN 978-626-315-319-6（精裝）

1.CST：版面設計　2.CST：平面設計

964　　112007837